ACTS OF UNDRESSING

DRESS, BODY, CULTURE

Series Editor: **Joanne B. Eicher**, *Regents' Professor Emerita, University of Minnesota*

Advisory Board:

Djurdja Bartlett, *London College of Fashion, University of the Arts*
Pamela Church-Gibson, *London College of Fashion, University of the Arts*
James Hall, *University of Illinois at Chicago*
Vicki Karaminas, *Massey University, Wellington*
Gwen O'Neal, *University of North Carolina at Greensboro*
Ted Polhemus, *Curator, "Street Style" Exhibition, Victoria and Albert Museum*
Valerie Steele, *The Museum at the Fashion Institute of Technology*
Lou Taylor, *University of Brighton*
Karen Tranberg Hansen, *Northwestern University*
Ruth Barnes, *Ashmolean Museum, University of Oxford*

Books in this provocative series seek to articulate the connections between culture and dress which is defined here in its broadest possible sense as any modification or supplement to the body. Interdisciplinary in approach, the series highlights the dialogue between identity and dress, cosmetics, coiffure and body alternations as manifested in practices as varied as plastic surgery, tattooing and ritual scarification. The series aims, in particular, to analyze the meaning of dress in relation to popular culture and gender issues and will include works grounded in anthropology, sociology, history, art history, literature and folklore.

ISSN: 1360-466X

Previously Published in the Series:

Helen Bradley Foster, *"New Raiments of Self": African American Clothing in the Antebellum South*
Claudine Griggs, *S/he: Changing Sex and Changing Clothes*
Michaele Thurgood Haynes, *Dressing Up Debutantes: Pageantry and Glitz in Texas*
Anne Brydon and Sandra Niessen, *Consuming Fashion: Adorning the Transnational Body*
Dani Cavallaro and Alexandra Warwick, *Fashioning the Frame: Boundaries, Dress and the Body*
Judith Perani and Norma H. Wolff, *Cloth, Dress and Art Patronage in Africa*
Linda B. Arthur, *Religion, Dress and the Body*
Paul Jobling, *Fashion Spreads: Word and Image in Fashion Photography*

Fadwa El Guindi, *Veil: Modesty, Privacy and Resistance*
Thomas S. Abler, *Hinterland Warriors and Military Dress: European Empires and Exotic Uniforms*
Linda Welters, *Folk Dress in Europe and Anatolia: Beliefs about Protection and Fertility*
Kim K. P. Johnson and Sharron J. Lennon, *Appearance and Power*
Barbara Burman, *The Culture of Sewing: Gender, Consumption and Home Dressmaking*
Annette Lynch, *Dress, Gender and Cultural Change: Asian American and African American Rites of Passage*
Antonia Young, *Women Who Become Men: Albanian Sworn Virgins*
David Muggleton, *Inside Subculture: The Postmodern Meaning of Style*
Nicola White, *Reconstructing Italian Fashion: America and the Development of the Italian Fashion Industry*
Brian J. McVeigh, *Wearing Ideology: The Uniformity of Self-Presentation in Japan*
Shaun Cole, *Don We Now Our Gay Apparel: Gay Men's Dress in the Twentieth Century*
Kate Ince, *Orlan: Millennial Female*
Ali Guy, Eileen Green and Maura Banim, *Through the Wardrobe: Women's Relationships with Their Clothes*
Linda B. Arthur, *Undressing Religion: Commitment and Conversion from a Cross-Cultural Perspective*
William J. F. Keenan, *Dressed to Impress: Looking the Part*
Joanne Entwistle and Elizabeth Wilson, *Body Dressing*
Leigh Summers, *Bound to Please: A History of the Victorian Corset*
Paul Hodkinson, *Goth: Identity, Style and Subculture*
Leslie W. Rabine, *The Global Circulation of African Fashion*
Michael Carter, *Fashion Classics from Carlyle to Barthes*
Sandra Niessen, Ann Marie Leshkowich and Carla Jones, *Re-Orienting Fashion: The Globalization of Asian Dress*
Kim K. P. Johnson, Susan J. Torntore and Joanne B. Eicher, *Fashion Foundations: Early Writings on Fashion and Dress*
Helen Bradley Foster and Donald Clay Johnson, *Wedding Dress across Cultures*
Eugenia Paulicelli, *Fashion under Fascism: Beyond the Black Shirt*
Charlotte Suthrell, *Unzipping Gender: Sex, Cross-Dressing and Culture*
Irene Guenther, *Nazi Chic? Fashioning Women in the Third Reich*
Yuniya Kawamura, *The Japanese Revolution in Paris Fashion*
Patricia Calefato, *The Clothed Body*
Ruth Barcan, *Nudity: A Cultural Anatomy*
Samantha Holland, *Alternative Femininities: Body, Age and Identity*

Alexandra Palmer and Hazel Clark, *Old Clothes, New Looks: Second Hand Fashion*
Yuniya Kawamura, *Fashion-ology: An Introduction to Fashion Studies*
Regina A. Root, *The Latin American Fashion Reader*
Linda Welters and Patricia A. Cunningham, *Twentieth-Century American Fashion*
Jennifer Craik, *Uniforms Exposed: From Conformity to Transgression*
Alison L. Goodrum, *The National Fabric: Fashion, Britishness, Globalization*
Annette Lynch and Mitchell D. Strauss, *Changing Fashion: A Critical Introduction to Trend Analysis and Meaning*
Catherine M. Roach, *Stripping, Sex and Popular Culture*
Marybeth C. Stalp, *Quilting: The Fabric of Everyday Life*
Jonathan S. Marion, *Ballroom: Culture and Costume in Competitive Dance*
Dunja Brill, *Goth Culture: Gender, Sexuality and Style*
Joanne Entwistle, *The Aesthetic Economy of Fashion: Markets and Value in Clothing and Modelling*
Juanjuan Wu, *Chinese Fashion: From Mao to Now*
Annette Lynch, *Porn Chic: Exploring the Contours of Raunch Eroticism*
Brent Luvaas, *DIY Style: Fashion, Music and Global Cultures*
Jianhua Zhao, *The Chinese Fashion Industry: An Ethnographic Approach*
Eric Silverman, *A Cultural History of Jewish Dress*
Karen Hansen and D. Soyini Madison, *African Dress: Fashion, Agency, Performance*
Maria Mellins, *Vampire Culture*
Lynne Hume, *The Religious Life of Dress*
Marie Riegels Melchior and Birgitta Svensson, *Fashion and Museums: Theory and Practice*
Masafumi Monden, *Japanese Fashion Cultures: Dress and Gender in Contemporary Japan*
Alfonso McClendon, *Fashion and Jazz: Dress, Identity and Subcultural Improvisation*
Phyllis G. Tortora, *Dress, Fashion and Technology: From Prehistory to the Present*
Barbara Brownie and Danny Graydon, *The Superhero Costume: Identity and Disguise in Fact and Fiction*
Adam Geczy and Vicki Karaminas, *Fashion's Double: Representations of Fashion in Painting, Photography and Film*
Yuniya Kawamura, *Sneakers: Fashion, Gender, and Subculture*
Heike Jenss, *Fashion Studies: Research Methods, Sites and Practices*
Brent Luvaas, *Street Style: An Ethnography of Fashion Blogging*
Jenny Lantz, *The Trendmakers: Behind the Scenes of the Global Fashion Industry*

ACTS OF UNDRESSING

Politics, Eroticism,
and Discarded Clothing

BARBARA BROWNIE

Bloomsbury Academic
An imprint of Bloomsbury Publishing Plc

B L O O M S B U R Y
LONDON · OXFORD · NEW YORK · NEW DELHI · SYDNEY

Bloomsbury Academic
An imprint of Bloomsbury Publishing Plc

50 Bedford Square
London
WC1B 3DP
UK

1385 Broadway
New York
NY 10018
USA

www.bloomsbury.com

BLOOMSBURY and the Diana logo are trademarks of Bloomsbury Publishing Plc

First published 2017

© Barbara Brownie, 2017

Barbara Brownie has asserted her right under the Copyright, Designs and Patents Act, 1988, to be identified as Author of this work.

All rights reserved. No part of this publication may be reproduced or transmitted in any form or by any means, electronic or mechanical, including photocopying, recording, or any information storage or retrieval system, without prior permission in writing from the publishers.

No responsibility for loss caused to any individual or organization acting on or refraining from action as a result of the material in this publication can be accepted by Bloomsbury or the author.

British Library Cataloguing-in-Publication Data
A catalogue record for this book is available from the British Library.

ISBN: HB: 978-1-4725-9619-2
PB: 978-1-4725-9618-5
ePDF: 978-1-4725-9621-5
ePub: 978-1-4725-9622-2

Library of Congress Cataloging-in-Publication Data
A catalog record for this book is available from the Library of Congress

Series: Dress, Body, Culture, 1360466X

Cover image: Gallery Stock. Wooden chair next to window with blowing curtain (GS1395580)

Typeset by Integra Software Services Pvt. Ltd.
Printed and bound in India

CONTENTS

List of Illustrations ix

Introduction 1

1 Private Acts, Public Display 9
Undressing at home: Participants and observers 11
Cut Piece: Public participation in undressing 16
The choreography of concealment 20

2 Narrative Tease: Neo-burlesque and Storytelling through Striptease 25
Neo-burlesque and dramatic undressing 28
Gender narratives 31
Autobiographical burlesque: Undressing in the pursuit of self 35
Exposing disability 37

3 "Where the Garment Gapes": The Eroticism of Intermittence 43
Versace: Exposure in motion 44
Hussein Chalayan and unstable coverage 49
Fasteners and unfastening 53

4 Deviance and Disruption: Streaking, Mooning, and Flashing 59
Indecent exposure 60
Exposure and sport 66
Legitimizing and commodifying public disrobement 72

5 Make Love, Not War: Conflict, Resistance, and the Revolutionary Body 77
Gestures of defiance 79
Anasyrma: Proof, shock, and awe 83
Memorializing the undressed 87

6 Abandoned Clothes: Separating Dress from Body 95
Abandoned clothes as territorial markers 98
Tossed shoes and gang territory 105
Abandoned selves 109

Conclusion 113

Notes 119
Bibliography 124
Index 142

LIST OF ILLUSTRATIONS

I.1 Studies of *A Woman Undressing*, Eadweard Muybridge, 1887. 5
1.1 "How a Wife Should Undress," *Life* (February 15, 1937). 13
1.2 Yoko Ono revives *Cut Piece* for a performance in 2003 at the Ranelagh theatre in Paris. 18
1.3 Masako Matsushita performs *UN/DRESS* at *Crash Festival*, Birmingham, UK, April 20, 2013. 23
2.1 Mitzi May performs a Cyberman burlesque routine. 26
2.2 Leyla Liquorice and Flora Gattina perform at the World Burlesque Games, 2013. 34
3.1 Actress Angelina Jolie arrives at the 84th Annual Academy Awards in Hollywood, California. 48
3.2 Hussein Chalayan's "Aeroplane Dress," *Echoform* (A/W 1999). 50
3.3 Sebastian Errazuriz's *N3 Zipper Dress.* 56
4.1 Janet Jackson and Justin Timberlake during Super Bowl XXXVIII Halftime Show at Reliant Stadium in Houston, Texas. 63
4.2 A streaker is tackled by Joique Bell of the Detroit Lions, 2013. 71
5.1 Eugène Delacroix (1830), *La Liberté guidant le people*, oil on canvas, 260 × 325 cm, Musée du Louvre, Paris. 81
5.2 Charles-Dominique-Joseph Eisen (1762), illustration for Jean de La Fontaine's "The Devil of Pope-Fig Island." 85
5.3 Gyula Pauer and Janos Can Togay, *Shoes on the Danube*, 2005, Budapest, cast iron. 91
6.1 Jude Tallichet, *Dropped Clothes*, 2011. 96
6.2 President Barack Obama tries out different desk chairs in the Oval Office, 2009. 103

6.3 Tossed shoes in the Copenhagen commune Christiania, 2014. 106

C.1 UCLA students perform Forest to the Floor as part of Center for the Art of Performance at UCLA's Trisha Brown Dance Company Retrospective at the Hammer Museum, Los Angeles, 2013. 115

INTRODUCTION

The human body is born naked, but moments after birth the body is clothed and begins a lifelong cycle of dressing and undressing. The process of dressing and undressing enables the primary use of fashion as a signifier of an individual's varying roles and responsibilities. Without frequent removal and replacement of clothes, it would not be possible to use a wardrobe for personal or professional expression. However, we do not solely use dressing and undressing to substitute one wardrobe for another. Dressing or undressing may be intended as a meaningful action, with messages contained not only in the garments that are removed or replaced but also in the gesture itself.

Undressing is an everyday activity that takes on a broad variety of meanings depending on context. The common gesture of removing an item of clothing alone at home is inspired by vastly different motivations to an identical gesture performed on stage in front of an audience, or when imposed by someone else. Philip Carr-Gomm (2010, pp. 89–92) proposes that undressing can be "motived by six different desires": to "enjoy [a] sensual experience"; to "excite ... another"; to "mortify ... flesh and to ignore the needs of [the body]"; to "commune with [a] deity"; for functional purposes such as preparation for a bath; or for exhibitionism. Carr-Gomm's list is extensive, and it will be drawn upon later in this book. He takes account of undressing for self and for others, for practical, emotional, political and spiritual purposes, but in all cases begins with the assumption that the ultimate goal is nakedness. This assumption denies many rich examples of undressing for the purpose of transformation rather than exposure. Take, for example, transition between costumes, as in theatrical performances of "quick change" (Sobchack, 2000) or Clark Kent's transformation into Superman (Brownie and Graydon, 2015, pp. 147–148). This assumption limits the potential for exploring the gesture of garment removal.

Other authors also present undressing, in all its many forms, primarily as the method by which we become naked. In doing so, they acknowledge only two states: naked and clothed. Ruth Barcan's fascinating text *Nudity* (2004, p. 8) divides humans into those who are naked and those who are clothed, and though she does acknowledge that there is a "borderline" between these two states, there is little existing discussion of that borderline as anything more than cultural variation in definitions of nakedness.

Barcan and other authors present dress and nakedness as two opposing states. Many such texts begin with references to Adam and Eve and the introduction of

shame, using this example to illustrate the physical and moral contrast between the clothed and unclothed body (Carr-Gomm, 2010, p. 27; Hanna, 2012, p. 129). Anne Hollander (1988, p. 157) acknowledges the relationship between clothes and the nude, suggesting that the nude figure often exhibits evidence of having recently been dressed. See, for example, Jenny Saville's grotesque self-portraits, *Trace* (1993–1994), in which her skin is inscribed with marks from the elastic of her underwear. The classical nude, writes Hollander, is depicted "emerging from real clothes or idealized drapery."

If such texts mention undressing, as Hollander does, it is to explore the nakedness that occurs as a consequence. Though this relationship between clothes and the nude is acknowledged, such texts rarely address the transitional gestures that enable the body to become clothed or unclothed. Nakedness or nudity, as the core subject of these texts, is presented as the main achievement of undressing, and so there are missed opportunities to acknowledge the significance of the journey, which leads to that destination. While there is meaning in the presentation of the clothed or naked body, there is also meaning in the actions that lead from one to the other.

Furthermore, it is inaccurate to assume that being clothed and being naked are always the only two poles that lie at either end of an act of undressing, or that undressing equates to *becoming naked*. There are numerous occasions on which an act of undressing does not culminate in nakedness, and in these cases when the body remains at least partially covered the meaning of undressing can often be found more in the nature of the act than in the flesh that it reveals. Indeed, in many cases there may be no exposure of flesh at all, but instead it may be another layer of clothes that is revealed. Quick-change artists perform a series of split-second undressings in a single act, substituting one costume for another, or removing one to reveal another hidden beneath using sleight-of-hand. In "bian lian" ("face changing," which originated in China in the seventeenth century), for example, great skill is involved in achieving change as quickly and smoothly as possible (Solomon, 2000, p. 3). One method, the "pulling mask," requires the performer to wear several layers of thin masks, which he or she peels off a layer at a time throughout the performance. To equate the act of undressing with the state of *becoming naked*, as so many authors do, is to ignore many such performances.

Our failure to acknowledge the significance of the gesture of undressing may arise from our predisposition toward a binary understanding of the world around us. Our tendency to structure society and culture around sets of binary opposites, such as life/death, human/animal, male/female, extends to our definitions of naked/clothed (Jones, 2010, following Levi-Strauss, 1972). It is a result of our binary understanding of the clothed or unclothed body that texts such as Barcan's rarely consider the transitional actions that connect and divide those two states.

INTRODUCTION

This book aims to consider the actions that lie between dress and nakedness, and in this way to contribute to the growing body of scholarship that examines "the liminal, the permeable and the structurally undetermined" (Reus and Gifford, 2013, p. 2). We have, writes Janet Wolff (2008, p. 15, cited in Reus and Gifford, 2013), moved away from our preoccupation with binary definitions, toward an interest in "the shifting of boundaries." Theorists no longer feel the need to present people, the actions they take or the spaces they occupy, in binary opposition, choosing instead to focus on transgression and transition and to "unsettle" the dichotomies between male/female, right/wrong, public/private (Reus and Gifford, 2013, p. 2). We cannot only think about dress as a state, when it may also be an action. More specifically, it is a destabilizing action which yields uncertainty.

Authors and critics have acknowledged that "there is no simple opposition between being clothed and being naked" (Barcan, 2004, p. 16). Philippa Levine (2008, p. 190) has rightly observed that "a state of unclothedness is fluid and unstable." Her use of the term "unclothedness" underscores the difference between being naked and being inappropriately covered for a particular context. The term "unclothed," as opposed to naked, presents the undressed (or under-dressed) body as somehow incomplete or inappropriate without its coverings. "Unclothedness" is a culturally variable concept, distinguished from the absoluteness of nakedness. While Levine and Barcan are correct in their assertions, their arguments fixate on cultures of unclothedness, not processes of becoming unclothed. There are missed opportunities in such texts to explore the space between clothedness and nakedness within an environment in which those notions are relatively stable.

This book must begin by differentiating the state of being undressed from the act of undressing. To equate undressing with nakedness is to confuse an action with a state. Undressing is a gesture—an active and purposeful event—whereas nakedness is a passive state of being. As an active gesture, undressing can involve more agency than nakedness. It anticipates nakedness, and it is in that anticipation that undressing holds its power. Undressing is a transformation between two poles and can, therefore, be considered in similar terms to metamorphoses, transitions or other means of altering the state or identity of a subject. Between the two poles of being clothed or naked lies the gesture of undressing, and how that undressing is performed affects the meaning of its destination.

The intermediate stages between being clothed and naked have no prescribed meaning or definition. One may be "semi-clad," but merely by labeling that state one assumes it to be a stable state rather than an unstable stage within an ongoing transformation. By naming things, we reduce "the continuous to the discrete" and perceive binary oppositions in our surroundings when it is sometimes more valuable to consider what lies between. Much communication,

as Daniel Chandler (2007, p. 46) observes, requires this reduction despite the fact that much of our world, and many human experiences, are analogue, involving "graded relationships on a continuum."

As an active gesture, undressing may be considered alongside other common motions such as walking, running or climbing. Like these other familiar actions, undressing takes the body on a journey, beginning in one place and ending in another. Just as we cannot realistically conceive of a person arriving at his or her destination without traveling from his or her starting place, it is unreasonable to neglect undressing when we consider the relationship between dress and nudity, or between different states of dress. The means by which a traveler reaches a destination almost always has a bearing on the state he is in when he arrives, and likewise, the way in which a person undresses informs our understanding of why he or she chose to exchange one mode of dress for another.

Pioneering photographer Eadweard Muybridge recognized undressing as a process worthy of study, along with other everyday human and animal locomotion. As with running, jumping and climbing, Muybridge used high-speed photography to capture the sequence of gestures that is required to strip the body of clothes (see Figure I.1). All of the motions recorded by Muybridge were familiar, even universal. The inclusion of undressing in his series draws attention to its universality, and yet, unlike the many other actions that were Muybridge's subjects, undressing is an exclusively human activity. By defamiliarizing this habitual process, he revealed the complex intermediary stages in between dress and nakedness. Muybridge's studies have the effect of transforming the everyday into spectacle, granting access to details of movement that were previously unseen (Lumley, 2014, p. 279), and in doing so prompting increased public interest in, and understanding of, the act of undressing.

It is these kinds of observed and observable acts of undressing that will be the focus of this book. I aim to focus not on solitary, domestic undressing that occurs habitually without conscious design, but rather on choreographed, considered *acts* of undressing, performed for the benefit of audiences. Such acts are not merely events, but purposeful gestures or actions, performed with the understanding that they will be observed. It is when undressing is performed with the knowledge that someone is watching that it is most meaningful. The acts explored in this book are executed in order to provoke a response from observers. Some are intended to provoke emotional response such as erotic arousal, surprise or dismay. Others are performed for more concrete returns, as when undressing invites a reciprocal gesture.

In the examples contained in the following pages, the everyday event of undressing is transformed into an action, and the body's habitual motions are transformed into intentional gestures. Nasrin (2007) suggests that "an event becomes an action when the agent's reason(s) for authoring the action are known." While everyday undressing may be carried out habitually, an *act* of

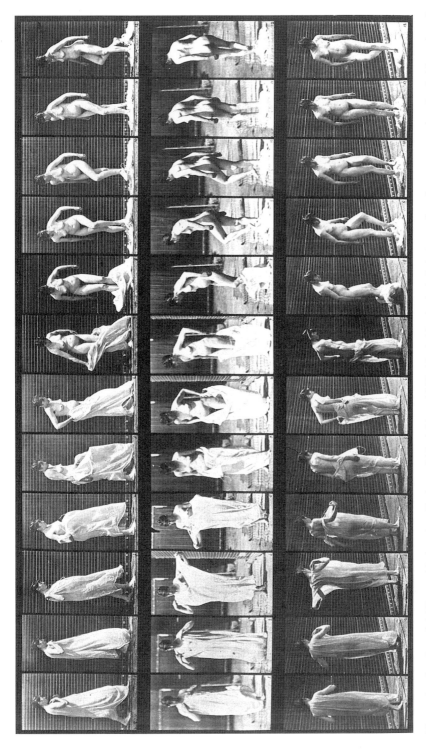

Figure I.1 Studies of *A Woman Undressing*, Eadweard Muybridge, 1887. Muybridge included photographs of a woman undressing in his series of studies of the human body in common motion, and in doing so transformed everyday gestures into spectacle. Wellcome Library, London.

undressing is consciously authored, with the aim of communicating particular meaning to an observer. By choreographing the removal of a garment, the body's common motions are transformed into a gesture, with expressive intention. The action is given meaning by the intentions of the agent or actor—the individual who undresses himself/herself, or a third party who undresses another. In order to understand undressing as a meaningful gesture, and to distinguish it from habitual, everyday disrobing, we must primarily investigate the agent's reasons for authoring the undressing action. As with all non-verbal gestures, we must consider these actions as part of a discourse between the actor and the observer (Kendon, 2004, p. 84).

Many of these actors' intentions are to provoke erotic arousal, but, as this book will show, the act of undressing in public is too frequently assumed to be an erotic performance. Particularly in mixed-sex environments, and when the audience is of a different gender to the performer, authors including Shawver (1996, p. 226) argue that undressing "would inevitably turn [any] situation into a sexual one." This book aims to show that only a proportion of such activities are sexual. The act of undressing can be a tool for protest as well as for pleasure, and a body exposed through undressing can become a sign of defiance, distraction, deception, revelation, pride, vulnerability, normalcy or otherness.

The examples featured in this book represent a range of contexts in which a public act of undressing may be performed. These are physical, cultural, social and political contexts, all of which affect the meaning of an undressing performance. The following chapters will consider acts performed for expectant audiences who anticipate a performance of undressing, as well as undressing intended for unsuspecting observers, who are unprepared and for whom the gesture may be unwelcome. In a few of the following examples, the agent of undressing is not the owner of the body that is undressed. The lines that separate participant, subject and observer are blurred.

The chapters will consider undressing as performance art, as erotic display and as fashion design, typically performed for appreciative audiences. They will explore gestures of undressing performed without observers' consent, typically carried out to disrupt ongoing proceedings, to shock or surprise and to challenge the status quo. They will also examine the motives for discarding garments in public places, when meaning is expressed not in the action of undressing but in the empty clothes that are left behind. These chapters do not provide an extensive survey of all of possible motivations for undressing. Instead, this book seeks to introduce just some of the gestures and meanings that make undressing a powerful action.

Chapter 1, "Private Acts, Public Display," argues that there is no clear division between private acts and public performances of undressing, demonstrating that private acts of undressing may contain elements of performance, and that in private dressing spaces, individuals are very aware of the potential to be

INTRODUCTION

observed and thus adjust their gestures accordingly. It considers the role and presence of the observer, invited or uninvited, in shaping the character of an act of undressing, through examples including domestic advice literature of the 1930s and performance art by Yoko Ono and Masako Matsushita. Examples demonstrate how the actions and gestures involved in undressing can differ depending on the actor's intentions, the location of the act and the nature of the audience.

Erotic performance of undressing is explored in Chapter 2, "Narrative Tease: Neo-burlesque and Storytelling through Striptease." It explores the striptease on stage, in neo-burlesque and boylesque. In striptease, audiences are typically able to anticipate a conclusion. This predictability of the destination makes the journey more meaningful, as it is the quality of the transformation, not the destination of nudity, which makes each burlesque performance unique. This chapter identifies some of the narrative techniques that are used to motivate burlesque undressing, including autobiography and gender-revelation. It emphasizes the importance of costume, props, character development and narrative to make each undressing unique. Through examples from the *World Burlesque Games*, the *London Burlesque Festival* and *Criptease*, special consideration is given to burlesque's critical engagements with the feminine ideal, through celebration of difference and disability.

Chapter 3, "'Where the Garment Gapes': The Eroticism of Intermittence," responds to Roland Barthes' (1976a, pp. 9–10) hypothesis that "intermittence" is more erotic than nudity. In examples including Versace gowns, Sebastian Errazuriz's "N3 Zipper Dress" and Hussein Chalayan's "Aeroplane Dress," unstable coverage creates erotic tension between dress and nudity. Focusing on fashion design and catwalk displays, this chapter considers garments that are designed to intermittently expose the body and to visibly highlight the body's potential to escape its coverings. The chapter identifies particular features of garment design that suggest the potential for undressing, such as zippers and other fastenings, demonstrating that undressing can be connoted even if not performed.

Chapter 4, "Deviance and Disruption: Streaking, Mooning and Flashing," examines the acts of undressing that are performed for deviance and disruption. It considers displays of public exhibitionism, including mooning, flashing and streaking, which have often been met with accusations of indecent exposure. The discussion places particular emphasis on the power of these activities to disrupt or offend and on the defenses employed to legitimize them. Streaking is presented as an action designed to disrupt public ceremonies and sporting events, and is considered in light of recent attempts to exploit the commercial and social value of bodily exposure. This chapter will examine the ways in which organizations and individuals have sought to legitimize streaking and flashing, through commercialization, political affiliation and cultural exchange. It also

stresses the importance of the temporality and activeness of flashing, mooning and streaking, at events including Mardi Gras, Philadelphia's "Wing Bowl" and the Super Bowl, to differentiate these gestures from other forms of public undressing.

Chapter 5, "Make Love, Not War: Conflict, Resistance and the Revolutionary Body," explores undressing in times of conflict, as an act of resistance and remembrance. The chapter examines how the semi-nude protestor is voluntarily reduced to his or her most vulnerable state through undressing, thereby revealing the inequality of victim and oppressor, exposing a conflict as unjust. Anasyrma is presented as a particular gesture of exposure that has the power to repel would-be invaders. While such activities have previously been oversimplified as "naked protest," this chapter reframes them by focusing on the gesture of undressing that enables exposure. The chapter goes on to consider the aftermath of war, and how the memories of wartime undressing are preserved. Empty shoe memorials, speaking of the non-existence of people who once wore them, are examined as part of the material culture of war.

The final chapter moves beyond undressing to investigate the destination of clothes after they have been removed. Chapter 6, "Abandoned Clothes: Separating Dress from Body," identifies acts in which the motivation to undress is not just to strip the body, but rather to send a message through garments once they have been separated from the body. It investigates the separation of clothes and body as the authoring of a message to those who may encounter the clothes while the body is absent. The chapter considers a code of abandoned clothes, in which the arrangement and location of clothes is designed to express a variety of intentions. Abandoned clothes can serve as territorial markers—left on restaurant seats and cinema chairs, or flung over urban utility lines—or they may signify more permanent separation of body and clothes, as in the staging of false evidence of a suicide. In each case, it is shown that the identity of the wearer is expressed through clothes even after they are removed, enabling the owner to symbolically extend himself beyond his or her own body.

In the following chapters, I do not intend to classify or categorize acts of undressing. These chapters do not present an exhaustive survey of all forms of undressing; rather, they aim to introduce a variety of gestures and contexts that evidence the breadth of practices that can be considered undressing. Undressing is not a single category of acts, but, as this volume aims to show, it includes a broad variety of actions and activities, featuring many different styles of gesture, and carried out for different reasons. Though they may all involve the separation of body and clothes, no two acts of undressing are the same.

1
PRIVATE ACTS, PUBLIC DISPLAY

For most of us, dressing and undressing are private activities, during which we transition between our public and private identities. Erving Goffman's (1959, p. 69) explorations of the "presentation of self in everyday life" identifies "backstage" events and locations, in which individuals engage in private activities in preparation for the everyday performance of self. Undressing may be the means by which we cast off our public identity and become our private selves, but it is not an exclusively "backstage" activity. It can, intentionally or accidentally, be transformed into a public spectacle. Undressing can also occur "front stage," as a performance. When we invite participation or observation, undressing becomes a carefully choreographed routine.

In James Cameron's *True Lies* (1994), Jamie Lee Curtis performs a two-part striptease, each with a different motive and destination, but both contributing to a single narrative that spans two scenarios and locations. Curtis' character, Helen Tasker, is a frustrated housewife conned by her husband (Arnold Schwarzenegger) into believing that she is working undercover for the CIA. The ruse requires her to plant a bug in a hotel room, after gaining access to the room dressed as a prostitute. Helen performs a two-part striptease: one in the corridor in front of a mirror, and the other in the hotel room for an observer. Having been instructed to dress "sexy" for her undercover mission, Helen (Curtis) dresses in the most provocative dress in her wardrobe. At the hotel, when she is made aware that she must present herself as a prostitute, she realizes that her housewife's interpretation of "sexy" is inappropriately conservative. In front of a mirror, she rips the sleeves, collar and hem from her dress, so that only the low-cut, skintight body remains. This prelude to the main event is not strictly a striptease, as it lacks the crucial element of "tease"; it is not a performance, but rather a preparation, and entirely functional. Aware that she is being watched by no one but her own reflection, Helen's movements are sharp and awkward. She makes no attempt at erotic performance.

The second part of Helen's undressing has an entirely different character. Now disguised as a prostitute, she enters the hotel room and removes her

clothes at the request of the man who awaits her (her husband in disguise). This part of the striptease is performed for the male gaze. She is awkward at first, demonstrating her discomfort in the role, but she soon gets into character and removes her dress with the sensuousness demanded by her as-yet-unidentified observer. The dim lighting and close-up shots help to transform Helen's gestures into an erotic act.

Helen Tasker's two-part act of undressing highlights the difference between undressing in private and for an audience. In the first part of her undressing, while she is still alone, her goal is to prepare her body for future performance. She does not worry about the awkwardness of her movements as she tears the sleeves from her dress, nor the unladylike grunts that she emits as she struggles to rip the frills from her hem. All of these actions are carried out in preparation for whatever will happen next. Her mind is set on the future, not the present.

Although she is alone during this private act, she is not unobserved. She stands in front of a mirror, in which she observes herself. Between gestures, she glances at the mirror to take stock of the results of her efforts thus far. She inspects her reflection, assesses her appearance, and considers what action she may perform next in order to continue her transformation. Whenever her gaze is directed at the mirror, her posture straightens and her motions become more elegant. When she performs the least elegant part of her transformation—the ripping of her dress—she casts her eyes downward, and turns away from the mirror. As her transition from housewife to prostitute progresses, the mirror plays an increasingly significant role. The final gestures in her transformation are performed as she gazes directly back at herself through her reflection. She adopts a sultry pout, and experiments with poses appropriate for her undercover alter ego, all the while measuring her success in the mirror.

The mirror enables Helen to transform her private act of undressing into a performance. The presence of mirrors, not only in this hotel corridor, but also in millions of dressing rooms, bedrooms, bathrooms, fitting rooms and locker rooms around the world, offers opportunities for the inhabitants of these spaces to observe themselves undressing. In the private spaces of a bedroom or fitting room, the act of undressing may be carried out for practical, not performative reasons, and yet the mirror may make an individual aware of the style of the gesture, the appearance of the body and the potential for performance.

When undressing, we inhabit a liminal identity, somewhere between a public and private persona. It is through this act that the body transitions from its public to private identities, or vice versa. There is, therefore, always consideration of the public presentation of self, if not in the presentation of the act of undressing, then in the identities that are created through dressing and undressing. Undressing is an act that may always be choreographed. Even in private, undressing to bathe or for bed, the act can take on elements of performance. Awareness that we

are (or could be) observed, and thus awareness of our expressive responsibility, provokes us to modify our gestures.

Undressing at home: Participants and observers

Undressing may be both public and private simultaneously. Though it is typically carried out in private spaces, those spaces have historically been populated not only by the individual who is undressing, but also other participants and observers. Nowhere has this participation been so elaborate than in the formal dressing and undressing ceremonies of the French, and later British, court, during which monarchs were prepared for the day or for bed. Dressing and undressing ceremonies performed in the palace of Versailles were attended by a select few, as intimate "access to the body of the king [or queen] was a privilege." Participation in the intimate act of undressing offers exclusive access. For attendees at the *lever du Roi* and *coucher du Roi* of Louis XIV and his predecessors, attendance conferred prestige, and the extent of participation "affirmed [a] courtly hierarchy" (Graafland, 2003, p. 87).

From the seventeenth century onward, the body was increasingly "privatized" so "undressing for bed ... called for care that one's body was not exposed to another's gaze" (Hatty and Hatty, 1999, p. 19). Contemporary notions of privacy began to emerge in the eighteenth century, and through the eighteenth and nineteenth century undressing became an increasingly private activity. However, new notions of public and private spaces did not yet lead to "clearly distinct arenas of human experience" (Ravel, 2007, p. 280), and undressing was still routinely observed. In middle-class homes in nineteenth-century Britain and the USA, dressing and undressing were intimate acts shared between servants and their mistresses. Victorian literature records the importance of the lady's maid, who would "assist in [the] elaborate procedure of dressing and undressing" (Puri, 2013, p. 504). The dressing room was a private space, separated from the rest of the house, but was nonetheless a site of homospectatorial display (p. 506).

As the Victorian era drew to a close, the act of undressing was forever changed. For Western women, undressing transitioned from a social to a private act.[1] This transition was prompted by social leveling and enabled by developments in corset design. Front-busk fastening and fan lacing enabled women to tighten and untighten their corsets without assistance (Steele, 2001, p. 41), early zippers were marketed as an innovation that would "make you independent of assistance" [sic] (Friedel, 1994, p. 54), and the need for domestic assistance in the dressing room was eliminated. Undressing became a solitary act; a second

person was no longer required to assist, and so the presence of an observer or participant in the dressing room took on new significance.

Albert Kirchner's (aka Léar) short film, *Le Coucher de la Mariée* (1896), which captures the act of undressing during this transformative time, ridicules the complexity of the Belle Epoque wardrobe while illustrating that the activity could be performed without assistance. In this silent short film, a man persuades his lover to undress. As his practical assistance is unnecessary, he is cast in the role of spectator. In the opening moments, he pleads to his lover on bended knee for her to join him in bed. She banishes him to an area behind a dressing screen, so that he cannot watch her undress. As she steps out of her many layers of Victorian undergarments and corsetry the man becomes tired of waiting and so opens a newspaper to relieve the boredom. He finally becomes so impatient that he feels an overwhelming desire to peek, and he peers over the top of the screen as she finally reveals her petticoat, and the film fades to black.

Without a participatory role to play in her undressing, Kirchener's hero serves no purpose other than to observe. Kirchener casts him as peeping tom as it is the only role that justifies his continued inclusion the film's narrative. The homospectatorial gaze of the servant is replaced by the erotic gaze of the lover; the presence of an observer, rather than an aide, transforms the woman's actions into a performance.

In the following decades, as women began to cast off their corsets, the demarcation of observer and performer in bedroom interactions persisted. A 1937 domestic advice feature published in *Life* magazine (15 February, pp. 41–43) contrasted descriptions of how a woman might dress unobserved with how she ought to dress in front of her husband. The article stresses the importance of rolling down stockings instead of pulling them off from the toes, in order to avoid "unesthetic wrinkles" [sic] and so that a husband may be pleased by "his wife's graceful method of displaying her legs." The advice is accompanied by photographs by Peter Stackpole, depicting an example of careless undressing, followed by an "artful" alternative (see Figure 1.1).

The magazine's demonstrations of how a wife should and should not undress focuses both on the appearance of the woman as she undresses, and the treatment of her clothes after they have been removed from her body. Demonstrating the "attractive dressing technique," the model "begins by … neatly sliding her dress down over her hips … No creases remain after [she] picks her dress up, smooths it out, places it on a chair." By contrast, the model who demonstrates the "worst possible method of disrobing" casts her clothes aside and then carelessly sits on them. Thus, the act of undressing becomes entwined with the domestic chores of maintaining a tidy home and unwrinkled garments.

Responding to popular demand from "amused" readers, *Life*'s March 15 edition included a follow-up featuring "various methods, some good, some

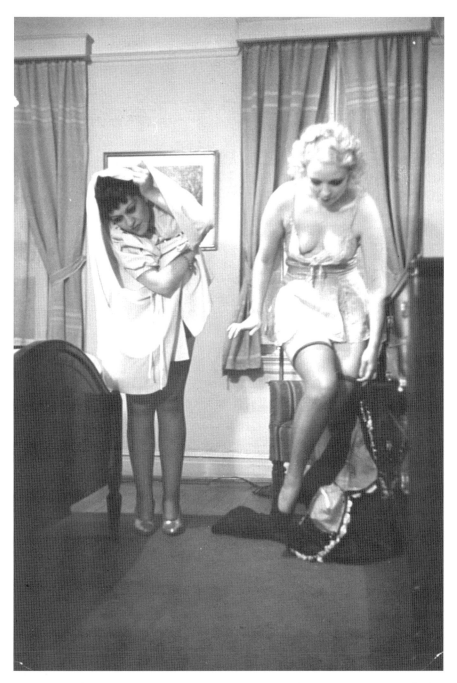

Figure 1.1 Pictured in a feature for *Life* (February 15, 1937), entitled, "How a Wife Should Undress," a housewife disrobes ungracefully (left), as a burlesque dancer demonstrates a more "artful" undressing technique (right), having reportedly received instruction from the Allen Gilbert School of Undressing. Photo by Peter Stackpole/The LIFE Picture Collection/Getty Images.

bad, of male disrobing" (*Life*, March 15, 1937, pp. 68–69). The advice for men focuses on the contrast between slovenliness and neatness in the removal of clothes. *Life*'s guidance for men features photographs of men with two very different body shapes: an overweight man plays the slovenly undresser, and "a more slightly fellow" demonstrates how to undress "with dignity and charm," suggesting that, at least for men, body shape significantly influences how graceful the action may be. In the interest of balance, *Life* magazine employed a male photographer to photograph the female subjects, and a female photographer to photograph the men.

The editors later discovered that the "professor" Allen Gilbert who had provided this guidance was in fact a fraud, having posed as an educated expert in undressing when he was in reality the owner of several burlesque venues, seeking underhand methods of publicizing his clubs (Lo, 2013). His hoax revealed that an instance of undressing cannot be neatly divided into private act or public performance, but rather falls on a continuum between private and public performance. In this case, women are invited to imitate aspects of public performance, specifically burlesque, in a private, domestic space.

Domestic space, write Reus and Gifford (2013, p. 2), is never entirely private. Readers of *Life*'s article were made aware of the potential that their private acts may be observed, and that they should, at all times, carefully choreograph their gestures. Such domestic advice perpetuated the notion that it was desirable for a woman, particularly a wife, to behave as if subject to constant surveillance (Newman, 2004, p. 8). Films of the era made even single women aware that their acts of undressing may be observed at any time without their knowledge. Marco Camerani (2009, p. 115) describes a "through-the-keyhole" genre of film that emerged in the early twentieth century. These movies, writes Camerani (2009, p. 115), typically featured a peeping tom, "usually a janitor or a butler" who peers at women through windows or keyholes as they bathe or undress. Many such films were screened on Biograph's Mutoscope, a peepshow device for a single viewer, which furthered the sensation of illicit voyeurism (Belton, 1996, p. 135). Viewers could guiltlessly enjoy one-shot sequences such as *Pull Down the Curtains, Suzie* (A. E. Weed, 1904), in which a passer-by stops to watch as a woman undresses in front of her window. Rather than chastising the peeping tom for his deviance, these films take for granted that there may always be a fly-on-the-wall, and that the observed woman must take responsibility for the style of her gestures.

Though these "through-the-keyhole" films ostensibly show women undressing in private, they undress as if they are "aware of being looked at" (Camerani, 2009, p. 115). Their domestic spaces are presented as if subject to a panoptic gaze.[2] Their behavior is adapted to account for the possibility of permanent surveillance by an unknown, silent observer: there are overly flamboyant gestures, or unnaturally graceful extension of limbs, that suggest awareness of an audience.

Dwain Esper's *How to Undress in Front of Your Husband* (1937), a short exploitation film inspired by the *Life* magazine article of the same name, warns that no "closed door will stop [a] snapshot sniper" with a long-lens camera. The narrator tells his audience, tongue in cheek, that "in this age of snooping reports and candid cameramen, nothing is sacred," and that a woman should always undress gracefully in case she is unwittingly observed.

The film takes two movie stars as its contrasting examples, apparently undressing alone in their boudoirs. The first, Elaine, is elegant and silent, while the second, Trixie, is lumbering and emits low grunts as she relieves her body of her garments. Much like the *Life* magazine article, advice extends to the tidiness of the bedroom. While Elaine folds her garments and lays them neatly on a chair, Trixie kicks off her shoes and flings her garments on the floor, leaving her bedroom in disarray. It seems Trixie lacks domestic skills, as well as "style, charm and distinction."

The two scenes are further distinguished by the presence and absence of a mirror. In Elaine's boudoir, a large mirror is visible, and she performs many of her actions close to her dressing table, and often while gazing at her own reflection. Elaine is confronted with her own appearance, and made aware of how her actions may look to an observer. As it so often does, self-surveillance has encouraged Elaine to objectify herself (Clark, 2011, p. 58). Moreover, as we can also see her reflection, the cinema audience is made aware that Elaine is observing herself, making visible her acceptance of expressive responsibility. In contrast, Trixie's mirror is never in shot, and her actions take place largely away from her dressing table, on a chaise longue in the middle of the room. Trixie's distance from her mirror may help to explain her lack of grace. She seems unaware of her slovenliness, and can see no reason to choreograph or coordinate her gestures.

By contrasting two acts of undressing in the same or similar contexts, *Life* magazine and the film that its article inspired demonstrate that the meaning of undressing is not only defined by context (as the rest of this book will show), but also by the extent to which it is consciously choreographed. Undressing is often habitual, but when we are made conscious of the qualities of our gestures, as a result of observation from ourselves or others, its character is altered. These acts are, in Marcel Mauss's (2005 [1936], pp. 75–77) terms, "techniques of the body," derived from actions that seem natural or habitual, but adapted through an "intervention of consciousness."

In these examples there is clear delineation between the role of undresser and observer. The role of participant, which was so common until the turn of the twentieth century, appears to have become redundant. However, the distinction between observers and participants in acts of undressing is complicated by some twentieth-century and contemporary performances, not least Yoko Ono's *Cut Piece*.

Cut Piece: Public participation in undressing

Yoko Ono's *Cut Piece* invites observers to participate in a performance of undressing. Ono performed *Cut Piece* in Kyoto and Tokyo in 1964, New York in 1965, London in 1966 and in Paris in 2003 (see Figure 1.2). In these performances she invites members of the audience to mount the stage one by one, and using scissors laid on the stage in front of her, to cut a fragment from her clothes. Ono sits motionless as participants strip the clothes from her body, and leave with the "gift" of a fragment of cloth. Audiences witness a "dangerous fluctuation between giving and taking" (Dublon, 2010, p. 19), in which Ono offers her body but does not undress herself.

Unusually for the act of undressing, Ono does not directly participate in the removal of her own clothes, rather, she is denuded by the audience. Thus, she is placed in the unusual position of observing the undressing of her own body without actively participating in it. Ono's agency is asserted only insofar as she provides parameters for the audience's actions. Beyond the reading of her instructions, she remains passive and motionless, moving only minimally when the participants' actions force her to do so. This is less an act of undressing as it is an act of denuding.

That this denuding is sanctioned by the artist herself invites audiences to consider the relationship between "giving" and "taking." "I felt that I was willingly sacrificing myself," recounts Ono (1974, as cited in Concannon, 2008, p. 89). The artist's use of the term "sacrifice" seems to equally reference giving and taking, acknowledging that giving necessarily deprives the giver of something precious. Ono wore her best suit for the performance, conscious that it would be a more generous gift, and a greater sacrifice, than if she had worn a more disposable garment.[3]

The dominant reading positions *Cut Piece* as a feminist critique of violence against women, "littered with notions of violence, passivity and sexual control." In hindsight, critics view the piece as a "precursor to later artworks emerging within a climate of widespread feminist consciousness" in the late 1960s and 1970s (Johnson, 2014, p. 5). However, Ono has herself confessed to having no notion of feminism at the time of her first performance (Rhee, 2005, p. 90), and Concannon observes that feminist readings did not begin to emerge until Haskell and Hanhardt's (1991) book *Yoko Ono: Objects and Arias*. Ono herself began to explore feminist interpretations in her later discussions, prompted by critics and interviewers.

Cut Piece has invited varying other interpretations, including "pacifist, anti-authoritarian, Buddhist, [and] Christian" readings and many, including Ono herself, have even equated the work to "a striptease" (Concannon, 2008, p. 92).

Jieun Rhee (2005, p. 96) interprets the piece as "an exploration of sadism/masochism and violence/victimization," and Johnson (2014, p. 4) focuses on the relationship between violence and generosity, in which the act of cutting Ono's clothing is both a violent act of "taking," and a generous act of "giving." Johnson reads the piece as "dehumanizing, objectifying and fetishistic" (p. 6).

Rhee further observes the significance of Ono's ethnicity, and her dual identity of "Japanese artist in the West, and American New York avant-gardist in Japan" presenting herself as an "exotic body in both settings" (p. 98). Her first performance in Kyoto, 1964, was featured as part of a program of *Contemporary American Avant-Garde* performances in the Yamaichi Hall. Ono wore Western clothes, associated with her American identity. By removing the suit, participants stripped her of that Western identity, reclaiming her as one of their own, unsullied by Western influence. In her New York and London performances, Ono presented herself as authentically Japanese (Rhee, 2005, p. 111). Readings of the Western performances interpreted Ono's Western dress as a "disguise," veiling her exoticism, and the performance as a "revealing of the truth" of the Japanese body beneath (Rhee, 2005, p. 114). In this context, the removal of Ono's clothes is an act of othering.

The meaning of *Cut Piece* seems to oscillate in every performance, owing to the various ways in which participants approach the task of removing pieces of Ono's clothing (Dublon, 2010, p. 18). *Cut Piece* continues to be remarkable for the way in which it exposes the audiences' attitudes toward a passive human body. Through the character of their actions, participants have framed Ono's performance as an invitation to violence, or a noble act of personal sacrifice. All participants seem aware of the potential for harm to Ono's fragile body, and some approach with caution while others relish the rare opportunity for sanctioned aggression.

Audiences acknowledge the potential for violence in their actions. A video recording of the 1965 performance shows most participants being cautiously gentle. One male remarks, as he takes his fragment of fabric, "this is very delicate. It might take some time … I don't want to cut her" (YouTube.com). Publisher Eric Ellena carefully cuts a piece of cloth the shape of a heart from Ono's skirt in the 2003 performance (Ayres, 2013). In contrast, Ono recalls one participant at the Kyoto performance who made a stabbing motion with the scissors (Haskell and Handhardt, 1991, p. 91). At the 2003 performance, one man cut a long piece; he then lowered the piece toward her neck as if to strangle her.

The varied and sometimes unexpected audience actions expose how little control Ono has over the outcome of her invitation. The performance in London left Ono "totally naked"—Ono's recounting of the performance expresses surprise at this result, as if she had expected the audience to show more restraint (Ono, 2009). Ian Ayres (2013) reads the actions of this audience as a symbolic rape. Although Ono admits to being afraid of some audiences, particularly at

Figure 1.2 Yoko Ono revives *Cut Piece* for a performance in 2003 at the Ranelagh theatre in Paris. This photograph captures an expressive gesture that was absent at Ono's earlier performances during which, following her score, she remained motionless. Photo by Francois Guillot/AFP/Getty Images.

"at Carnegie Hall, [where] it seemed to draw violence out of the audience" she chooses to reject the offer of bodyguards at her performances, saying "I wanted to show that we have to trust each other" (Ono, 2009).

Though Ono's suit was her most valued item of clothing at the time of each performance, that value is lost as the suits are destroyed. The fragments instead adopt a new kind of value as mementoes of the event. Johnson (2014, p. 9) speculates that the fragments may have been "cherished as souvenirs or discarded as scrap." Although Ono was virtually unknown at the time of her first performances, and so the fragments may have held little value, by the time of her 2003 revival Ono's fame would have imbued each piece of cloth with cultural capital. As a consequence, some participants in the Parisian performance have preserved and displayed their souvenirs as evidence of their proximity to the notorious artist and widow of John Lennon (see, for example, Ian Ayres' proud display of his fragment on his blog, alongside the sought-after ticket that allowed him access to the private event).

One fragment from the 1966 performance found its way to the Tate gallery's archive, and went on display in the exhibition *Art Under Attack* (October 2, 2013–January 5, 2014), a collection documenting 500 years of "assaults on art." The exhibition firmly positions the fragment as the relic of a destructive act: it is exhibited alongside the remains of destructive art performances and the subjects of religious desecration (Cumming, 2013). Other artifacts on display included Jake and Dinos Chapman's disfigured portraits, illuminated manuscripts "with pages torn out," and *The Statue of the Dead Christ*, salvaged from beneath the floor of Mercers' Hall in London in 1954, with missing crown, arms and feet that are thought to have been sliced off by Protestant iconoclasts (Jones, 2013). This setting focuses attention on the fragment itself, positioning Ono's fragmented suit as the most significant record of her performances, and perhaps even reifying the artistic value of the suit itself. It prioritizes the fragment over the act in which it was created. The fragment is presented as a witnessing artifact of a past event (see Chapter 5).

Moreover, the Tate's setting equates Ono's actions, or those of her audience, to vandalism. Other exhibits include "fragments of monuments destroyed in Ireland in the 20th century, paintings attacked by suffragettes in 1913 and 1914, and Allen Jones's *Chair*, 1969, damaged in a feminist attack in 1986" (Tate, 2013). The attacks on each of these artifacts sought to destroy its value and reduce its power over audiences. In this respect, *Cut Piece* could be presented as a violent protest against the superficiality of dress, or to undermine the powerful influence of the fashion system. Ian Ayres (2013) more explicitly identifies the value of Ono's garments as fashion items. He notes the significance of the Parisian location of the 2003 performance. Performed in "the fashion capital of the world," *Cut Piece* provides an antidote to the veneration of dress that takes place elsewhere in the city.

The final destination of fragments of Ono's dress illustrates how little control she has not only over her own denuding but also over what happened next. By inviting observers to become participants, she relinquished control of the act of undressing and every act that proceeded. The issue of control characterizes other acts of undressing too, wherever there are observers or participants. The actor of undressing must often take countermeasures to regain some control over his or her actions.

The choreography of concealment

Control is maintained in the choreography of undressing, when the act is styled or altered so as to invite or evade the erotic gaze. Efforts to control the presentation of the body during undressing, observable where public and private spaces converge, suggest unease at the potential for observation. Venues including public locker rooms, fitting rooms and prison showers allow potential voyeurism. A public changing space is simultaneously public and private. It is "a place of strangers" (Moran and McGhee, 2000, p. 108), and yet also one that is designated as the venue for acts that are otherwise carried out in the home, alone or in intimate company. In such spaces there exists "a tension between the public space of citizenship and the private space of intimacy" (Moran, 2001, p. 113).

In many designated undressing spaces, efforts are made to conceal the body as clothes are shed. The actions of undressing, and the body parts that are revealed are concealed beneath towels and gowns. Donn Short (2007, p. 183) observes, in men's locker rooms, the "informal policing" of undressing, resulting in modest concealment of the body with a towel while underwear is removed. This, he argues, is an emerging practice, resulting from shifting "codes of masculinity" that acknowledge the homosexual and homophobic gaze.[4] Marianne Clark (2011, p. 60) proposes that undressing in public changing rooms shifts an individual's experience of her body, from one that is "lived in" to one that may be observed. The appearance of other, contrasting bodies in the room prompts "a judgmental awareness of the self" (p. 61).[5] It is this self-consciousness, Clark argues, that causes women to conceal their acts of undressing through "careful choreography" (p. 57): towels are knotted under armpits as makeshift curtains; bras are pulled out through shirt sleeves; and underpants are pulled off through the leg holes of swimwear.

Product designers recognize the need for alternatives to these awkwardly choreographed gestures. They offer solutions including David Kalina's (2002) and Darryl Cazares' (2007) elongated hoodies for surfers undressing on the beach, and Douglas Segel's (2007) "skirt type cover garment which allows a user to change clothing while remaining covered between the waist and knees."

Dennis Caco and April Estrada's "Undress" is perhaps the most widely publicized solution, marketed primarily at women with active lifestyles as a "dress system" for women who are forced to change out of their sportswear in public spaces (Estrada, 2014). The garment features openings at the hip, through which wearers can access their torso for undressing.

There are also garments that aim to control the unwanted observation of undressing by preventing the act altogether. Such garments remove even the opportunity to undress, with the goal of protecting the potential observer as much as the individual who may undress. While the products described above offer control to the individual who wishes to undress unobserved, other products place that control in the hands of a third party. Sonja Iltanen-Tähkävuori et al. (2012, p. 50) identify anxiety among care-workers that socially inappropriate undressing carried out by dementia patients may offend observers. Their concerns are not only for the dignity of the patient, but also for any potential observer who is unprepared to witness a public act of undressing. The frequency with which dementia patients undress, in the care home or other semi-public settings, has led to the introduction of "anti-strip suits." These overalls are constructed in order to prevent undressing, with zippers or other fastenings on the back, inaccessible to the wearer (p. 53), or, in more recent designs such as *Care-Wear*, are constructed of separate trousers and shirt that resemble ordinary clothes. These separate garments can be attached at the waist by a horizontal zipper so that dressing and undressing may be performed only with the help of another (p. 56), thereby offering carers control over the time and place of undressing.

Products marketed at athletes or those with active lifestyles typically shroud the body, encasing all or part of the wearer's body in a personal changing space. They require the wearer to cover up before uncovering; to dress further before undressing. Often, the process is as simple as donning another, loose layer on top of an already complete wardrobe. In the case of the "Undress," a more elaborate sequence of gestures is required. The wearer dons an Undress by pulling it over her clothes as far as her waist, then passing the drawstring neck under her top and bra, and over her head. She is then free to pull her bra and top over her head (over the dress), and pull her skirt or trousers down (under the dress), without revealing her body. In this process, covering and uncovering become part of the same action, and the line between dressing and undressing is blurred. This is not, then, an act of exposing the body, but rather, reconfiguring the relationship between a garment and the body beneath.

In such actions, dressing and undressing are intertwined. Undressing becomes inseparable from dressing, and indeed, one is dependent on the other. Performance artist Masako Matsushita explores how the migration of garments can transform an act of undressing into an act of dressing. In *UN/*

DRESS (2012), she transforms the coverage of her body by relocating garments from her torso onto her limbs.[6] At *Hangartfest* in Pesaro, Italy, Matsushita begins her performance with many layers of underwear wrapped around her torso.[7] An assortment of bras are strapped around her waist, in so many layers that they add considerable bulk to her form, and she wears approximately thirty layered pairs of briefs, of various styles. The first gesture of her performance is to remove the first pair of briefs as far as her ankles. She rolls the waistband over as the briefs are drawn downward, so that they are flipped upside down, forming a colorful band around her ankles. She then repeats the action with the next pair, this time ending the gesture sooner, so that the second pair of briefs sits around her shins, directly above the first. The next pair is lowered as far as her knees, and the next to her thighs, and so on until her legs are entirely covered, from ankles to hips, with underwear. Since each pair is a different color and pattern, they have the effect of an ankle-length striped skirt, constructed of layers of various fabrics.

Next, Matsushita slides her arms through the straps of all of the bras that lie around her torso, so that the straps become sleeves, covering her forearms. At this part of the performance, she appears as if fully clothed in a skintight, yet modestly-complete dress, with long sleeves and low hemline (see Figure 1.3). After a pause, she releases her arms, then pulls the briefs downward and off her body. She bundles them into a hat, which she wears for most of the remainder of the performance.

Matsushita's act displays a sequence of gestures that the artist herself has defined as "un/dress." Each gesture is an act of undressing, and yet it has the result of covering more skin than it reveals. At the climax of her undressing, her body is almost entirely concealed, as each of the garments that were initially layered in a single spot now occupies its own territory. She allows her audience to observe her undressing, but her invitation is to view the choreographed gestures, not the body parts that remain concealed underneath.

Both Matsushita's *UN/DRESS* and Caco and Estrada's Undress were developed with the expectation that undressing may be observed or observable. They begin with the intention of undressing in public, but without revealing their bodies. Similarly, observers of the complex choreography that occurs in locker rooms and on beaches witness acts of undressing that remove garments without revealing the wearer's body. Indeed, the body is typically even more fully concealed during these acts of undressing than it has been beforehand, when the body was fully clothed.

When contrasted with the everyday process of removing underwear, Matsushita's gestures may be seen as incomplete. She removes each pair of briefs only partially, thus postponing the moment when the garment leaves the body. It is a gesture toward undressing that does not fulfill its promise. The audience is forced to reassess its expectations about the gesture: to see it as

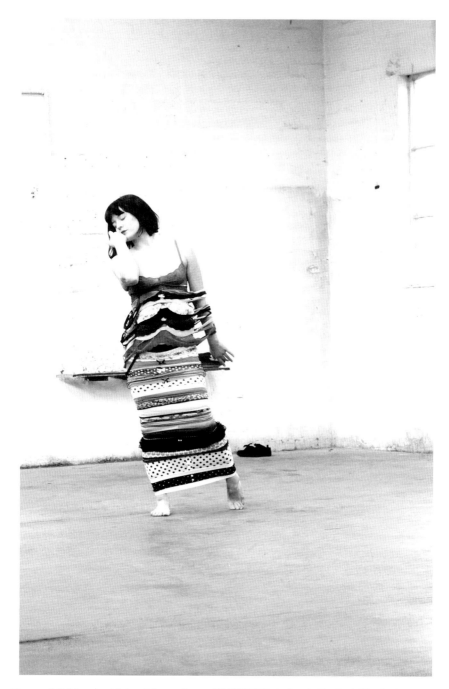

Figure 1.3 Masako Matsushita performs *UN/DRESS* at *Crash Festival*, Birmingham, UK, April 20, 2013. At this moment in the performance, Matsushita's legs and lower torso are completely covered by the many layers of underwear that she has partially removed. Photo © Cornelia Voglmayr.

one of relocation, not removal. Athletes who use the Undress similarly engage in complex gestures of relocation and substitution of garments, as the Undress is woven under and over sportswear. Their actions recall advice given by the narrator of Esper's *How to Undress in Front of Your Husband*: "It isn't what you obviously reveal, but what you artfully conceal that makes disrobing an intriguing art." Esper's sentiment is echoed in analyses of the burlesque routines that are the subject of the next chapter.

2
NARRATIVE TEASE: NEO-BURLESQUE AND STORYTELLING THROUGH STRIPTEASE

At the fringes of the sex industry, nudity has become so commonplace that its erotic power has been neutralized, and Barthes (1991 [1972], p. 84) considers the striptease artist to be "desexualized at the very moment when she is stripped naked." The institutionalization and ubiquity of the nude body have prompted striptease performers to seek new means of delaying gratification, and so in contemporary burlesque the focus of performance is the undressing, not the nudity that results.

The meaning of any act of undressing is governed largely by context and style. On a stage, undressing becomes a theatrical performance. The striptease, as performed in burlesque, presents undressing as a narrative spectacle, with complex costumes and "strong character narrative" (Dunsone, 2014, p. 23). These theatrical aspects frame burlesque acts of undressing in a tradition of performed fantasy, parody and satire. Performances at Chaz Royal's annual World Burlesque Games, the London Burlesque Festival and other contemporary burlesque events include parodies and erotic reenactments of classic and contemporary narratives, ranging from *The Phantom of the Opera* to *Doctor Who* (see Figure 2.1). The result is a themed context for the striptease, transporting it away from traditionally erotic settings to narrative genres of satire, science fiction, fairy-tale, comedy, horror or tragedy.

Burlesque, which is sometimes thought synonymous with stripping, is arguably more about keeping clothes on than taking them off. "The most significant convention that sets burlesque apart [from other forms of stripping] is the focus on 'tease,' while a typical exotic dance focuses on exposure" (Dunsone, 2014, p. 23). "The use of tease persistently delays the climactic moment of supply" (Hill, 2013), and even at the end of the act, the performer is

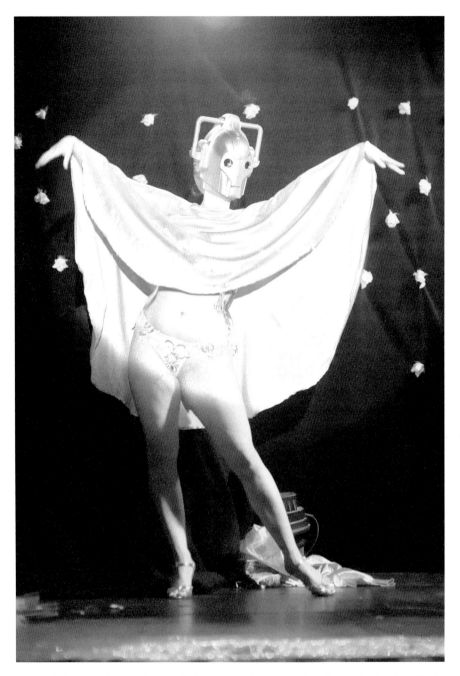

Figure 2.1 Mitzi May performs a Cyberman burlesque routine, in which she transforms from a cyborg (as depicted in the BBC's *Doctor Who*), whose mission is to impose uninteresting uniformity on the human race, to a human, who celebrates her unique imperfections. Photo © Michael Namberger.

"never completely naked" (Scott and Gilbert, 2014, p. 6). In contrast to a strip-club act, in which stripping is only a prelude to nudity and the core of the show is performed either mostly or completely nude, burlesque dancers sustain the striptease until the very last moment of the show. The act explores the promise of nudity, not nudity itself.

The burlesque costume is designed to slow the progress toward nudity. It contains many more garments and accessories than an everyday wardrobe, and dresses are often composed of several parts that can be detached and removed separately. Costumes can consist of numerous layers, beginning with an overcoat or cape, then a dress of several parts, and even when that is removed, there are often three or four layers of lingerie underneath, each layer of which is progressively smaller and more revealing. In describing her debut, Dita Von Teese (2006, p. 20) contrasts her performance to those of strippers by detailing her complex costume of many layers. She wore "a proper crinoline dress over a tightlaced corset with seamed stockings, garters, and long black opera gloves" and later "left the club a lady—in hat [and] gloves." These wardrobes necessarily contain a large number of individual components so as to delay the undressing. As each small part is removed, only minor progress is made toward revealing the body.

"Detailed costuming" transforms the act into an opulent spectacle (Dunsone, 2014, p. 23). Dancers are celebrated for having unique and elaborate costumes. They establish the tone and theme of the act, and are essential in defining a dancer's performance. The costume establishes the identity that the dancer has chosen for a particular act, and the show is choreographed to suit the component parts of a very particular costume. So entwined are the costume and the act that it would be impossible to perform a burlesque dance in a substitute costume without making modifications to the routine. The costume is so vital that Eliza DeLite (2013), winner of the 2014 World Burlesque Games, recently put her *Strip "n" Shimmy* act on hold for costume restoration. Every movement is choreographed around a particular garment or accessory. To a great extent, the costume dictates the moves.

As a spectacle of costume and character, burlesque presents undressing as theatre. The burlesque artist becomes a storyteller, expressing her tale through the medium of undressing. In contemporary burlesque, these stories are often self-referential, directly challenging preconceptions about striptease and erotic performers through subversion and self-mockery. Neo-burlesque sees its role as to examine and challenge gender roles and critically address misconceptions about sexuality. Performers "reproduce stereotypes" in order "to question them" (Nally, 2009, p. 634), and to experiment with identity transformation.

Neo-burlesque and dramatic undressing

Burlesque has its origins in the vaudeville entertainment of the late nineteenth and early twentieth century, an era of variety showcases in which the term "burlesque" described grotesque and unsentimental satire (Davis, 2011, p. 2). Now that burlesque is more commonly associated with striptease, these characteristics still remain. After the demise of striptease in the 1960s, prompted by the feminist movement, it reemerged in the 1990s as "neo-burlesque" (Dodds, 2013, p. 77). Neo-burlesque takes elements of vaudevillian satire and combines them with contemporary intertextual references and postmodern forms of self-reference. The comedy and striptease segments of burlesque events have been combined in a hybrid form of comedic undressing, in which the striptease is a form of parody or self-parody. Neo-burlesque, performed by men or women, is frequently played for laughs. Using humor, performers "reframe ... the sexualized body, enabling a shift of perspective away from mainstream views of striptease culture as pornographic or disempowering" (Hill, 2013).

The burlesque traditions of vaudeville as described by Andrew Davis (2011, p. ix) were constructed around short routines that were passed on from one generation of performers to the next. These were stock acts, not owned by any particular performer, but individuals added improvised dialogue to take ownership of their performances. While the striptease is not, in its essence, original,[1] burlesque artists customize their undressing just as their comedian forebears did, with gimmicks and props that are unique to each individual performer: Dita Von Teese writhes in her giant Martini glass; Anna the Hulagan strips while spinning a hula hoop; Chrys Columbline plays classical piano with one hand while removing garments with the other. It is through these innovations that burlesque artists distinguish themselves from one another. An innovative prop or gimmick is an extension of the dancer herself, forming a significant part of her identity as a performer. So entwined are the performer and her act that these props or gimmicks become signatures, inseparable from the artist (Blaize, 2010).

The prop becomes an extension of the costume, expressing the personality of the performer and, like the cloth of a garment, is suggestively drawn against the surface of the performer's skin. The sometimes surreal choice of props and the various ways in which they are employed in neo-burlesque demonstrates that "humour and sexiness are not necessarily inherently contrary ideas" (Whitehead, 2014, p. 30). Props are often subtly or overtly phallic, and more often than not trigger a humorous diversion from the erotic striptease. In Leyla Liquorice's *The Magician*, for example, she transforms from moustached magician to corseted rabbit in joyous celebration of an unfeasibly oversized carrot. Humorous asides such as these serve to accentuate the performer's pleasure at partaking in neo-burlesque.

It is in facial expression that neo-burlesque presents itself as so overtly satirical. Sherril Dodds (2014, p. 39) argues that burlesque performance is as much about the face as it is about the body. Dodds writes about the importance of the wink in establishing the tone of a burlesque act, marking it as tongue-in-cheek. Mimi Amore's *Egyptic* is, on the surface, presented as an erotic pastiche of Turkish belly dancing. Following Kiremidjian's (1969, p. 232) description of the aesthetics of parody, she closely imitates "the formal conventions [of belly dancing] in matters of style ... [and] rhythm": her elaborate costume and gestures convey the impression that this is a serious dance performance. However, whenever she approaches a potentially acrobatic or risqué piece of choreography, she introduces expressions that are alien to the form of belly dance in more traditional contexts. She makes eye contact with the audience; her face contorts into maniacal grins, interspersed with exaggerated expressions of disbelief, and she sullenly rolls her eyes as if exasperated by the audience's expectations of her body. Her facial expression becomes a mode of critical commentary on the actions of the body beneath it. Her raised eyebrows highlight the absurdity of the actions carried out by the rest of her body, and hence the performance becomes a playful critique on erotic dance.

The parodic nature of neo-burlesque does not attempt to erode the erotic appeal of the striptease, rather it aims to present eroticism as empowering, and often, comical. While they are laced with innuendo, bawdy burlesque performances rarely become pornographic. Mehdi Nasrin (2007) proposes that erotic gestures can be distinguished from pornographic events by assessing the wider context. The pornographic, he proposes, "focuses on the event itself," while the erotic demands a "holistic treatment" that takes account of the agent's intentions, beliefs, desires and histories. Nasrin's analyses suggest that an act of undressing may be deemed pornographic when presented only as an event, but that it can be perceived as erotic when framed within the context of "the agent's web of actions." It is for this reason that, in order to understand the erotic power of the striptease, it is essential to address the larger narrative within which that act of undressing is contextualized.

Hill (2013) contrasts burlesque with other narrative performances that commonly unfold in the direction of a "surprising resolution," writing that in burlesque the spectators are able to predict the climax but not the journey that precedes it. Spectators know that the performer will leave the stage wearing only pasties and a thong; "the surprise is hidden in the 'how', in the pathway leading up to the final moment of full exposure." Burlesque performance celebrates progression toward nudity, rather than nudity itself. The longer the dancer can sustain the tease, the more erotic and entertaining the performance will be. It is in the dancer's interest to keep the clothes on for as long as possible: to remove the costume a small piece at a time, and at an almost languid pace. Both

audience and performer know that once she is naked the show is over. There is nothing left to discover.

The performance of delay, or, in Nasrin's words, the "web of actions," which precedes a glimpse of flesh, provides specific meaning to any burlesque act. Each gesture of the tease—gestures that would otherwise be trivial (Blanchette, 2013, p. 2)—is drawn out for as long as possible. The actions contain carefully prescribed meaning, laying out a complete narrative which explores and explains the performer's motives for undressing. These narratives, and the costumes that accompany them, function to excuse or motivate the undressing.[2]

Jamie Dunsone (2014, p. 25) describes burlesque as a case of "dressing up to dress down." Meaningful costumes and props provide a vital part of the burlesque narrative, framing and motivating the striptease. As the costumed performer takes the stage, a character is established, a scene is set and a drama begins to unfold. In her act, *All of Me*, burlesque performer Bambi the Mermaid arrives on stage dressed as a lobster, with giant padded claws as gloves and spindly red legs attached to a belt. She nibbles on one claw, appearing to find it tasty. So delicious is the claw that she rips it away from her body, revealing white stuffing inside that resembles the flesh of cooked lobster. When the claw has been devoured, she moves on to the legs, consuming each one in turn, and thereby revealing more of the human body beneath the costume. Piece by piece, she rips off and devours each part of the lobster costume, leaving herself exposed. Bambi's undressing is disguised as something other than a striptease—she makes a meal of herself—and the exposure of her body is presented as an incidental consequence.

Burlesque performances employ similar dramatic structures to the vaudeville "bits" surveyed by Andrew Davis (2011). Building on Harold Scheub's (1977, p. 345) exploration of the "expansible image," he observes "formal patterns" at "the base of the performance." The burlesque performer presents him- or herself as a storyteller, creating "dramatic build" through repetition of action "with slight variation" (Davis, 2011, p. 111). The striptease performance can be considered as an "altered image," in which the image—the costumed body of the performer—is altered by a series of similar actions, and thus steadily progresses toward a resolution.

The burlesque performer repeats variations on similar gestures of undressing. The burlesque striptease is not an analogue undressing, rather it is intermittent: punctuated by the removal of each part of the costume. There is typically a pause for celebration between each removal, as the audience is given time to appreciate the sight of the freshly unveiled area of skin or costume. The sleeve of a long glove is teased down the arm in staccato motions; suspender clips are unsnapped one at a time, with flamboyant gestures that delay the hand's journey from one to the next. As parts of the costume are stripped away, a pattern is

established, creating the expectation that more clothing will be removed. The pattern of gestures begins to "build tension and create suspense" (Davis, 2011, p. 112), establishing an expectation of progression toward nudity.

Scheub (1977, p. 346) also observes moments of "friction" in which "the artist purposely neglects to fulfil the audience's expectations by refusing to complete a pattern." Burlesque dancers introduce similar friction, toying with their audience, and it is this that characterizes the "tease." He or she may begin a gesture and then refuse to complete it until the audience has provided satisfactory encouragement.

The audience's encouragement is vital in progressing the narrative. Sherril Dodds (2013, p. 76) writes that burlesque performance "produces an accumulative spatio-temporal exchange" in which the audience's whoops and applause drive the striptease forward. The performer is "continually in communication with the audience through eye contact … and invited audible response" (Owen, 2014, p. 36), and comperes are keen to point out that the louder the audience whoops, the more flesh they will get to see.

Gender narratives

The eroticism of the striptease may be, in part, nostalgic. Nostalgia is at the core of many burlesque acts. Burlesque celebrates 1920s Hollywood glamor, the 1940s pin-up and 1950s rockabilly style. The costumes tend to include vintage or historical references, not least with corsets. Notably, these early twentieth-century references celebrate a time when bare flesh was not so ubiquitous, and when a flash of thigh was more controversial than it is today. Annie Blanchette (2013, pp. 1–2 following Goulding, 2002, p. 1) describes neo-burlesque dancers as "vicarious nostalgics," who idealize the past "outside of [their] living memories." Blanchette argues that burlesque venerates a "'golden age' of creativity and style," but does so critically. She identifies that, in neo-burlesque, "critical readings" of the past coexist with "nostalgic rendition" (p. 2). Through "comedic and playful" engagement with "nostalgic femininity," burlesque destabilizes the "popular female image" while simultaneously embracing it (Dodds, 2013, p. 81). The vintage-inspired neo-burlesque costume celebrates both early twentieth-century aesthetic and women's release from it.

As an essential component of any burlesque wardrobe, the corset is a key tool with which neo-burlesque performers examine gender construction and the feminine ideal. Nally (2009, p. 629) describes how the wearing and removal of a corset on stage "becomes a parodic … dramatization of femininity." She contrasts the "composed" corseted waist with the "very *discomposed*, shimmying, undulating body" that emerges from it. Sherril Dodds (who herself performs under the pseudonym, "Scarlett Korova") presents burlesque as the

staged revelation of imperfect flesh. She observes that burlesque dancers typically do not conform to the feminine ideal. While they are dressed, padded and corseted, their forms are manipulated to conform to ideals. However, as they remove these artificial restraints, "the non-idealized body is set free" (Blanchette, 2013, p. 19). The lumps and bumps, "sagging breasts and wobbly bellies" that are ordinarily kept hidden are instead "voluntarily magnified" (Blanchette, 2013, p. 19; Dodds, 2014, p. 78). By undressing, these performers liberate themselves from the constraining ideal. The body becomes satire, making a spectacle of imperfection in order to "delegitimize the ideal" (Blanchette, 2013, p. 21).[3]

Blanchette (2013, p. 11) reports witnessing, in burlesque acts, performances of nostalgic feminine masquerade in which gender is amplified. For burlesque dancers (female or otherwise), the feminine role must be assumed deliberately (Nally, 2009, p. 629). Burlesque classes instruct dancers in the art of performing hyperfemininity, with the aim of achieving an "excessive femininity of appearance and gesture" (Ferreday, 2008, p. 50). Ferreday proposes that, by presenting femininity as a learned (and arguably inauthentic) set of behaviors, burlesque establishes a relationship with drag (p. 51). Drag, she argues, as "self-aware" and "hence potentially subversive" performance of gender, liberates women from the more normative feminine ideals precisely because it is presented as inauthentic (p. 51). Indeed, burlesque performer World Famous *Bob* (2014) presents herself as a drag artist, despite being biologically female. As a "female female-impersonator" she presents her gender as an artificial construction, and has "realigned her gender multiple times" over the course of her burlesque career (Joseph, 2012).

Urish (p. 162) proposes that there were two narrative elements that appeared consistently throughout "nightclub era" burlesque performances. The first was a "surrogate male presence" (as in, for example, Dolan's *Satan*), and second, "the performer's control and manipulation of the surrogate as a means to self-empowerment." While the surrogate male apparently sought to control the performer, she ultimately remained in control by performing both roles. The "half-and-half" costume, in which the performer plays "both subject and object" (Urish, p. 161), persists in contemporary burlesque performances. In her *Half and Half* act, Bunny Love marches onto the stage apparently dressed as a man, in khaki suit and fake moustache. The march is stiff and militaristic, conveying masculine restraint. A few moments in, the performer turns to reveal the other half of her body, scantily clad in a leopard skin minidress. When this female side presents itself to the audience, her movements are flamboyant and enthusiastic, as if celebrating the freedom of being a woman. During the striptease, each half is responsible for undressing the other. The right hand, representing the masculine side, gropes the left breast, and when the trousers are removed to reveal a prosthetic penis, the left hand, representing the female half, fondles it.

These gender narratives are often drenched in metaphor. Flora Gattina and Leyla Liquorice perform a double act entitled *The Flower*, in which Leyla plays the role of a bee, and Flora the role of a flower who is too shy to be pollinated (see Figure 2.2). The stage is set like a garden, with a white picket fence. Flora's costume consists of a fishnet body-stocking, a floral hat, and four large leaves tactfully positioned on her body. Leyla wears a black corset with striped yellow and black ruffles, and a headdress of dangling antennae. Flora sits coyly in a flower bed, while Leyla performs a provocative waggle dance. The dance climaxes as Leyla produces a phallic black "sting" and straps it to her back. Initially, Flora's flower is wary, but eventually finds herself enticed by the sight of the bee's sting, and is encouraged to shed her costume.

While Leyla's bee represents the dominant half of the duo, she remains respectful of the flower's feigned bashfulness throughout the act. Leyla gropes Flora, but with the aim of preserving her modesty in front of the audience rather than to take possession of her body. With a gleeful expression of achievement, Leyla places one hand over each of Flora's breasts. She has successfully seduced the reluctant flower, and yet even in this display of dominance she is protecting Flora's body from the gaze of the audience.

Male burlesque performances, otherwise known as "boylesque," also often engage in dialogue with gender expectations. Judith Lynne Hanna (1988, p. 238) identifies a competitive component in drag stripping, in male attempts to outdo their female counterparts in the performance of femininity. Though few boylesque performers present themselves as female impersonators, they do apply the conventions of female burlesque while performing as male. Through female affectation, they highlight the shortcomings of the male body for comic effect, inviting direct comparison to curvaceous female forms and so forcing awareness of the male form which is, in this context, inadequate. Numerous boylesque performers wear nipple tassels, and shimmy as if aspiring to jiggle. The gesture acknowledges that, although the world of burlesque is increasingly inclusive, it is dominated by women, or more specifically, by female bodies. Their actions become parodies of their own attempts at gender transgression.

Christopher Hayden (as cited in Whitehead, 2014, p. 29) of Toronto-based troupe Boylesque TO proposes an alternative motivation for the male nipple tassel. Boylesque striptease, he suggests, "disrupts the assumption that a penis is the only sexual part of a man." Following Barthes observation that any part of the body may be erotic provided it is exposed in the right way (see Chapter 3), Boylesque TO's performance invites sexualization of every part of the male anatomy. This they achieve by stripping every part of the body with a coy expression that one would associate with the revelation of a dirty secret. Presenting each part of the body as if it were equally precious, and equally

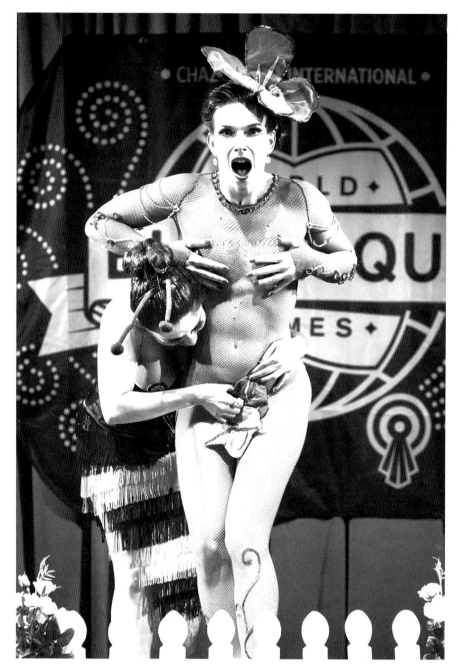

Figure 2.2 Leyla Liquorice and Flora Gattina perform at the World Burlesque Games, 2013. Leyla plays a bee whose waggle dance persuades a flower (Flora) to disrobe. Photo © Ambra Vernuccio.

taboo, strips the penis of its mythical significance by elevating the rest of the body to equal status. In agreement, Whitehead (2014, p. 28) proposes that the striptease enhances the sexual power of the male body precisely because it does *not* reveal the penis. As with female burlesque, boylesque stops short of total nudity, thus preserving the erotic appeal of the body. Whitehead posits that the sight of a penis is inevitably perceived as either aggressive or comically grotesque, and that this perception would eclipse any erotic readings of the rest of the body.

Autobiographical burlesque: Undressing in the pursuit of self

The Vivid Angel, a London-based "alternative performer" presents the journey from despair to recovery in the aftermath of a breakup. She begins her act at the 2014 World Burlesque Games slumped in a chair, weeping and swigging from a wine bottle. As the drinks, she mimes the words to Bonnie Tyler's *Total Eclipse of the Heart*. When the song ends, it gives way to *Holding Out for a Hero*, Angel is evidently transformed by the upbeat tone of the music, and strips away her nightgown to reveal a crimson superhero cape and an oversized mock vagina. She drags a male blow-up doll onto the stage, also wearing a superhero cape, and lowers her false "super pussy" onto his inflated member and simulates sex in various positions. After the gleeful (and rather messy) climax, Angel is reinvigorated and discards her inflatable hero. She has been healed by casual sex with her hero, whose superpower is to save her from her sadness, but throughout she never relinquishes control to her hypermasculine partner. She remains dominant throughout, using the inflatable hero for her own satisfaction and discarding him when she has finished. In her own superhero cape, she finds the strength to save herself.

So common are these cathartic burlesque acts that they have become known in some circles as "Phoenix Number[s]," in which performers "take all of [their] emotions, set them on fire, and rise from the ashes" (Ordare, cited in Disman, 2014). In many such examples, the performer begins the routine as a "domestic body" and then, through an act of undressing, "emerges as a highly-wrought sexual body, independent, and utterly autonomous" (Nally, 2009, p. 635). Ruthe Ordare (cited in Disman, 2014) speaks about producing her *Broken Doll* act as a means of healing "after a very toxic and emotionally abusive relationship" in which her partner had controlled her diet and weight, thus "denying [her] body autonomy." She performs the act dressed as a rag doll with "no internal motivations, desires or feelings of its own, only the ones

projected onto it by a child." As she strips the doll costume, she regains her autonomy. The performance is a cathartic experience for Ordare, and she reports a sense of relief at being able to perform it.

These cathartic works of self-parody have value not only in the performance itself but also "in the sharpness of the insight" (Kiremidjian, 1969, p. 232). The acts critique the "weaknesses, the eccentricities, [and] the disharmonies" of the performers, their personal experiences and the people they have encountered on their journeys through life, exploiting their own experiences for the purposes of "self-knowledge" (p. 233).

Ruth Barcan (2004, p. 98) observes how frequently the exposed body is employed as a metaphor for truth. She identifies "allegorical figures representing Truth" in European art that are often "naked or lightly draped." For many burlesque performers, striptease is the pursuit of personal truth. Female burlesque artist Burgundy Brixx (as cited in Dioman, 2011) equates her striptease to "peeling" of other kinds. She considers her act a performance of "the removal of all the complex layers of a sensitive topic until a raw simple concept remains." Her striptease is as much about exposing an issue as it is about exposing the body: stripping away the hype and rhetoric to expose the truth underneath. Burlesque can, in more ways than this, be viewed as an act of uncovering the truth: the truth of the unadorned and unrestrained body; of a performer's gender; or even, in some science fiction acts, of a performer's species.

Morris Meyer (1991, pp. 26–27) describes a striptease performance by a transsexual known as "Jeannie," in which the act of undressing reveals the performer to have undergone gender reassignment. The performance took place as part of a drag and cabaret event, the *Holly Brown Show*. Draped in a long cold cape, Jeannie emerged from a cloud of smoke that appears to emanate from a giant genie bottle. Toward the end of her performance, the cape was flung open to reveal an unexpectedly "feminine figure" in cold underwear and rhinestone body harness. Meyer describes how a hush descended on the room at the moment Jeannie's cloak fell open to reveal her body. The crowd, who had met the act so far with "enthusiastic laughter, screams and applause," were now "uncommonly silent." Their silence, writes Mayer, illustrated the moment at which spectators realized that Jeannie was not, like other acts, a man in drag, but rather a post-op transsexual, with "ample breasts" and hairless skin.

Jeanie's "bodily revelation" is about exposing truth in an environment of deception. In burlesque—a world in which gender is not always as it seems—undressing is the only reliable way to evidence one's "sociosexual status" (Meyer, 1991, p. 29). Just as female performers reveal the artificiality of the corseted female form, Jeannie exposes all costume as masquerade. For Jeannie, the striptease recounts the discarding of her former identity as a

transvestite—an imitation woman—and claiming the new identity as a real woman (1991, p. 27).

Exposing disability

For actor and occasional burlesque performer Mat Fraser, burlesque reveals and celebrates his disability. Fraser's acts often revolve around the phocomelia of both arms that occurred as a result of his mother being prescribed thalidomide during her pregnancy. In his performance for *Criptease* at London's South Bank (2012), Fraser wears prosthetic arms under the sleeves of a black suit, and initially the stiffness of his hands is the only indicator of his deformity. His prostheses remain flaccid and unused as Fraser performs his striptease using other parts of his body. He kicks off his shoes and trousers, and shimmies out of his jacket, revealing the rest of the arms and their ungainly elbow joints. The more clothing he removes, the more apparent his disability becomes. He starts to twirl across the stage, swinging the arms from their joints, mocking the lack of control that these artificial appendages offer their user. Progressing toward the finale, he sheds the limbs, freeing his real hands in all their malformed glory. Having shed his stiff and restrictive augmentations, Fraser is suddenly free to use his hands like any able-bodied burlesque performer, and reenacts the actions from the standard striptease toolbox, caressing his torso and coyly hiding his nipples behind his fingers.

True to the spirit of neo-burlesque, Fraser's act "rejects the notion of [imperfect] flesh as shameful, that is central to mainstream notions of beauty" (Ferreday, 2008, p. 60). His performance is received by the audience with whoops and cheers of delight. His confidence as "the imperfect on stage" challenges audiences to feel similarly unafraid of their own imperfections. Audiences are exposed to the revelation that "we are all imperfect" and that there should be no correlation between body confidence and body type. Fraser's hope is that audiences will watch him and think "look at that guy, he loves himself; maybe I can love myself better." This response, says Fraser (2013) in interview, "normalizes" him. By inviting his audience to embrace their own imperfections as he embraces his, he "become[s] more normal by highlighting [his] difference."

Petra Kuppers (2003, p. 39) observes that undressing, which remains private for most people, is often more public for those with disabilities that limit their capacity to dress and undress unaided. They might, observes Kuppers, "if they have rare congenital impairments, … [be] required to undress in front of doctors … demonstrations held over their mute, or even their protesting bodies." As medical subjects, they are de-eroticized. Wheelchair-bound comedian Liz Carr (2007) recalls her teenage experience of being "wheeled out [naked] in front

of a lecture theatre full of medical students as a rare disability curio," a memory that surfaced years later when she took a striptease course, a training that would later lead to a public performance at *Criptease*. Voluntary and celebratory undressing is a method by which performers at the *Criptease* event, not least Mat Fraser and Liz Carr, reclaim their own bodies.

Inviting audiences to observe and adore disabled bodies, Fraser and other *Criptease* performers challenge what Lennard J. Davis (1995, p. 135) identifies as the historically founded tradition of averting the attention away from a body that is incomplete. The gestures of a burlesque act direct the viewer's gaze toward individual body parts, one at a time. Where an able-bodied performer's gesture may direct the gaze down the length of a slender arm toward a gloved hand, for Frazer, the same gesture directs the viewer's gaze toward the absence of an arm. Thus, for a disabled performer, the gestures of the striptease consciously highlight difference.

At the 2010 *Criptease* event, as part of the Southbank Centre's *Women of the World* festival, Liz Carr performed a Superman-inspired striptease. In her performance, Carr, a self-described "cripple," initially appears to struggle with the task of removing her clothes, every action seemingly an immense effort. Just as her strength begins to wane, she unbuttons her shirt to reveal a Superman costume beneath. The theme from *Superman: The Movie* plays, and Carr, suddenly imbued with the strength of a hero, rises from her wheelchair and triumphantly removes the rest of her suit to reveal the Superman costume in all its glory. As she exits the stage, with her wheelchair at full speed, the scarlet cape flaps behind her. Carr's undressing does not leave her naked, but rather makes reference to the transformative undressing through which Clark Kent becomes Superman. Like Clark Kent, Carr feels meek and underestimated in her everyday garments, but through striptease she is able to reveal the heroic strength within.

The neo-burlesque community prides itself on its inclusivity, and *Criptease* in particular aims to invite the engagement of audiences to whom the pleasure of watching is otherwise denied. The visually impaired, argue Udo and Fels (2010, p. 63), are "unable to fully participate in a culture that is heavily saturated by and based on the enjoyment of audiovisual entertainment experiences." As one such visual culture, burlesque is potentially accessible only to sighted audiences. At a live burlesque performance, audiences are unable to hear the sounds of undressing that may, in other circumstances, signify undressing. The sounds of unfastening zippers, clothing rubbing against skin, or falling to the floor, are obscured by music and distance. However, improved accessibility to predominantly visual media has, over the past few decades, provided an increasing number of opportunities for the visually impaired to experience scenes of undressing that were previously presented as primarily visual experiences. Audio description acts as an aural substitute for the visual image, and typically

communicates the appearance of characters or objects, actions, positions and contextual information (Piety, 2004).

The *Criptease* event has featured a number of striptease performances by or for the visually impaired, including "spoken word burlesque" by Penny Pepper, and a performance organized by physical theatre group Extant, which invites the audience to describe what they see on the stage (Muehlemann, 2013). In a performance initially developed by Extant in 2007, blind performer Amelia Cavallo describes her own striptease, and then invites sighted audience members to contribute by describing each body part as it is revealed. Since 2005, Extant have explored means of "creating sound equivalents to the visuals on stage" (*Extant*, 2014). Their various burlesque acts arose from their exploration into locating audio description at the site of an erotic event. They have sought to avoid "technical audio description which is usually facilitated from an external source and away from the performance," favoring descriptions recited by the performer herself. These "descriptive monologues" which, as in Amelia Cavallo's striptease, allow the audio description to "be located exactly where the performer's body [is] rather than having a remote source delivering the description away from the action" (*Extant*, 2012). This offers insights not only into the performer's actions, but also her personal anxieties and experiences of feeling and hearing the audience looking back at her.

Amelia Cavallo begins her performance seated, with a large scarf draped over her body. Her description directly addresses the audience, acknowledging their presence in the room from the very start of her striptease. The following is transcribed from a video recording of a performance at the *Blind in Theatre* festival, at the New Life Theatre, Zagreb, in 2009:

> Amelia: I sit in the middle of the stage. I'm covered from head to toe in a long orange scarf. I raise my bare … feet, point them at you and lower them to the ground … I reveal my right … elbow … followed by my hand, raise it above my head, give my wrist a twirl, and pull my arm slowly back under the scarf … I show you my left arm, raise it above my head, give that wrist a twirl, then bring my right hand to meet my left. I move my hands along the scarf, down my body. I lean forward and spread my bare legs. I reach up, take the top of the scarf and hold it in front of me like a curtain … I stand. I take step towards you, and stop … I slowly lower the left side of the scarf to show you … my hair.

Cavallo employs verbal tease as a substitute for visual tease. There is a short pause before the mention of any body part so that the audience is given time to anticipate the information about which body part might be revealed next. The body parts revealed after these pauses are not erogenous zones, but are given erotic value as a consequence of the verbal tease.

At this moment in the performance, Cavallo begins a dialogue with the audience. She invites audience members to contribute their own descriptions of her body parts:

> Amelia: What color is it? Go on, tell me.
> Audience: [inaudible]
> Amelia: Interesting
> [the audience giggles]
> Amelia: I lower the right side of the scarf and I show you my ... eyes ... Do they smoulder? ... Anyone?
> Audience: Yes!
> Amelia: Good. I'm glad And again the scarf is lowered ... to show you my ... nose. Isn't it cute?

Cavallo's questions invite the audience to objectify her. When they fail to do so, she offers encouragement ("... anyone?"). These questions are equivalent to the gestural prompts performed by other burlesque performers, who rely on the audience's encouragement to drive the striptease forward. Cavallo knowingly toys with the audience's expectations, later teasing them with the phrase, "I know what you were thinking ... better luck next time."

Extant's invitation for audience members to contribute their own narration introduces the potential for interpretive content that is expressly forbidden in audio description for screen media. *Media Access Australia* (2014) warns against narration that expresses "value judgments and aesthetic opinions" in its audio description guidelines. By contrast, aesthetic judgments are encouraged by Extant's use of audience members' improvised descriptions. Cavallo explicitly requests that her audiences make judgments about the appearance of her body parts (the cuteness of her nose, the lusciousness of her lips). After the audience has been warmed up with leading, closed questions, she moves on to open questions, and begins to pass the burden of responsibility for description over to those that are watching her. They are invited to finish her sentences, and describe her body parts as she reveals them.

The show concludes not at the revealing of Cavallo's body as the audience may have expected, but with the staged performance of an error. Raising the scarf above her head, she begins to twirl. Her twirls become increasingly enthusiastic until the scarf flies out of her hands. This apparent mistake leads the performance into a direct engagement with Cavallo's experience of being blind. When the scarf slips out of her fingers, her description comes to an abrupt end, and she lets out a horrified gasp, "I dropped it ... Where'd it go?" Her commentary takes on a new tone, lacking the confidence that she had moments before, and instead she starts to speak as if to herself. Her voice trembles with uncertainty as she wanders blind around the stage, her body shielded behind

her arms. She drops to her hands and knees, and crawls across the stage as if unable to find her way without vision. She stumbles across a hand mirror, which she identies by touch. She turns the mirror to face the audience and invites them to look at their own reflection. She asks questions that reflect the anxieties of the visually impaired, about the inability to assess the appearance of one's own body without sight, and the insecurities that arise as a result:

> Amelia: I reflect parts of my body in the mirror that I can't see … I wonder … Look in my mirror … What do I look like? Do I look normal? … what do I look like to you?

Cavallo's use of the term "normal" is noteworthy in the context of neo-burlesque, a practice that so actively rejects normality. She turns the mirror on the audience in an almost accusatory gesture, challenging them to face their own abnormalities. Like so many burlesque artists, she bundles her own bodily anxieties into and act that forces the audience to reassess their approach to their own and others' bodies. In doing so, she demonstrates that eroticism is contained within the style of a gesture, more than in the qualities of the body that performs it.

The erotic gesture can be performed by anybody, and any body, regardless of shape, size, gender or ability. Burlesque demonstrates that eroticism lies not in the contours of the body, but in how that body moves or behaves, particularly in its interaction with clothes. That is not to say that the gestures of burlesque are designed to detract from the body. On the contrary, it employs proud gestures in order to express body confidence. While the still nude of fine art or *tableaux vivants* would have marked the classical nude apart from the grotesque Other, when the body is empowered to expose itself through erotic gesture, it is always inspiring.

3
"WHERE THE GARMENT GAPES": THE EROTICISM OF INTERMITTENCE

When a body is covered in clothing, observers can reasonably assume that it will continue to remain clothed for the time being. Perception theory tells us that observers make "an implicit assumption that objects are permanent" (Rock, p. 131). However, events, actions or visual cues can remind observers of the possibility of change. When there is a suggestion of change, the assumption of permanence can be disrupted, and observers can be made aware of the possibility of undressing. Movement of cloth can appear to destabilize the relationship between garment and body. Garments can be cut or fastened in ways that imply the possibility of change, and clothed bodies can gesture within their coverings in ways that imply the potential for escape.

The perceived permanence of dress is undermined by any hint of progress towards nudity, and such change is particularly tantalizing as it expresses the potential for further undressing. When the garment gapes or shifts on the body, the relationship between clothes and the body is destabilized, in imitation of the first stages of disrobement. These first stages of disrobement can be connoted by garments cut in imitation of those that are falling from the body. Alexander McQueen's low-rise bumster jeans (1993), for example, sit so low on the hip that they threaten to drop to the floor. Asymmetrical cut, in particular, is suggestive of undressing, appearing to be incomplete or in the process of slipping (Cabrera, 2010, p. 81). An asymmetrical gown can appear to be flung unreliably across the body, so that its stability is called into question.

Roland Barthes' *The Pleasure of the Text* (1976a, p. 10) explores the experience of "tmesis"—a feeling of absence or incompleteness—that arises from inconstant "intensity of reading" of a text so that it appears to "continuously skip, meander, redefine itself" (Cavallaro, 2001, p. 64). The body of a text, he proposes, is pleasurable in its fragmentation. Barthes uses a comparison to clothing to illustrate his argument, with a reference to erotic intermittence that has since been reframed as part of contemporary

fashion discourse, thanks in part to Malcolm Barnard's (2007) inclusion of the following passage in *Fashion Theory*:

> Is not the most erotic portion of the body where the garment gapes? ... There are no erogenous zones; it is intermittence ... which is erotic: the intermittence of skin flashing between two articles of clothing ... between two edges ...; it is this flash itself which seduces, or rather: the staging of an appearance-as-disappearance. (Roland Barthes, 1976a, pp. 9–10)

So effective is intermittence at creating erotic tension that it allows the migration of erogenous zones. If, as Barthes proposes, the glimpse of skin may locate eroticized flesh anywhere on the body, then a gaping garment can challenge the assumption that there are only certain designated sexual parts in the human anatomy (Hayden, as cited in Whitehead, 2011, p. 20). Cleavages and thighs, which may once have been titillating, have lost their capacity to arouse. Instead, sexual curiosity is sparked by intermittent exposure of any part. Intermittence has the power to re-chart the erotic map of the body.

Barthes' words have been employed in reflections on fashion items ranging from fishnet stockings to Marilyn Monroe's billowing dress. Valerie Steele (2014) describes the "interplay of seen and unseen" in fishnet tights, which "paradoxically ... make the flesh they cover seem more exposed." Smith (2004) illustrates Barthes' text with images of Marilyn Monroe's billowing white dress, photographed while filming the problematic "subway gate scene" in *The Seven Year Itch* (1955). The role required Monroe to stand over a subway grate as the train passed below, creating a breeze that lifted her skirt to reveal her legs and undergarments. The shot was photographed by numerous paparazzi and received considerable press coverage long before the film reached cinemas. The images teased audiences with glimpses of Monroe's undergarments, and they flocked to cinemas in droves to see more. Marilyn's hemline follows a predictable path up her thighs, but nonetheless, the event itself is tantalizing in its unpredictability. The gust of wind appears suddenly, and the sight of her thighs is fleeting. The billowing fabric wafts uncontrollably, so that it is impossible to predict whether, in the next moment, she will be more exposed or more concealed. Thus, the image of Marilyn's exposed legs is redefined from moment to moment as the fabric floats around her body.

Versace: Exposure in motion

As on the burlesque stage, stripping and teasing are essential tools in catwalk choreography. The "aura of exclusivity" (Khan, 2000, p. 116) that surrounds a show may also surround individual garments if, in their initial appearance on

the runway, they are shrouded by overcoats or shawls. A sense of anticipation may be heightened as a model teases the audience with glimpses of a garment before revealing it more fully as she turns, and lets her coat slide down her arms and tosses if over her shoulder. See, for example, Vivienne Westwood's Autumn/Winter 1993 collection, *Anglomania*, which premiers several fur coats of extravagant proportions. In true burlesque style, Westwood's catwalk models initially hold their coats clutched firmly closed, keeping their other garments a closely guarded secret. As they stride down the runway, they allow their coats to slip open, a little at a time, offering glimpses of what lies beneath. Finally, to the audience's approving applause, they pull open and throw off their furs, revealing the rest of the ensemble.

The catwalk is a site of motion, and in this motion there is often a suggestion of undressing. Catwalk displays are differentiated from the static displays in store windows and fashion photography by their exhibition of the garment in motion. Clothes are presented not only for their appearance, but also their behavior, particularly in relation to the body. Draped over the body of a promenading model, cloth comes alive, and can be seen to shift against the skin as it does during dressing and undressing. This suggestion of undressing is particularly present when the motion of body against garment causes intermittent exposure. Such an exposure undermines the apparent permanence of the relationship between body and garment.

Anne Hollander (1988, p. 154) proposes that an image of the body in motion offers "a perpetual suggestion of all the other possible moments at which it might be seen." A glimpse of skin through gaping garments may be read in the same way. It seems to hint as all other possible interactions between the edge of clothing and the body beneath, and hence suggests the possibility of total undressing. Eroticism appears, writes Mario Perniola (1989, p. 237), in this "possibility of … transit from one state to another." A glimpse of skin invites a male observer to "undress a woman with his eyes": to imagine her as an available sexual subject. It invites a "desire for discovery," or, as Harper (1994, p. 62) puts it, "by the instruments of vision [to] seek to 'know' the woman." In this way, a gaping garment seems to permit the fantasy of undressing, with every momentary withdrawal of fabric referencing the fantasy of removing the garment completely.

Erotic dressing is a language of allusion (Schwichtenberg, 1981, p. 27), much like the verbal erotic codes identified by Barthes (1976b, p. 26), who observes that "our society never utters any erotic practice, only desires, preliminaries, contexts, suggestions, ambiguous sublimations, so that, for us, eroticism cannot be defined save by a perpetually elusive word." Cathy Schwichtenberg (1981, p. 27) explores, via Barthes, suggestiveness as a substitute for gratification. She describes suggestiveness as "a glimpse of [a subject] as it disappears," and in doing so identifies the equal value of appearance and disappearance

in generating a "glimpse." Disappearance is vital in distinguishing intermittent flashes of skin from the full striptease. The gaping garment offers a glimpse without gratification, defined first by appearance, then by disappearance, or "veiling and unveiling" (Steele, 2014). The glimpse is fleeting, and satisfaction is withheld or suspended.

Gianni Versace (and after his death, Donatella Versace) offers observers a fleeting glimpse of a woman with every step that she takes, exposing her body through "teasing veils" (Martin, 1997, p. 13). Many of Versace's floor-length gowns drape the body from shoulder to toe, concealing everything as the wearer stands still, but as she walks, the body reaches out and escapes the fabric via a slit running from hem to hip. Harold Koda (2003, p. 212) describes a beaded silk satin gown from Versace's Spring/Summer 1996 collection, in which the body emerges from a Versace dress, then sinks coyly back inside:

> This gown's silver satin sheathes the torso, then opens up to fanning pleats at the skirt. Arcing inserts of silver gauze, with iridescent paillettes and crustal beads densely embroidered at their crest, waft over the wearer's legs in a wave-like undulation, opening the gown and exposing the body beneath. In response, the satin pleats endow the wearer with a columnar dignity, but in motion, the disclosure of the body and the liquid drift of the sheer fabric suggest Venus emerging from the sea.

More recently, Atelier Versace collections have employed slits on the upper half of the body. Versace's Spring/Summer 2013 haute couture collection includes a blue gown sliced diagonally across the torso, from shoulder to waist, threatening to reveal a breast as the light fabric wafts over the wearer's body. Versace gowns are typically bias cut, so that garment "skims rather than clings to the body," encouraging fluid motion in the fabric (Cochrane, 2014). Intermittence is dependent on this motion. The static body has no capacity for disrobement, whereas the body in motion has the potential to escape its coverings. Thus, the relative position of the body and garment may be compromised only by motion of some kind. Versace's garments do not inherently contain intermittence, but by designing for the moving body Versace has created the conditions in which intermittence may occur.

The feminine ideal, writes Hollander (1988, p. 153), is not merely a body shape, but also of a style of bodily movement. "Female allure" arises not directly from bare flesh, but from the qualities of the motion through which it is revealed. Skin that is revealed via a feminine gesture is more erotic, she infers, than skin that is on constant, static display. The locomotion provides a regular and predictable exposure of skin as the limbs swing back and forth. Thus, with every step there is a "fluid veiling and exposing of skin" (Breward, 2003, p. 212).

Hollander presents our interest in the body in motion as a twentieth-century phenomenon, prompted by the development of cinema, which "made the public increasingly aware of style in feminine physical movement" (p. 154). Moving images, Hollander argues, informed static images, leading to more dynamic depiction of bodies in motion. Photos were now more widely understood as depicting a "single instant" extracted from a "sequence of instants." Actors on the red carpet pose as if in motion, stretching their limbs outward, beyond their coverings (see Figure 3.1).

A body in motion has a fluid silhouette, with the potential to expand beyond the confines of a garment. Fabric yields to make way for a body's movements, but only to an extent, so that the act of wearing is a "negotiation" between body and garment (Lewis, 2007, p. 312). The role of a designer is, in part, to account for a body that occupies not only actual space but also "possible space" (Hollander, 1988, p. 155), within or beyond the confines of the garment. A garment must accommodate the body's expansion through choice of fabric and fit, or must give way, to reveal intermittent glimpses of skin. It is the latter of these that characterizes Versace's gowns.

If intermittence is erotic in part because of the motions that force a garment to gape, then it follows that the migration of erogenous zones, as described by Barthes, is also a consequence of kineticism. It is the motion of exposed flesh that transforms it into an erogenous zone, perhaps because it appears visibly motivated to peer from behind its coverings. The motion of the body is, in most cases, voluntary, and so any exposure of flesh that occurs as a consequence of bodily motion can be considered motivated. Thus, the gaping garment can be read as an invitation to gaze.

That is not to say that all Versace gowns, or indeed, all split skirts, suggest voluntary exposure. Versace has also incorporated slashes, as opposed to slits, which reveal the body in a more aggressive manner. Though he favors the goddess look, Versace owes his reputation in part to his interpretation of the little black dress worn by Elizabeth Hurley in 1994, which is "spliced, but triumphantly whole" (Martin, 1998, p. 97): slashed down one side, and repaired with gold safety pins. Between the safety pins, "interstices of skin that break through and seem to threaten the stability of the dress" (p. 99). The dress threatens a wardrobe malfunction that is beyond the control of the wearer. The safety-pin dress took inspiration from the anti-fashion sentiment of the punk era, during which rips, tears and slashes were imposed upon already-complete garments, appearing to suggest the violation of the garment and the body.

The slash, as displayed in Versace's safety-pin dress but perhaps more so in garments by the likes of designer Zandra Rhodes, is a mutilation of the dress. Inspired by her punk contemporaries in the late 1970s, Rhodes demonstrates the aggressive connotations of the slash in garments including her "punk

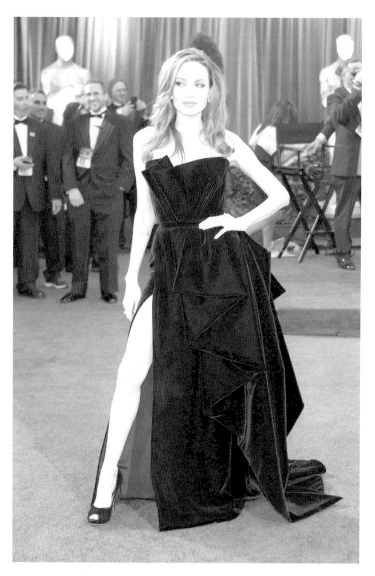

Figure 3.1 Actress Angelina Jolie arrives at the 84th Annual Academy Awards in Hollywood, California. On the catwalk, Versace gowns are showcased on bodies that are constantly in motion, highlighting the extent of bodily exposure that is permitted by their design. Beyond the context of a runway show, Versace's intention is to design for other circumstances that similarly involve kinetic bodies. Versace has dressed actors for awards ceremonies including Penelope Cruz (2012), Angelina Jolie (2012, pictured here) and Halle Berry (2013). During their red-carpet parades, actors stride and twirl for photographers, allowing their gaping garments to expose bare legs beneath, and each of these actors takes the opportunity to pose for photographs as if in motion, with one leg extended through the thigh-high split in her gown. The red-carpet setting is characterized by the kinds of bodily motions that showcase a body and its coverings to best affect. Photo by Ethan Miller/Getty Images.

wedding dress" of 1977, which reveals the wearer's leg through a series of rips and tears, stretching from hem to hip, and adorned with safety pins (Rhodes and Knight, 1984, pp. 177–183). Like the slit, the slash hints at the possibility of further exposure, but this exposure seems beyond the wearer's control, as if her desire to remain clothed is at odds with the designer's desire to expose her. This is not so much a negotiation as a conflict. The safety pins struggle to stabilize a dress that would otherwise fall apart.[1]

Hussein Chalayan and unstable coverage

With the invention of mechanical garments, there is the possibility of gaping motions performed by clothing, and operated by external, remote forces. British fashion designer Hussein Chalayan is celebrated for his kinetic garments, described by Stephen D. Seely (2013, p. 255) as erotic encounters between living bodies and technology. Traditionally, "the body animates the garment," but in Chalayan's transforming dresses, the garment is itself animated (Birringer and Danjoux, 2006, p. 44). Chalayan employs concealed robotic mechanisms to alter silhouettes, so that his garments mechanically readjust while worn, having the potential to be constantly in flux. The shifting surfaces reveal and conceal the body beneath, offering glimpses of bare skin. Bradley Quinn (2002b, p. 367) identifies Chalayan's garments as exhibiting "the techno-sexualization of the body," highlighting the potential for future fashion technology to "reveal/conceal erogenous zones."

An exploration of the relationship between fashion and erogenous zones is, writes Quinn (2002b, p. 367), at the heart of many of Chalayan's designs. His work explores the "sensuality" of the ways in which the body may be concealed and revealed. He avoids conventional or direct reference to the sexualized body, instead acknowledging that "pleasure centres [are] highly individual; zones to be explored and identified on individual bodies"—an exploration he carries out via kinetic clothing that gapes or otherwise transforms to reveal the body beneath.

The "Aeroplane Dress" (originally presented in Chalayan's *Echoform* collection, Autumn/Winter 1999) is an idealized, minimalist female form molded from fiberglass and resin. The stiff shell incorporates several hidden panels that can be activated remotely to slide or flip open, allowing selective exposure of the wearer's body. The largest panel lies at the front of the dress. As this panel migrates, sliding downward, it leaves a void through which the bare skin of the model's midriff is revealed. The displaced panel reveals a small area of soft, living skin, which is markedly organic in contrast to the artificial shell (Figure 3.2).

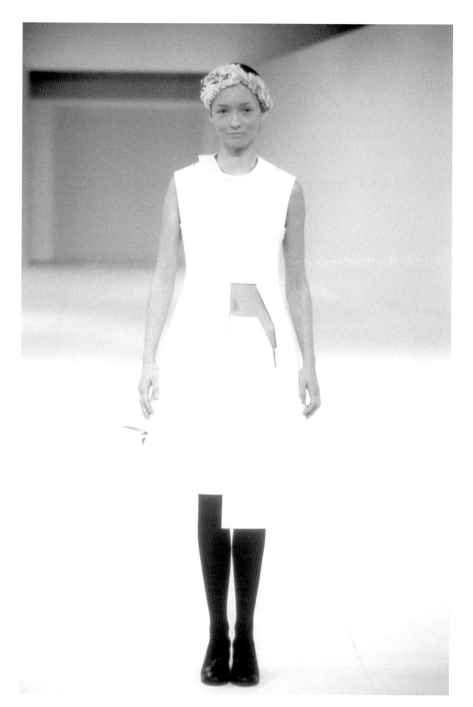

Figure 3.2 Hussein Chalayan's "Aeroplane Dress," *Echoform* (A/W 1999) mechanically reveals areas of body through gaping panels that can be activated remotely. Photo © Chris Moore.

Maria Petrides (2006, p. 2) draws on Chalayan's remarks about mobile "comfort zones" to describe his work as explorations of the pursuit of territory that is always just out of reach. She proposes that Chalayan's childhood in Cyprus, a divided island, prompted an interest in stability and instability. For Petrides, Chalayan's garments "prevent us from becoming attached to any particular image," telling us to accept that territory is transient; that there is "no 'stable' place to which we can return." Clothing offers temporary shelter, but is unreliable. The rigid structure of the "Aeroplane Dress" is like a protective shell, but one that can be compromised. It offers security, but not stability, leaving the model constantly at risk of exposure.

Chalayan's models suffer a loss of control over the territory of their own bodies. When a third party has control of a kinetic garment, the wearer is vulnerable to denuding. Birringer and Danjoux (2006, p. 42) observe that such technologies locate fashion in the field of choreographed performance. The panels migrate almost as of their own accord, as the invisible force that moves them is unknown to the audience.

Chalayan's comments about instability suggest that his work is motivated by anxiety about a lack of security and control, and in his transformable garments, the exposure of skin is choreographed from elsewhere. This issue is made explicit in the *Remote Control Dress*, presented at Chalayan's *Before Minus Now* show (Spring/Summer 2000). The dress, and the model who wears it, are accompanied on stage by a boy with a remote controller. The boy's presence is a reference to remote-controlled model aeroplanes, an inspiration for the streamlined form of the panels (Rosenau, 2005). As the boy points the aerial of his controller at the model and slides the joystick, the panel on the dress flaps open, thus forcing the perception that the dress, and by extension the female body beneath, is a toy to manipulate as he pleases. Meanwhile, the model passively accepts the motion of the panels around her body.

Stephen D. Seely (2013, p. 256) notes that although Chalayan's robotic garments do appear to invite associations with the masculine control of the female body, through technology, he has made efforts to counteract such readings. His Autumn/Winter 2011 show, *Kaikoku*, featured a dress that could be controlled by the model herself. Further, the facial expressions of the models whose garments are transformed sometimes express a hint of satisfaction, as if they have telepathically invited the transformation. In particular, he observes, the model who is entirely denuded in the finale of his Spring/Summer 2007 show, wears a subtle, satisfied grin on her face.

Chalayan's Spring/Summer 2007 collection includes a number of transformable dresses that change to reflect historical developments in fashion (Edkins, 2006). The technology that allows these transformations is largely contained within packs that are worn at the rear of each dress. Each pack contains a battery and pulleys. The pulleys are attached to wires that are fed

through tubes in a corset and attached to various key points of the garment, including zippers and hemlines. When activated, the mechanized pulleys tighten and release the wires, so that parts of the dress can be shortened, lengthened, rotated, curled, joined or released (Choe, 2007).

The dresses, when viewed and transformed in sequence, take a journey through twentieth-century fashion. The first dress initially resembles a high-necked gown of the belle époque, but then, thanks to an array of concealed wires and pulleys, shortens as the neckline parts, revealing a flapper-style dress underneath. The hem of the second dress begins at ankle length, but is then raised to above the knees, while the neckline zips up, transforming into an elaborate interpretation of 1940s utility style. The third begins at knee length and transforms into a mini dress. The remaining dresses continue to follow the historical trend for progressively shorter hemlines until the final dress in the sequence presents a vision of the fashion future, as Chalayan predicts it, with a dress that disappears completely, leaving the model's entire body nude.

Seely (2013, p. 255) observes that, although these dresses do get progressively shorter, these robotic transformations "cannot be said to 'undress' the models in any straightforward way." He notes that those garments that reveal one area of the body, do so while simultaneously concealing another. For example, a neckline zips up while the hem of a skirt rises. Following Barthes, the exposed zone migrates from one part of the body to another.

Chalayan's many experiments with partial undressing have culminated in the finale of his dance production, *Gravity Fatigue* (2015). In collaboration with choreographer Damien Jalet, Chalayan conceived and directed his first dance production for Sadler's Wells in London. The production consists of eighteen set pieces, many of which extend ideas that have previously inspired Chalayan's fashion collections. The theme of dressing and undressing emerges in several of these scenes: in "Omnipresence," a male and female dancer undress as if to shower, hidden from one another by a screen but mirroring one another's movements; in "Arrival of Departure," dancers spin in and out of reversible jackets that transform into sequined dresses when flipped inside out during the process of removal. The process of removing these jackets, says Chalayan (2015), informed the choreography of the scene. In the early stages of development, Chalayan and Jalet observed that when a dancer removed and reversed the jacket, it created a kind of "centrifugal movement" that carried the dancer around in a spinning motion. This spinning movement, as the body escapes the jacket, became the central action of the scene.

Gravity Fatigue's finale, entitled "Anticipation of Participation," presents what dance critic Mark Monahan (2015) describes as "a collective poolside wardrobe malfunction." As the scene begins, a female performer stands in front of a pool, with a sarong apparently wrapped around her torso. Other dancers,

male and female, line the back of the stage, watching in anticipation of her disrobement. Facing away from the theatre audience, she flashes open the sarong as if exposing herself to the erotic gaze of her fellow dancers, then turns, revealing that the cloth wrapped around her body is not in fact a sarong, but rather a complex elasticated contraption that combines swimsuit with wrap, which traps her body, leaving her unable to undress. She is joined by another dancer, who attempts to remove the skirt of her dress only to find that she is similarly thwarted. One by one the remaining dancers join the first at the poolside, each in a different but equally complex elasticated garment that somehow prohibits removal. Some dancers manage to uncover one part of their body, only to find the cloth relocated to another body part. They struggle with their garments, concealing and revealing body parts as they battle against awkwardly placed seams and the elasticity of the fabric. Dancers become entangled as they struggle to escape their clothing, until they finally merge into "an orgiastic, homogeneous gloop of limbs and torsos" (Monahan, 2015).

Fasteners and unfastening

The migration of a piece of clothing can simultaneously be an act of dressing and undressing. When the panels of Chalayan's "Aeroplane Dress" reveal one part of the body, they necessarily conceal another at the same time. Just as a gesture can reference the act of undressing without fulfilling its promise of garment removal, a garment can itself suggest the possibility of undressing. This is particularly true of fastenings, which are employed in both concealing and exposing, and equally connote the potential for connecting or separating the pieces of cloth that cover a clothed body (Howe, 1851). Fasteners cry out to be unfastened. They provide visual cues to how a garment may be removed from the body, and fulfill their potential when used to conceal or reveal.

 The need to dress and undress swiftly and easily has prompted a host of fastening innovations, from the popper to the zipper. The slide fastener, later known as zip or zipper, was marketed in the early twentieth century as a modern mechanical innovation that would speed up the dressing process and prevent the gapes that had previously plagued the wearers of buttoned garments (Friedel, 1994, p. 84). Overcoming initial skepticism, designers began to adopt zippers for fashion use in the 1930s, most prominently by Elsa Schiaparelli and Charles James. Although it was initially (and still can be) concealed, Schiaparelli exposed the zips in her designs, thereby emphasizing her use of this new method of joining and separating cloth for dressing and undressing. Despite zipper manufacturers' efforts to concentrate on the benefits of the zipper for swift and tidy closure for dressing, in Schiaparelli's garments they were promoted in connection to "openings" (Friedel, 1994, p. 193), and

so the zipper was positioned in direct relation to the gape, and as a means of releasing the garment from the body. In Charles James' Taxi dress, lengths of fabric were fastened with zippers instead of seams, spirals around the body "as if the garment could be unzipped into narrow bands of fabric" (Worsley, 2011, p. 48). Zip manufacturer Lightning Fasteners Ltd. published an advertisement in 1933 showing the James' Taxi dress unzipped, so that a gape spirals around the body of a model, from neckline to hip (MMA, 2014). Such images emphasized the zip's potential to release a seam with ease.

At this time, the zipper represented modernity and sexuality. Robert Friedel (1994, p. 211) cites Aldous Huxley's *Brave New World* (1932) as evidence. In Huxley's envisioning of a totalitarian future London, undressing is made effortless, and "robbed of its allure" by the ubiquitous zip fastening. Undressing is an efficient, mechanized process, shown to be easily accomplished as John observes Lenina asleep and finds himself "reflecting that he had only to take hold of the zipper at her neck and give on long, strong pull" to free her body from her one-piece pyjama (Huxley, 1932, p. 98). Friedel (pp. 212–213) observes that the zipper "remained a tool and symbol of seduction not only in literature but in other cultural expressions" as well, including motion pictures such as *Gilda* (Charles Vidor, 1946), in which Rita Hayworth's zipper presents a method of "quick and complete disrobing."

As had been so well illustrated in *Brave New World*, the zipper's sexual connotations arose largely because of the speed and ease at which it permits disrobing. Indeed, the term "zip" was borrowed from the verb, "to zip," or to move quickly (Friedel, 1994, p. 215). The ease with which zippers open or close offers opportunities for tease, as demonstrated by burlesque performers (see Chapter 2), who incorporate slow unfastening of zips into their acts, sometimes combined with coy re-fastening to prolong the tease. Unzipping, writes Nina Edwards (2012, pp. 15–17), has different connotations to unveiling or unbuttoning. While unveiling may be subtle, delicate and gradual, unzipping is a gesture that is "unrestrained."

Zippers can connote sexual availability aurally as well as visually. Many fastenings are constructed from solid components and therefore make more audible and identifiable sounds than soft cloth. Zips, poppers and Velcro all have distinctive sounds and can be used to paint an aural picture of gestures of unfastening that may be heard but not seen.[2] Unzipping sounds are perhaps the most identifiable aural indicator that someone is undressing in the dark or off-screen in film or television. Some kinds of fastenings make sounds only during unfastening: poppers can be significantly louder when unpopped than when popped, and Velcro is virtually silent when stuck together but generates clearly audible sound when pulled apart. Consequently, the sound of fastenings is more readily associated with undressing than with dressing. Stone (1988, p. 82) describes the sound of Velcro as "a stirring sound of seduction," observing that

it is almost always erotically suggestive. Hearing the sound of Velcro, she writes, signifies "that something's going on because something's coming off."

When the wearer has control over how his or her garment conceals or reveals, intermittence can become a powerful tool for self-expression. Zippers and other fastenings offer opportunities for the wearer to apparently destabilize a garment without fully removing it. Unbuttoning, for example, may lower the neckline of a blouse, exposing the décolletage and inviting the erotic gaze. Thus, the wearer is able to position a garment as if frozen in a state of partial undress. Fastenings necessarily work in conjunction with a gape. To enable dressing and undressing, their role is to expand the garment by creating or extending a hole. Fastenings expand a garment by adding space, and through that space, the body may escape.

This unfastening can be precisely controlled. An exact number of buttons, poppers or hooks, or a precise length of zip, can be separated so as to securely fix a garment in a state of partial undress. While they allow the wearer control over the degree of exposure, fastenings simultaneously reference the potential for further undressing. Atelier Versace's Fall 2013 couture collection includes dresses sliced fully in half from neck to hem, held together by rows of visible hook-and-eye fastenings. The fastenings are the only ornamental feature of these dresses, and so draw the gaze directly to the site of potential disrobement. The dresses have potential to be conservative, as the fastenings could be, if so desired, fastened from ankle to neck. However, in their debut catwalk appearance, they are only partially fastened so that the fabric falls open and the torso and leg are exposed. The few fastenings that remain closed are just enough to keep the garments on each models' body, and it is visibly evident that a few quick gestures of the fingers is all that would be required to separate the two halves of the dress and let it slide to the floor.

Fastenings typically locate instability along a vertical line that originates at the neckline or underarm and terminates at the hip or hem. The downward movement of an unfastening zipper, from top to bottom, extends into the vertical movement of a garment as it falls from the body. As a dress, unzipped along the spine, falls from the body, the unzipping and falling are two parts of one continuous downward movement. Sebastian Errazuriz's *N3 Zipper Dress* (Figure 3.3) transfers this effect to other regions, and rotates the gape to horizontal lines around the body. The dress is constructed entirely from zippers—120 in total—all of which can be opened partially to create gapes that segment the garment, or fully to reduce the dress' overall length. The design does not prioritize any part of the body, and so gapes may be located wherever the wearer chooses.

Errazuriz's dress offers wearers the flexibility to control how their body is covered or exposed, as tools for emotional expression through physical exposure or concealment. The garment overtly displays "sexual … potential"

Figure 3.3 Sebastian Errazuriz's *N3 Zipper Dress* presents itself as destined for unfastening. Made entirely from zippers, every piece of the garments suggests the possibility of undressing. © Sebastian Erruriz Studio.

(Schwichtenberg, 1981, p. 27). Every part is prepared for unfastening and removal. The continuation of the zippers all around the body invites observers to consider unzipping further. Even if wearer elects to reveal only a small area of skin, the zipper is a visual indicator of the potential to reveal more.

Errazuriz's concern is flexibility. He aims to offer wearers the option of customizing their dress, and adapting to suit any given situation. The wearer can be responsive in her creation of gapes, as she may choose to zip or unzip in reaction to immediate surroundings. In so doing, she invites or rejects the observer's gaze. She may be modest, with the zippers fastened, or daring, with gapes wherever she pleases, and may transition from one state to another in response to her environment.

A gape, controlled through fastening can, in this way, become a mode of communication. Eunjeong Jeon (2009) identifies the emotional states that might cause the wearer of an adaptable garment to expose or conceal his or her body. Her studies find that a wearer's decision to conceal or reveal the body expresses the wearer's emotional state, and can be read as an extension of body language. Flexible garments, she writes, provide wearers with the means of physically responding to "secure" and "insecure" situations.

Jeon's study records wearers' interactions with her own flexible garments. Her "un-instructional and uncompleted form[s]" may be manipulated to increase or decrease coverage of the body (p. 8). She finds that wearers' manipulation of the garment directly correlates with the open and closed body language (p. 4). Wearers who feel threatened tend to seek more coverage, while simultaneously presenting defensive body language including folded arms and lowered head, while those wearers in familiar and comfortable surroundings tend to extend body parts out of the garment while displaying an open stance. In particular, Jeon notes that wearers choose to conceal different body parts when in friendly or threatening environments. In an "insecure situation," wearers choose to adapt the garment so as to conceal their necks, shoulders and arms, drawing them into the same enclosed space as the rest of the body. Those wearers who feel more secure tend to cover only their torso, exposing their arms and neck, thereby allowing free and expressive movement.

Jeon identifies those body parts that remain uncovered in secure environments, the arms, for example, are those that are most expressive. The revealing of these body parts invites observers to engage emotionally with the wearer (p. 9). She finds that wearers choose to expose their bodies not only to offer themselves as erotic objects, but also to counteract objectification with increased potential for emotional expression. Extending their bodies beyond a garment, wearers can invite intellectual or emotional engagement as well as, or instead of, the male gaze.

The examples in this chapter can perhaps not be described as "acts of undressing," but are rather *suggestions* of undressing. They may invite the

observer to imagine a complete act of undressing, but do not deliver on their promise. As an action, undressing is associated with change, not stability, and so once a gesture of undressing has apparently been set in motion, it is reasonable to anticipate that the transformation will continue. Fastenings that have begun to open will be imagined opening further, a blouse that slips off the shoulder will be imagined falling to the floor, and a flash of bare skin will remind the observer that there is a whole naked body waiting to escape its coverings. This promise of exposure may be, as in the examples above, enticing and arousing, but as the next chapter will show, the threat of nudity may also be scandalous.

4
DEVIANCE AND DISRUPTION: STREAKING, MOONING, AND FLASHING

While it may be acceptable to unfasten a button or two, more extreme public exposure can be met with accusations of deviance. Practices of flashing, mooning and streaking straddle the fluid line that separates erotic and hostile gestures. These practices are often forbidden by law, regulation or etiquette, largely because of their capacity for causing offense and disruption. In almost all cases, these gestures are intended to interrupt ongoing proceedings or to challenge status quo. Relying on the shock value of sudden, unexpected exposure, and the potential offense caused by public nudity, they have both "surprise and taboo on [their] side" (Barcan, 2004, p. 185).

Flashing in particular has sinister connotations, being primarily associated with criminal sexual deviance. Classifying it as indecent exposure, a study by Bader et al. (2008, p. 274) identifies flashing as "the act of exposing one's genitals to an unsuspecting stranger with implied sexual intent." Thus, the meaning of this gesture is heavily tied to consent. The unwilling observer is cast as victim, and thereby distinguished from willing audiences of striptease and other public undressing. Bader et al.'s study explicitly excludes examples of public exposure performed with consent, even when those gestures are mechanically identical to the flashing that is classified elsewhere as criminally deviant.

Streaking and mooning, while also perceived as vulgar, avoid association with sexual predation. Like flashing, they involve sudden and often unexpected exposure of naked flesh, but context and intention mark these practices apart. Both streaking and mooning have, on many occasions, been intended and received as politically motivated gestures. In its infancy, argues Bill Kirkpatrick (2008, p. 7), streaking had "social [and] political significance." The older gesture of mooning, which involves the playful bearing of one's backside in order to express disrespect, may be hostile, but may also "take on secondary characteristics involving questions of identity" (Ardener, 1974, p. 54).

While other forms of public indecency, such as flashing, are associated with sexual deviance, streaking is presented primarily as "an assault on social values" (Toolan et al., 1974, p. 157, as cited in Forsyth, 1995, p. 384). Streaking is not, by most accounts, a sexual act. Indeed, Bryant (1982, p. 134) argues that streaking cannot have "any erotic value." Craig Forsyth (1995, p. 385) aligns streaking with nudism, which is presented as "purposefully antierotic," aiming to neutralize associations between nudity and sexuality by making it routine.[1] Nonetheless, even those streakers who reject erotic readings of their actions, "may have to struggle to keep unwanted meanings as bay" (Barcan, 2002, p. 3).

Writing from the United States associates the practice of streaking with college campuses, but such texts describe it as a short-lived fad that largely died out by the end of the 1970s (Herring, 2008; Hoffmann and Bailey, 1991; Kirkpatrick, 2008). This does not mean that these practices are now extinct, rather they no longer retain the degree of novelty that allowed them to be used for political expression in previous decades. To some degree, streaking retains its "power to agitate individual authority figures," but has largely been relegated to the status of "harmless and ultimately meaningless fad" (Kirkpatrick, 2008, p. 2); a "humorous assault on social decorum" (Jones, 2009). While streakers in the 1970s expressed political agendas, including the struggle for sexual equality, or conversely, the preservation of traditional gender roles (Kirkpatrick, 2008, p. 13), contemporary commentators tend to present the practice of streaking less as a tool for influence, and more a sensation-seeking prank (Kohe, 2012).

While such texts from the USA align streaking with anti-war activism of the 1970s, texts from the United Kingdom and elsewhere are more concerned with streaking at sports events, and present it as an ongoing activity that is just as common today as it has been in the previous four decades (Carr-Gomm, 2010; Kohe, 2012). The sports environment has, it seems, provided an arena for the preservation of streaking as it died out elsewhere. Through association with the more trivial context of sport, naked protest was preserved in its new form, streaking, which reduced the political value of this form of undressing while continuing to provide an outlet for groups and individuals who felt the need to express via their naked bodies.

Indecent exposure

Courts around the globe have grappled with the question of whether acts of public exposure may have legitimate political value. In Australia, the legal defense for James Albert Ernest Togo, an Aboriginal who had been arrested for exposing his buttocks in the direction of a passing police car, asserted that

the gesture had been "a weapon of civil disobedience deployed in the long-standing conflict his own Aboriginal culture and the disciplinary institutions of the Australian state" (Ravel, 2007, p. 280). Mooning, defense attorney Eugene O'Sullivan argued, was an act of political expression on a par with free speech, and should therefore be protected under the Australian constitution (p. 279). The magistrate, however, disagreed, ruling that Togo's mooning "undermine[d] the authority of the police" and should not be legally permissible. Togo was convicted of indecent behavior.

The court of Maryland, USA, takes a different view. Maryland resident Raymond McNealy was cleared of indecent exposure charges by Judge John W. Debelius III, after McNealy's lawyer successfully argued that his mooning gesture was intended as an expression of disapproval, comparable to other forms of gestural or verbal protest. Debelius ruled that mooning, while "distasteful," does not "constitute indecent exposure" (National Conference of State Legislatures, 2006). His decision rested upon previous case law, which tended to define indecent exposure as exposure of "private parts" with intent to offend. Buttocks, he ruled, could not be classified as "private parts."

Attempts to formally regulate deviant behaviors are problematic, since the perception of indecency or deviance depends wholly on the subjective judgment of the audience (Herman, 1995, p. 5). Perceptions of these gestures of exposure differ in part because of varying definitions of nudity (whether, for example, the definition of "private parts" extends to the buttocks). What constitutes deviance or indecent exposure depends not only on contrasting definitions of nudity in different cultures, but also on context. The location, the identities of offended observers and the characteristics of the gesture, all influence interpretation and legality.

When exposure is witnessed by a large audience, there are inevitably multiple interpretations of the act, and potentially conflicting views about the extent to which it can be considered indecent. At the Super Bowl Half Time Show in 2004, Janet Jackson and Justin Timberlake performed for a crowd of 71,000 live spectators and ninety million television viewers (Cogan, 2014). Jackson performed first, then remained on stage for Timberlake's song, during which she danced, first alongside his dancers, and then with him. At the very end of the song, Timberlake sang the final line, "I'm gonna have you naked by the end of this song," then reached across and tore a cup from Jackson's leather bustier, revealing her breast. Jackson glanced down in apparent surprise, before the broadcast cut to a commercial break. Media responded with the assumption that the event was a stunt, premeditated by Jackson, with the complicity of Timberlake (Holland, 2009, p. 130), an accusation that both parties denied, saying that the action should have revealed a lace bra, not a bare breast. Jackson's spokesperson Stephen Huvane dismissed the exposure as "a malfunction of the wardrobe."

A star-shaped nipple ring, which some cite as evidence that the exposure was premeditated (Mounsef, 2008, p. 248), partly concealed Jackson's nipple and areola, thus "block[ing] the full access to visual pleasure" (2008, p. 256). The glimpse was so brief that it may barely have registered in the minds of live viewers, lasting only 9/16th of a second (Bar, 2014). Nonetheless, broadcaster CBS was the subject of 542,000 complaints from viewers outraged by this "corruption of an American institution" (Leonard and Lug-Lugo, 2005, p. 102). The Federal Communications Commission (FCC) fined CBS $550,000 for "broadcast indecency" (Holland, 2009, p. 244).

Donia Mounsef's (2008) analysis of the $550,000 fine proposes that, by declaring the sign of Jackson's breast an offence, the FCC position the male audience as the primary victim of the event. While some readings position Jackson herself as the victim of Timberlake's actions (it was, after all, he who tore off the cup), the large number of complaints and the resulting fine reflect widespread agreement that it was the audience who were the victims "of an affront to family values and public morality" (Mounsef, 2008, p. 252).

Shannon L. Holland's (2009, p. 139) survey of media responses to the broadcast finds that "mainstream reporters … interpret the scandal in a way that directed the public's attention toward Jackson's breast and away from Timberlake's act of ripping the bodice," thereby absolving him of any responsibility for the exposure, and shifting the blame to Jackson, her wardrobe, and her body. Headlines paint Jackson as "highly sexualized," presenting her exposed breast as "a sign of her innate deviance," either "construct[ing] the event as a passive occurrence [or] as a scheme used by Jackson to 'seduce' Timberlake in order to boost her own career" (p. 137). Holland notes that one third of those articles surveyed "failed to mention the cause of exposure," and cites the "passive terminology" of journalists which, through omission, implies that "either Jackson exposed her own breast or as if the breast had spontaneously exposed itself" (pp. 137–138).

Those headlines that suggest "spontaneous exposure," Holland posits, align Jackson with the myth of the Jezebel, "premised on the image of the instable [and uncontrollable] black female body" (p. 139). Accusatory phrases including "the offending breast" (*Pittsburgh-Post Gazette*) seem to credit Jackson's body "with an extreme amount of agency." The "disobedient breast" (Mounsef, 2008, p. 254), or "rogue breast" (Guins, 2009, p. 25) is presented as capable of independently provoking "communal trauma." Indeed, many other "wardrobe malfunctions" are similarly framed, as triumph of the body over clothes, as if the celebrity body begs to be released (Weiss, 2012).

The garment itself also arguably begged to be dismantled, having been purposefully designed with detachable cups over each breast. Still images captured from the broadcast show the breakaway cup in Timberlake's hand, with a row of snap fastenings lining its contours for easy release (see Figure 4.1).

DEVIANCE AND DISRUPTION 63

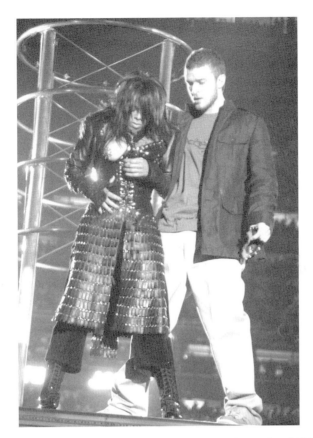

Figure 4.1 Janet Jackson and Justin Timberlake during Super Bowl XXXVIII Halftime Show at Reliant Stadium in Houston, Texas. Shortly after Jackson's "wardrobe malfunction," it is possible to see her breakaway cup in Timberlake's hands, revealing the row of snap fasteners that made it possible to remove the cup so easily. Photo by Jeff Kravitz/FilmMagic/Getty Images.

Perhaps most significantly, in light of claims that there was supposed to be a red lace bra underneath, a narrow band of red lace is shown trimming (but not covering) the underside of the cup. Inspection of images of the garment shows that the other breast cup was similarly designed, thereby offering potential for further progression toward nudity should it so be desired. It appears that Jackson's garment has been constructed with the purpose of revealing what lies beneath.

Denials like those that followed Jackson and Timberlake's apparent mishap are not uncommon in similar cases of public exposure. Denial of responsibility or intention is a defense against accusations of indecency, not least because legal definitions of indecent exposure require that the gesture is deliberate. It is not bodily exposure, but rather the intention behind the gesture that defines an

indecent act. It typically falls to the actor to provide evidence of his intentions, and to prove that the gesture was politically rather than sexually motivated. The Australian magistrate who convicted James Togo of indecent behavior remarked that she may have been more sympathetic to his defense if he had written a slogan on his naked rump (Ravel, 2007, p. 295). Her remarks invite contrast with the actions of numerous other protestors who have combined nude protest with written slogans, conscious that their nudity could be misinterpreted as vulgar exhibitionism. Colorado students protesting against curriculum change (Prager, 2014), and other protest groups including Ukrainian feminism activists FEMEN, have found that the ambiguity of their nudity necessitates the display of written slogans on their torsos. Colorado students employed signs reading "censor this"; FEMEN's torso's display slogans such as "my body my rules"[2]; and war protestors such as artist Hala Faisal have painted "stop the war" on their unclothed skin (Kaysen, 2005). Such written messages are employed to ensure that their motivations are known to audiences. Though writing does not necessarily save such public disrobers from arrest, it does work to legitimize and politicize their actions.[3]

FEMEN employ nudity to make visible their "bodily suffering" (Barcan, 2002, p. 6), in a protest against objectification, specifically the feeling that women have been "stripped of ownership" of their own bodies (FEMEN Statement of Objectives). FEMEN exploit the power of nudity to counteract "ornamental meanings of female nakedness" (Barcan, 2002, p. 3), though not because they feel that nudity has innate power; they achieve power via, not through, naked flesh. Nudity is a tool by which to achieve media coverage, and by their own admission, it is the press coverage that provides power against their oppressors (Girard, 2012).

The media tends to focus on FEMEN activists' toplessness, and it is in this semi-naked state that they have potential to cause offense, and to invite accusations of indecent exposure. However, the meaning of their actions is not always located in their nudity, but rather in the gesture of undressing that preceded it, or more specifically, the act of discarding signifying garments. Some FEMEN protests directly present their nudity as a result of having stripped away the garments that signify their oppression. Opposition to the veil is expressed in messages specifically targeted at Islamic societies, including slogans such as "Pakistan: Take off your clothes ... I am free." Parallels can be drawn to the myth of bra burning, and a history of protest against garments that force adherence to an artificial ideal. These protests reinforce the role that clothes have played in gender construction, stripping the body back to its unconstructed state. Thus, they call on other women to undress in order to claim their freedom. In this call, they request that women use the act of undressing as a kind of rebirth, to mark a personal transformation: the culmination of a personal journey from meek acceptance of the world as it is to defiant pursuance of the world as it should be.

DEVIANCE AND DISRUPTION 65

FEMEN's spectacle of toplessness is perhaps a distraction from the more specific message that can be communicated in their casting off of particular garments. Indeed, an act of protest undressing may express meaning more precisely when focus is shifted away from the body and onto the clothes that are removed. Undressing must be considered not only as progress toward nakedness, but also as the removal of "cultural property" (Masquelier, 2005, p. 1). Clothes function to assert identity, but some aspects of that identity may be beyond the wearer's control, as in uniform, or arguably, when clothing choice is dictated by social or cultural convention. Stripping oneself of property and cultural signifiers frees the body from the social and cultural constraints that may otherwise govern our behavior and identity. By stripping those signifiers, piece-by-piece, we strip the wearer of their socially constructed self, and in particular any aspects of self that are felt not to be representative of the wearer's own values. For St Francis of Assisi, for example, who "tore off his clothing in a dispute with his father," undressing was a rebellion against his cloth-merchant father, whose business had provided the family's clothes (Carr-Gomm, 2010, p. 78).

The act of discarding signifying cloth can serve its disruptive purpose before, and even in the absence of, nakedness. This motive for disrobing does not require the protestor to become naked, just to remove those items of clothing that signify adherence to particular rules or values. Students at Syracuse University, New York, organized a mass disrobing at their 2010 graduation ceremony, in protest against the choice of guest speaker, Jamie Dimon (DiVirgilio, 2010). Dimon's visit to the university coincided with a widespread vilification of the banking industry in the wake of the banking crisis, and Dimon's role as CEO of JPMorgan Chase, who had accepted a government bailout, made him an unpopular speaker. Students considered boycotting their graduation ceremony (Markham, 2010), but instead opted for partial disrobing as a method of protest that would allow them to partake in this right of passage without implying support for the values represented by Dimon's presence at the event. A call to action posted on Facebook invited the class of 2010 to "be part of a respectful, silent protest and take off your [sic] cap and gown." Syracuse students' university press, *The Daily Orange*, described the students' planned disrobing as "quiet yet powerful way to show their discontent" (Ronayne, 2010).

A significant factor in ensuring the respectability of this protest was the silence with which it was carried out. Their disrobing generated only a quiet rustle, with potential to cause only minimal disruption. The students' goal was not to interrupt Dimon's speech (indeed, they supported his right to make the speech in accordance with the First Amendment), but rather to express disagreement with the university's decision to select him for the commencement speech by removing the robes that signified their institution's values. Their gesture was

designed to send a very particular message, not to disrupt or detract from Dimon's words, but to distance themselves from the institution's decisions leading up to the ceremony.

On the day of the ceremony, a handful of students removed their ceremonial caps and gowns as Dimon took the stage, divesting themselves of signifiers of the institution but not exposing their bodies. The protest allowed participants to retain their dignity, avoiding accusations of exhibitionism that would normally accompany a naked protest, making their views known without disrupting the ceremony. By avoiding shock tactics, the students were able to ensure that the protest had an air of respectability. The gesture distanced participating students from the values expressed in the university's choice of guest speaker, and replaced their shared identity, as a member of an institution, with their individual identities, expressed through personal wardrobe choice.

Not all rapid public undressing is intended to be so respectful. On the contrary, it is more often designed with disrespect as its main goal. Mooning or streaking, as in the cases of Togo, McNealy and FEMEN, is enacted to express an objection to the values of the observers or their institution. Disrespect for those values is at the very heart of the gesture, and underlies the actor's motivation. However, it would be inaccurate to solely define streaking or mooning as expressions of antiestablishment views. Sports streaking, for example, is at times a celebration of the physicality of sport, and a desire to actively participate in the game.

Exposure and sport

In the sporting arena, streaking can present itself as a form of ideological opposition to the commercialization of the game. Streaking's alignment with sport has occurred alongside its commodification. Richard Giulianotti (2002, p. 27) recognizes a "bourgeoisification" of soccer in particular, as clubs have sought to attract "wealthier audiences." Consumption of extortionately priced, branded clothing has become one of the primary means by which fans express their support for a team (Meir, 2009, p. 23). The removal of branded sports clothing in front of an audience of spectators can express opposition to the "hypercommodification" of a sport, and a desire to reclaim its grassroots origins. Paradoxically, in recent years, streaking itself has become increasingly commercialized. Regulations at sporting events treat streaking as a commercial practice that is a potential threat to their sponsors, indirectly, as it may promote values that are at odds with those of the sponsors, or more directly, when streakers adorn their bodies with the names of competing commercial enterprises. Streaking has achieved a degree of legitimacy, as part of a sanctioned commercial exchange, and an extension of other sporting practices.

The sporting arena is, and always has been, a venue for thinly veiled eroticism. Kelly Nelson's (2002, p. 408) study of sports fans finds that the sports spectator's gaze is both respectful and erotic. Spectators' viewing habits are based partly on the perceived sexual attractiveness of particular athletes, even when an athlete is not explicitly a subject of his or her erotic fantasies (p. 410). Sports practices have always straddled the boundary between athleticism and eroticism, and ancient civilizations "acknowledged and celebrated the erotic element in sports" (Guttmann, 1996, p. 1). The sporting arena is therefore a home to other activities that are marginally erotic. Nelson (2002, p. 409) argues that in the sporting arena, athletic skill and eroticism are inseparable: one cannot exist without the other. Streaking makes this connection visible. It presents itself as a sporting challenge, but also invites the sexual gaze. While not overtly as erotic performance, streaking highlights that any semi-naked body, in an arena that celebrates physicality, is inescapably sexual. Furthermore, although it is not classified as a sexual act, streaking is, to some extent, reliant on erotic associations. Public nakedness represents nonconformity primarily because it is deviant, and this perceived deviance stems from erotic associations, whether they are invited or not.

Sports streaking is regarded as deviant both for its disruption of a game in progress and for its perceived erosion of the respectability of the sporting environment. Anxiety about streakers reflects unease about the relationship between the athletic and the erotic body. The respectability of sports is considered sacred by commentators including Murray Elkins (1974, cited in Kohe, 2012, p. 200), who describes streaking as an "attempt to erode and destroy decency," while others, including Kohe (2012, p. 205), describe streaking as a display of "bravado" that itself contains many aspects of sport. Streaking, writes Kohe, illustrates "in its own exhibitionist manner, the vitality of the body in motion" (p. 209).

Concerns about streakers' apparent disrespect for the values of the sport are perhaps partly responses to their removal of visible signifiers of team allegiance, which might in turn express disinterest or even disapproval of some aspect of the game.[4] In a sports setting, clothing has special value as an indicator of team brand loyalty. Sports fans are visibly marked tribes, and clothing is an essential part of the expression of one's fandom (Meir, 2009, p. 19). The removal of clothes in this context therefore acts in part to neutralize the streaker.

Jack Silburn, a young New Zealand rugby fan, began a streak in 2010 still wearing his team colors (Smith, 2010). Silburn was seen racing onto the pitch partially clothed in his green and black striped Manawatu rugby shirt, which he stripped from his body while running. As he undressed, he stripped himself of visible signifiers of team allegiance, thereby positioning himself as the only neutral body on the pitch (other than the referee). The removal of team clothing

distances Silburn and other streakers not only from the team brand, but also from fellow supporters and the values that they represent. Sports fandom is founded on "a spirit of 'us' verses 'them'" (Richardson, 2006, p. 179). Teams are inextricably connected to the locations in which they are founded, and many fans are socialized from childhood into team support so that it becomes an extension of their local and family allegiance. In Europe in particular, geography is "the most influential factor in selecting a team" (Keaton and Gearhart, 2013, p. 7). For "partisan" fans, sports team fandom demonstrates a personal or "geographical connection" (Dixon, 2001, p. 151). Support for local, regional or national teams, or school and college clubs, allows supporters to feel a sense of personal pride, and to "feel enlarged ... by the success of teams representing the [community] to which they belong" (p. 150). When team colors represent not only a team, but also a local community, undressing expresses rejection of the social and cultural traditions of that community.

Silburn's act of undressing reveals streaking as a "costumed practice," having the same capacity as dressing to transform a participant's social and cultural identity. A streaker's nakedness is, writes Geoffery Kohe (2012, p. 197), a kind of "anti-costume." It strips him or her of visible signs of team allegiance, and marks him or her as the only neutral individual in an arena that is otherwise fiercely tribal. Nudity is irregular in a public arena, and in its contrast to the clothes of athletes and spectators, it acts similarly to fashion items, marking the wearer as an individual. Streakers can therefore, argues Kohe, "be viewed as fashionable beings" (p. 198). In any environment in which clothedness is the norm, undressing becomes a kind of dressing up.

Aside from being acted out within a sporting arena, streaking shares much in common with sporting activities, incorporating elements of competition and athleticism. Sporting conventions and traditions have been appropriated by the streaking community. Streakers compete for equivalent records to professional athletes, and share a similar sense of pride when achieving, for example, the world record for greatest number of streaks (currently held by Mark Roberts). "Inveterate" streaker, Roberts, set himself the goal of streaking at every known sport (Kohe, 2012, p. 205), setting himself a personal challenge that is equivalent to those of sportsmen.

Streaking also contains an element of sensation-seeking risk that makes it comparable with some extreme sports. Streakers exhibit tendencies toward "adventure seeking" and disinhibition, two forms of sensation seeking that are associated with extreme sports and excessive forms of social interaction (Goma-i-Freixanet, 2004, p. 187). Gunnar Breivik (2007, p. 169) identifies three categories of risk taking: "pro-social risk"; "anti-social risk"; and "ludic risk." Streaking may fall into all three of these categories, being primarily an example of "ludic risk," that is, risk taken for personal satisfaction. It may, however, be performed under the guise of "pro-social risk"—"risk is taken for the sake of others"—when

aligned with a social or political cause. In both cases, it is vulnerable to the label of "anti-social risk," as a form of rebellion that actively damages the reputation of a sport or its sponsors.

Streaking is gamified when it becomes a game of catch-and-chase with the authorities. Streakers seek (nonsexual) arousal through thrill of the chase, evading capture for as long as possible. Success is measured by how long the streaker is able to remain exposed, by outmaneuvering security personnel. Security and other game officials make their best efforts to catch and clothe the streaker, often approaching with outstretched garments and the aim of reclothing the naked body as quickly as possible. The infamous image of Christ-like Michael O'Brien, photographed by Ian Bradshaw at an England versus France rugby match in 1974, captures the moment in which a police constable shields O'Brien's private parts with his helmet, while an official rushes toward them with a long coat, preparing to drape it over O'Brien's naked body at the first possible opportunity (Selwyn-Holmes, 2009). At more recent sporting events, officials have raced toward streakers with towels (Hong Kong Rugby Sevens, 1994), blankets (State of Origin Game III, 2013), swathes of red cloth (Wimbledon, 2002 and 2006) or in one case, a floral-print bedsheet (One Day International Australia versus South Africa, 2014). Thus, streaking has become a competition against two sides with competing goals: the streaker, whose aim is to remain unclothed for as long as possible, and the sports officials, whose aim is to reclothe him or her as quickly as possible.

The temporality of exposure is vital in defining the streaking experience (the term "streaking" makes reference to the speed at which the action is carried out). Bryant and Forsyth (2005, p. 27) identifies streaking as a kind of bingeing, alongside other forms of "deviance compression." These are not the languid, strung-out stripteases of burlesque (see Chapter 2) but speedy "dashes" (Kohe, 2012) that must be performed in "an accelerated or compressed fashion" (Bryant and Forsyth, 2005, p. 27). One festival disrober interviewed by Shrum and Kilburn (1996, p. 430) expresses disappointment that the gesture is "over so fast," identifying that one of the goals of disrobing is to "stretch it out as long as you can." Success demands considerable athleticism, as streakers must outrun the professional sportsmen as well as security. They must sprint and leap their way across the sports field, evading attempted tackles, as exemplified by one teenage streaker at an American football match in Seminole High School, Florida, who managed to evade capture by outrunning campus security and leaping over two fences (Moye, 2012).

The streaker's wardrobe must be designed with speedy undressing in mind. Clothes must be selected or adjusted to permit quick release, or to grant the streaker better access to the pitch. Streakers tend to have more success when they, like professional sportsmen, choose clothes that are appropriate for their athletic activities.[5] A young streaker, Jacen Lankow, at a University of Arizona

versus UCLA football match in 2011 demonstrated the importance of an appropriately selected wardrobe, designed to enable unimpeded undressing. Despite heavy security at the edge of the pitch, Lankow achieved his intended streak with the help of a customized costume, designed to camouflage his intentions, and to permit speedy undressing. The costume closely resembled a referee's uniform, so that Lankow could infiltrate an unsuspecting crowd of players and game officials. Having made his way to the center of the field, he revealed himself as a streaker as he began to sprint while stripping his garments. Thanks to breakaway panels on his shorts and shirt, he was able to fully remove his disguise without interrupting the sprint. His carefully selected wardrobe abled him to complete his dash toward the end zone, and to succeed in stripping down to his Speedos before security were able to catch up (Stevens, 2011).

Lankow's actions reveal the strategies that must be employed in order to stay one step ahead of security, in times when sports organizations are increasingly prepared to defend their games from unwelcome displays of flesh. The streaker's wardrobe must act as a kind of camouflage, disguising the streaker as an ordinary fan until the moment in which his or her gesture of undressing reveals otherwise, thus delaying the response time of anyone who might prevent their undressing. Streakers might benefit from advice from quick-change artists, adapting their clothing for quick release. See, for example, David Maas' (2001) patent for "convertible costume construction," which enables "total removal … of a costume … by one or more rapidly disconnectable fastening means." When these disguises are also easy to remove, perhaps with the help of tear-away panels (like those of Janet Jackson's bustier), they reduce the time it takes to undress, and increases their chances of evading capture.

Players, police, security and other official personnel sometimes work as a team in their efforts to take down a streaker. Footage from a 2008 India versus Australia cricket match shows batsman Andrew Symonds throwing his elbow at a passing streaker's shoulder, felling him while police officers approach from all angles to encircle his felled body (Pandaram and Bibby, 2008).[6] In this way, professional athletes are often the first line of defense, using their superior speed and strength to bring the streaker to the ground. Typically, it takes just one sportsman to singlehandedly succeed in the tackle (Figure 4.2). The police or security officers are next to intervene, approaching from all directions so that the streaker is cornered on all sides. As they converge on the streaker, other officials approach with garments or other fabric to clothe the naked body.

Aware of the tough opposition that they will face on the pitch or field, streakers must carefully plan and execute their undressing. Video footage shot by friends of a streaker at a Detroit versus Cleveland football match in August 2013 records the tactical advice shared before he took to the field.[7] One friend advises on timing, and another on the route that he should take in order to best avoid

DEVIANCE AND DISRUPTION

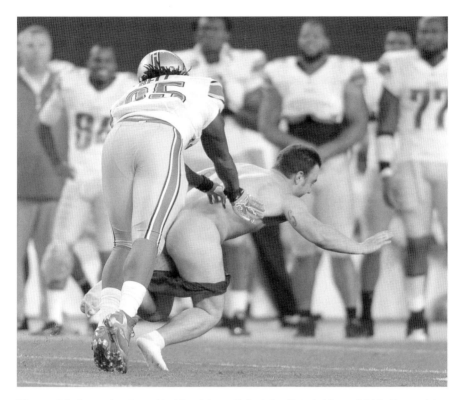

Figure 4.2 A streaker is tackled by Joique Bell of the Detroit Lions, 2013. Recognizing that he will have limited time before being apprehended, this streaker is already partially undressed when he leaps onto the field. Having received tactical advice to remove his boxer shorts while running, he finds, like so many other streakers, that it is impossible to sprint and remove underwear at the same time. Though he moves quickly enough to successfully remove his t-shirt, he is tackled to the ground before he can fully remove his underwear. Photo by David Dermer/Diamond Images/Getty Images.

security personnel and other officials. A third advisor recommends that he try to remove his boxer shorts while running, so that he may continue to outmaneuver game officials even during his act of undressing. These advisors share the role of coach, providing both tactical advice and motivation. While their advice proves largely successful, and the streaker is able to evade capture until he is almost fully naked, he is tripped up by a Detroit player before he is able to fully remove his boxer shorts (Figure 4.2).

When players engage a streaker, they maintain their roles as sportsmen, applying similar techniques as they would in play. When New Zealand rugby player Ruben Wiki tackled a streaker in a 2013 Warriors versus Broncos pre-season match, commentary from *The Crowd Goes Wild* (Fox Sports) responded by analyzing his tackle as they would an in-game defense. Some sportsmen go so far as to apply not only their sporting moves, but also the rules of their

game. During a friendly soccer match between Mexico and Bosnia-Herzegovina in Atlanta in 2011, one sportsman dutifully adhered to the rules of the game while confronting a streaker. Footage on YouTube captures the moments when the streaker nears the goal and the goalkeeper comes to meet him. The goalkeeper attempts to block the streaker's dash as he would block a goal in play, and then pursues him only as far as the edge of the penalty area, where he passes responsibility on to others. The line that bounds the penalty area marks the end of the goalkeeper's handling of the streaker, just as it would normally mark the end of his handling of the ball.

Legitimizing and commodifying public disrobement

Even outside of the sporting arena, streaking continues to present itself as a sport. Elizabeth Herring (2008, p. 7) observes that on college campuses, streaking is commonly a group activity. She hypotheses that college streakers present themselves as part of a "streaking team," thus inviting onlookers to associate their actions with team sports. This perception is furthered by more explicit reference to sporting conventions, including the employment of sporting terms in the description of their activities. Streakers at Hamilton College, for example, label themselves the "Varsity Streaking Team" (p. 8).

Both Herring and Kirkpatrick argue that streaking on college campuses has attained a degree of legitimacy as a kind of "sanctioned deviance." This, Herring (2008, p. 13) suggests, arises in part because of its perceived connection to sport, or, according to Kirkpatrick (2008, p. 14), with "youthful innocence." Gestures that would, in other circumstances, be perceived as "mere debauchery" may become embedded in wider ritual practices, so that they are legitimized and normalized (Shrum and Kilburn, 1996, p. 423). Shrum and Kilburn (1996, p. 425) argue that otherwise deviant gestures may be legitimized "in a sacred context" by occurring within or alongside "preexisting ritual practices," or when sanctioned by an authority or majority.

Shrum and Kilburn (1996, p. 424) observe "displays of exhibitionistic flashing" at New Orleans' Mardi Gras festival. These are "individual acts of disrobement," which occur as part of a "ceremonial exchange ... between strangers." Participants of both sexes briefly reveal body parts in exchange for strings of plastic beads, handed over by other "street revelers" or thrown from balconies above (p. 425). In response to an offer of beads, female participants generally expose their breasts, while male participants tend to expose either their genitals or buttocks (p. 436). These exposures are brief, usually only lasting for a few moments, and the rest of the body remains covered. If the initiator is satisfied by the display, he or she hands over a string of beads, or sometimes offers

the recipient a choice from a selection of different strings of different lengths and colors. Sometimes a bargaining process occurs, in which participants negotiate for a more interesting set of beads before agreeing to disrobe. The exchanges observed by Shrum and Kilburn legitimize public exhibitionism by placing it within a structured ceremony. The gesture has become an accepted part of a cultural exchange through adherence to a precise set of rules, and as a result of a chain of reciprocal gestures. Reciprocity lures participants "into an alternative behavioural code" in which abnormal conduct becomes acceptable (p. 431).

The exchange is often triggered by clothing, which signifies an individual's willingness to participate. Revelers can be identified as willing by the style of their clothing or the presence of beads around their neck, implying that they may have already engaged in a previous exchange (pp. 439–440). In other contexts too, certain garments seem to be an invitation for denuding. Where clothes differ from the conventional dress of a society or setting, they inevitably invite questions about the motives for wearing such garments. Masks and veils in particular are "known to have no inside." Deprived of the visual information that they would normally use to identify the wearer, audiences seek to solve the mystery: to "peer behind the mask" (Jones, 1971, as cited in Napier, 1986, p. 9).

Mardi Gras exposures are further legitimized by their frequency in a particular time and place. This practice is relatively commonplace within the context of Mardi Gras and on specific streets in the French Quarter, and so within this context it is considered socially acceptable.[8] Shrum and Kilburn's study records that refusals to disrobe are "extremely rare." Indeed, on the last three days of their study, the ratio of disrobement to refusal was 14 to 1 (p. 434). The low refusal rate further legitimizes the actions of the majority who do agree to expose themselves. If a gesture becomes normalized, as Shrum and Kilburn's study seems to suggest in this case, it ceases to be deviant and becomes a legitimate response to the context.

There is no evidence for this form of ritual disrobement occurring at Mardi Gras before the 1970s, so it cannot be said to have become legitimized through historical tradition (p. 426). Instead, revelers have appropriated elements of preexisting ritual "resulting in the innovation of new ritual paradigms," in particular the rituals of capital exchange. The exchange of a glimpse of flesh for a string of beads "reflect the routine transactions of commercial life" (p. 425). Before this reciprocal exchange was established, disrobement was uncommon even at Mardi Gras. The practice of exchange, leading to the accumulation of cultural capital (beads) by those who disrobe, links the gesture to "symbolic wealth" and lessens associations with deviance (p. 446). A complex system of exchange and negotiation has evolved, in which some beads have more value than others, and participants make assessments of the competing offers before deciding to engage with one offer over another (p. 448).

All of these examples of streaking and flashing are further legitimized by the fact that they occur out in the open. The results of Shrum and Kilburn's survey reveal that Mardi Gras exchanges occur most often during daylight, with two-thirds of the incidents of disrobing occurring before 6 pm (1996, p. 438). The timing of these bodily exposures may account for their legitimacy, by further distancing them from the nighttime activities of strip-clubs and burlesque bars that line some of the streets in the French Quarter (p. 429) and from the shame or dishonesty that is implied by stealth and concealment. At Wing Bowl, a chicken wing eating competition held annually in Philadelphia, the "Can Cam" goes further in making visible the act of exposure, not only illuminating it but also broadcasting it to the rest of the arena. There is an apparent honesty and legitimacy to such visible events that distances them from deviant acts that occur in the shadows.

At Wing Bowl, flashing is sanctioned and encouraged by the event organizers. The event, drawing up to 25,000 spectators, is a commercially sponsored eating contest that is described as a "spectator support" (Burton, 2014). The rounds of wing eating are punctuated by interruptions from the Can Cam, a mobile camera that scours the stadium for female spectators and broadcasts their image on a big screen. The camera is specifically focused on these women's torsos, and with the aim of provoking them to expose their breasts. Some wear brightly colored bras for the occasion, and others willingly expose bare chests. A few of the camera's subjects are initially reluctant, but eventually relent when heckled by the audience (Burton, 2014). Here, as in Mardi Gras, those who refuse are in the minority, and bodily exposure is so normalized that if the crowd's expectations are not met the nonparticipant is subjected to aggressive disapproval.

Such flashes of nudity are now, argues Kohe (2012, p. 207), "constrained and sometimes managed by the sporting establishment or by commercial enterprise." Temporarily unclothed bodies are "commercially valuable" (Kohe, 2012, p. 207). They are the main attraction for many spectators, to whom the wing-eating contest is a sideshow. The exposure of breasts is authorized by the organizers as an integral part of the event, and anticipated by commercial sponsors whose advertisements will appear on screen between live shots from the Can Cam. Vodafone have similarly profited from encouraging spectators to streak at sports events. In 2002 they agreed to pay the fines of anyone who would run naked onto the pitch at an Australia versus New Zealand rugby match in Sydney, wearing only a Vodafone logo. Two streakers accepted their challenge, feeling that their actions were sanctioned, and effectively sponsored, by Vodafone (McCusker, 2005, pp. 84–85). There is enough commercial interest in the practice to financially sustain the antics of some high-profile streakers. Mark Roberts is now considered a "professional streaker," having been sponsored to the tune of a million US dollars to streak at the Super Bowl in Dallas, Texas, in

2004 (Graham, 2015). Roberts describes his actions in terms of financial risk. For each event, he must weigh the cost of travel, event ticket and possible fine, against the money offered by his sponsor.[9]

This commercialization of the practices of flashing and streaking, via the commodification of the naked body, seems to undermine the efforts of those streakers whose actions are designed to protest the "hypercommodification" of sport that was identified earlier in this chapter (Giulianotti, 2002, p. 27; Meir, 2009, p. 23). It also seems at odds with the arguments made by activist groups to legitimize the exposure of their bodies. FEMEN and other activist groups, such as PETA (People for the Ethical Treatment of Animals), are unafraid to exploit others' readiness to associate all nudity with sexuality. These protestors do not typically view their own actions as self-exploitation, but rather a savvy subversion of the striptease. They present their protests as cunning exploitation of a male audience's inability to focus on other things while in the presence of erotic gestures.

PETA's *State of the Union Undress*, a series of videos shot between 2007 and 2010, uses the promise of nakedness to provide viewers with a motive for watching the charity's sponsored messages. The videos feature attractive, smartly dressed PETA supporters, delivering a formal address against the backdrop of an American flag, interspersed with footage of applauding senators (Lunceford, 2012, p. 15). As each speaker makes statements about corporate mistreatment of animals, she gradually strips her garments, until naked. The striptease is a delaying tactic, providing motivation for the viewer to remain transfixed until the speaker has delivered her message. The tactic ensures mutual satisfaction, in which both the viewer's need to view the woman's body and her own need to express her protest in its entirety are satisfied.

PETA have been criticized for undermining the actions of other protest groups by prioritizing the rights of animals over those of humans in their willingness to commodify the female body for their cause (Torres, 2007, p. 108), and in doing so "layering … one oppressive system on top of another" (Adams, 2011, p. 268). Critics of PETA's methods argue that the videos trivialize the organization's mission, paint pornography as a lesser evil than the mistreatment of animals (p. 267). Further direct references to pornographic undressing appear in *Milk Gone Wild*, a parody of the *Girls Gone Wild* franchise, in which young women are persuaded to lift their shirts for a camera (p. 268). Viewers' expectation that this disrobement will result in the exposure of breasts is disrupted when the women instead reveal prosthetic udders.

Though PETA embrace the male audience's erotic gaze, when women employ nakedness in protest it is more frequently to oppose an aspect of patriarchy, employing their bodies in "sacrificial style" in the form of a "shaming mirror" (Barcan, 2002, p. 6). Their motives make it necessary to distinguish the actions of groups like FEMEN and PETA from those of sports streakers

and Mardi Gras flashers, whose acts of undressing are defined in part by their triviality. Although many streakers, flashers and mooners do make efforts to align themselves with legitimate causes, or to gain acceptance via commercialization, their acts of undressing are largely received as trivial and inconsequential. FEMEN view their activism as on a par with peace protestors, and their war against oppression can be aligned with resistance movements and campaigns for peace. In this context, undressing is often intended and accepted as legitimate political protest, or even, as the next chapter will show, as a noble gesture of resistance.

5
MAKE LOVE, NOT WAR: CONFLICT, RESISTANCE, AND THE REVOLUTIONARY BODY

Human conflict is predicated upon the relational power of opposing parties. While power may often stem from control of tangible resources, it is also exercised symbolically, through bodily gestures. Foucault's (1977, p. 136) writing on subjugation equates power to control of the body. In times of conflict, dominance is asserted through actions that demonstrate control over the "docile" bodies of others. Conversely, to evidence control over one's own body in the face of an enemy is to maintain control over one's dignity and identity.

Clothes offer the wearer the means to regulate the body's physical comfort, and to control an observer's perception of his or her identity. Control of clothes is therefore an extension of control over the body. "From this perspective," writes Mario Perniola (1989, p. 237), "nudity is a negative state, a privation, loss, dispossession." Humans distinguish themselves from beasts and our less evolved ancestors in part by our wearing of clothes. The perception that nakedness equates to savagery makes denuding an effective "tool in the assertion of … domination" (Barcan, 2004, p. 72). In a patriarchal Western culture, men whose clothes are removed are placed "in a position of subjugation" (Whitehead, 2014, p. 28), and women too, are dehumanized when stripped of their garments, either objectified or rendered vulnerable and wretched (Barcan, 2004, p. 134).

Nakedness has been imposed (through persuasion and force) to reinforce the perception of natives as primitives. Among European and American slave traders, nakedness was imposed to keep perceived savages in their place, as a sign of their status as chattel. For those at the very top of human hierarchy, denuding is a means of stripping signs of power and status, as when regalia are torn from those condemned to execution (see, for example, Robert Wynkfield's descriptions of the execution of Mary Queen of Scots, 1587). Prisoners of war are often denuded, stripped of all possessions including their

clothes. Wars of the twentieth century saw denuding used as a demoralizing tactic by all sides (Hastings, 1987, p. 300; Rowley, 2002, p. 277; Waterford, 1994, p. 232). Dehumanizing practices of denuding were revived in post-9/11 conflicts (Krammer, 2008, pp. 73–74). In 2003, a working group at the Pentagon recommended "removal of all clothing ... by military police" with the aim of creating among unlawful combatants "the feeling of helplessness and dependence" (Jeffreys, 2009, p. 68).

Conversely, wartime undressing can be a gesture of defiance. While denuding may make individuals appear vulnerable or enslaved, when undressing is carried out voluntarily these same meanings may exist, but rather than diminishing the power of the undressed individual, they act in his or her favor. If, as Turner (2012, p. 486) argues, clothes are a way of "socialising individuals, that is, of integrating them into the societies to which they belong," then undressing can express discontent with social norms, or the system that imposes them. Vulnerability becomes strength, and the publicized impression of enslavement becomes a vital tool in the march toward liberation. It is this paradoxical power of the fragile, exposed body that makes stripping a popular means of protest (Carr-Gomm, 2010, p. 12). Protest undressing can "embody the dialectic between power and vulnerability, defiance and risk" (Sutton, 2007, p. 144).

Robert Helvey (2004, p. 153) lists "protest disrobings" among other symbolic public acts of nonviolent protest. Like many of the streaking and mooning activities described in the previous chapter, protest undressing has the power to undermine authority by presenting observers with a sudden, unpredicted image of nudity. It demonstrates the emotional resolve to carry on in the face of aggressive or oppressive forces. These are not "direct attacks on the opponent," but rather, a deliberately alternative method of engaging in conflict. The silent, nonviolent gesture is a tactful alternative to aggressive resistance, which may, by demonstrating contrast to the violence of an oppressive regime, "expose the actions of the regime to public scrutiny ... and attempt to persuade others that change is needed" (Helvey, 2004, p. 35).

The refusal to disrobe may function as powerfully as undressing as a means of protest. There are situations in which undressing is sanctioned or even demanded. In these settings the roles of dress and nakedness are reversed, and nakedness represents passive conformity rather than active defiance. In such situations, the refusal to undress is a demonstration of dissent. Diaries of imprisoned conscientious objectors during World War I record how prisoners refused to disrobe in the hope of saving themselves from compulsory cold showers (Mason, 1919, p. 204). Civil rights activists, convicted for using "whites only" bathrooms in Mississippi in 1961, beginning their jail sentences, refused to undress in order to save themselves from the striped uniforms that would mark them as convicted criminals (Tischauser, 2012, p. 139).

Gestures of defiance

Although man has developed war machines that surpass the abilities of the human body, there is a perceived political and emotional strength in the presence of human forms. In political protest, the naked body can symbolize "raw power" and "fearlessness" (Carr-Gomm, 2010, pp. 11, 13), and can oppose the power of military foes (Sampaoi, 2013). Power is opposed not simply by the presence of people, but by emphasis on the vulnerability of the individual in contrast to the might of an opposing army. It is with this intention that "nudity that is strategically employed as a mode of social and political action" (Lunceford, 2012, p. x). This extends not only to the state of nakedness, but also the act of becoming naked. It is the removal of clothes—making a show of the act of undressing—that is meaningful in these contexts. Stripping down to bare flesh demonstrates "dramatically enacts protesters' willingness to put their bodies on the line" (Sutton, 2007, p. 144).

Undressing is a resistance to everything that clothing represents. Matthew T. Jones (2009) presents the relationship between the clothed and unclothed body as a metaphor for the "tension between culture and nature." While nakedness is an "essential" human state, that predated dress (Badiou, 2005, p. 67), clothes can represent artificial or constructed aspects of identity that may be considered to be imposed by culture and civilization, including, most notably, class structure (class differentiation being one of the driving forces of fashion). "The act of removing one's clothes can help strip away symbolic identity and work roles, allowing one to become merely a body" (Baumeister, 1991, p. 38, as cited in Jones, 2010). Artificially constructed signifiers of culture, profession and class may be removed along with clothes, potentially rendering us all equal in our "common humanity" (Sutton, 2007, p. 146).

Power relies on pillars of support and obedience, and so forms of disobedience, most notably strategic nonviolent protest, help to undermine the power of authorities (Helvey, 2004, p. 19). In societies that prescribe the wearing of clothes in public, the states of dress and nakedness can express either adherence to or rebellion against the social contract. Through undressing, it is possible to "step outside of the artificial sanction of prescribed social relations and demonstrate the individual has the potential to rise above any system of social control merely by rejecting its premise." Jones' proposition that it is possible to "rise above" a social system suggests that dominant social values are only powerful if they are adhered to. It is for this reason that naked protest is meaningful. Bret Lunsford (2012, p. 3) observes that nakedness has particular power in antiwar demonstrations. He cites an antiwar campaigner who proposes that, through nakedness, she is "disarmed." This protestor argues that "naked people ... can never make war," observing that the outcome of war is usually dictated by inequality, with victors being those that hold the most power.

Stripping away this power by removing weapons and uniforms, both sides are made equal, and conflict cannot occur.

This protestor's views stem from the idea that nakedness renders everyone equal, and that equality resolves conflict. In almost any protest, inequality draws attention to perceived injustices. The vulnerability of naked flesh contrasts so severely with the uniformed and armed body of a soldier that it highlights the inequality of the solder–victim relationship. Photojournalist Ladislav Bielik photographed resistance to the Soviet tanks that occupied Czechoslovakian streets in 1968, in *The Forceful End of the Prague Spring*. The image captures the moment when a protestor rips open his shirt to reveal his bare chest, and presents it defiantly to an approaching tank. His shirt rending is equivalent to the gesture of a raised fist, expressing a pent-up anger so overwhelming that it can no longer be contained internally, and is forced out of the body in the form of a visible gesture. When a bare chest is pressed against a canon, as in Bielik's photograph, the stark inequality seems unfair. The conflict is revealed as unjust, with the opponents clearly presented as victim and oppressor.

Such gestures appear to transform the sight of a fragile, exposed body into a show of raw force, with the power to overcome the might of opposing forces. In Eugène Delacroix's *La Liberté guidant le people* (see Figure 5.1), the robust figure of Liberty leads revolutionary forces onward with one breast exposed.[1] In these same wartime scenarios, nudity, or progress toward nudity, can be employed to signify active or aggressive resistance. The nude body is primal, animalistic, and it is not uncommon for it to be accompanied by bared teeth or a war cry. These are aggressive displays of the primal human, stripped of all material signs of civility. The savage body, with its "potential for wildness" (Barcan, 2002, p. 4), is dangerously unpredictable, expressing aggressive resistance. Here, the naked body conveys the message that resistors will not give up without a fight.

Nude and stripping protests have become "methodologies of the oppressed" (Sandoval, 2000). Undressing is a tool that is at almost any protestor's disposal: a last line of defense that is almost universally accessible. It is an act of defiance that is still available even to those who are disempowered by low status, by lack of funds, or simply by ordinariness (Barcan, 2002, p. 7). Mexican farmers protesting government appropriation of their land in 1992 turned to naked protest as a last resort, explaining their action by saying "we are stripping because … we don't have money to buy an ad in the news … we have no other arms, all we have are our bodies" (Carr-Gomm, 2010, p. 116).

Such protests have predominantly been recorded as static images, which capture only a single moment, not a gesture that unfolds over time. In these static photographs, subjects are defined by their nakedness, rather than the undressing that occurred in the moments before. Those unrecorded gestures are, in many cases, more meaningful than the naked body that results. Although

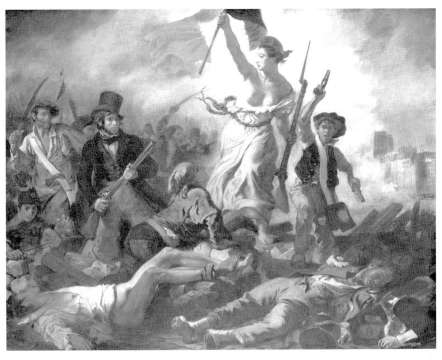

Figure 5.1 Eugène Delacroix (1830), *La Liberté guidant le people*, oil on canvas, 260 × 325 cm, Musée du Louvre, Paris. Liberty is represented as a "working-class goddess," with an exposed breast, "denuded by the exertions of the moment" (Hollander, 1988, p. 202). Photo by Culture Club/Getty Images.

it is the naked body that is photographed, the subjects' intentions are often more effectively expressed in the ways in which garments are removed. The stability of clothing makes the protestor an apparently quantifiable threat. By contrast, the gesture of undressing makes dress an unstable state, and so the undressing protestor presents his or her actions as unpredictable. There is power in this unpredictability.

By demonstrating a freedom and ability to undress, the protestor marks his or her power. While nakedness succeeds in creating spectacle, attracting the attention of those who may be persuaded to support the protestor's cause, the state of nakedness alone does not complete expressions of defiance. Meaning is drawn from the knowledge of how, and at whose hands, the protestor became naked. Images of naked protestors succeed only when audiences possess the knowledge that the protestor voluntarily enacted the transition from dress to nakedness. The body is composed of form and capacities (Patton 1998, p. 66) Thus, the body, dressed or naked, is endowed with the capacity to take action to change its state of dress. It is not the state of nudity, but rather the exercising of the power to undress oneself that symbolizes power. Power is evidenced in one's ability to choose one's state of dress, to maintain control of one's body, and is demonstrated in the action of public undressing.

For FEMEN, nakedness serves as the primary evidence of an act of undressing that in turn signifies their journey from oppression to liberation. Likewise, for other feminist protestors, control over the body is expressed by replacing the experience of denuding (literal or symbolic) with the act of undressing voluntarily. Once the act of undressing has been carried out, the decision to remain naked prolongs messages about how or why the body has been stripped, ensuring that the memory of their oppression or mistreatment lives on.

Female protestors, who use their bodies as an invitation to "make love not war," consciously exploit their own sexuality to distract and disarm. The recent conflict in Iraq provoked displays of breasts as "weapons of mass distraction." Such methods present "love" (and, by extension, "sex") and "war" as two mutually exclusive extremes. This message is dependent on erotic readings of the naked female as a body prepared for lovemaking. When conflict directly involves the sexual abuse of the female body, self-objectification is a particularly meaningful tool of protest. Sexual abuse is a crime evidenced by the state of the stripped body. Protesting naked after a rape, the victim directly refers to the way in which her body has been rendered naked. FEMEN's protests against rape have presented observers with a body that is voluntarily naked (emblazoned with the slogan, "no means no"), asserting their rights to undress on their own terms.

Deepti Misri (2011, p. 603) explores naked female protest in India via Mahasweta Devi's *Draupadi* (1988). Devi's novel features the rape of the titular revolutionary while in military custody. After her rape, Draupadi refuses to put her clothes back on, and in an act of defiance faces down her rapist who is reduced

to "a state of terrified paralysis usually associated with the victim" (Misri, 2011, p. 603). Her refusal to reclaim the clothes that have been stripped from her body forces Draupadi's rapist to confront his actions. Her prolonged nudity preserves the memory of her denuding so that it cannot be "covered up" as clothes cover up the body.

Whether they disrobe in spite of social and legal expectations of dress, or fight to retain their clothes in spite of overwhelming pressure to disrobe, all of these protestors seek to control the space between body and garment so that they may also take control of their own fate. The refusal to undress has been employed with almost identical aims to protest undressing. A refusal to remove garments can express defiance where undressing would not, thus revealing that power does not lie directly in the act of undressing, but rather in any challenge to cultural expectations about the presentation of the body. The Tanakh (Esther 1, verses 11–17) tells the legend of Queen Vashti, who refuses to disrobe for the pleasure of King Ahasuerus and his entourage. Brown Crawford (2002, p. 61) identifies Vashti's resistance as a refusal to be objectified that had the potential to empower all women in her husband's kingdom. Her actions have resulted in her being labeled a proto-feminist by contemporary critics (Kaplan, 2013), and comparable to the actions of naked feminist protest groups such as FEMEN. Both FEMEN's undressing and Vashti's refusal to undress recognize that taking control of their state of dress asserts their rights of ownership over their bodies.

Anasyrma: Proof, shock, and awe

The gesture of ripping or lifting a garment permits a sudden transition from compliance to defiance. Anasyrma, the gesture of skirt lifting to expose the genitals, has historically been used in order to avoid conflict by warding off the enemy (Dexter and Mair, 2010, p. 40), presenting the female body not as an erotic object but as an intimidating Other. The Irish legend of Cú Chulainn, for example, describes how, when he turns against his uncle King Conchobor during a bout of youthful revolt, the King sends out a company of women to "expose … their boldness to him" (*Taín Bó Cuailnge* 1186–1192, cited in Dexter and Mair, 2010, pp. 38–39). The young warrior is so intimidated by their bold gestures that he retreats.

Jean de La Fontaine's tale of anasyrma reveals that the power of the gesture may arise from observers' unfamiliarity with the exposed female form. La Fontaine's "The Devil of Pope-Fig Island" (published in *Tales and Novels*, 1674) features an anasyrma as part of a deception that wards off the devil. La Fontaine's fable describes how a farmer's wife saves her husband from a confrontation with a demon who has sworn to return to claim his land. The wife, Perretta, hopes to convince the demon that if he were to engage her husband

in combat he would surely lose. She fabricates tales of her husband's savagery, and lifts her skirt to reveal the horrific "gash" between her legs, presenting it as evidence (see Figure 5.2). Believing the woman's "wound" to have been inflicted by her husband's terrible claws, the demon imagines the farmer to be even more monstrous than him, and retreats in fear. The verse that tells of her deception reads in English translation (1896) as follows:

> Perretta at the house remained to greet
> The lordly devil whom she hoped to cheat.
> He soon appeared; when with dishevelled hair,
> And flowing tears, as if o'erwhelmed with care,
> She sallied forth, and bitterly complained,
> How oft by Phil she had been scratched and caned;
> Said she, the wretch has used me very ill;
> Of cruelty he has obtained his fill;
> For God's sake try, my lord, to get away:
> Just now I heard the savage fellow say,
> He'd with his claws your lordship tear and slash:
> See, only see, my lord, he made this gash;
> On which she showed:—what you will guess, no doubt,
> And put the demon presently to rout,
> Who crossed himself and trembled with affright:
> He'd never seen nor heard of such a sight,
> Where scratch from claws or nails had so appeared;
> His fears prevailed, and off he quickly steered …

Jones (2010) argues that any exposure of the genitals may potentially be sexualized, since sexual practice is a context in which genitals operate, but La Fontaine's tale is one of many that bypass directly erotic interpretation in favor of other readings. With his ignorance of the female anatomy, the devilish imp does not possess the knowledge or experience to make a connection between Perretta's "gash" and sexual activities. He reads it instead as a wound—and evidence of a man's brutality.

Though it would be remiss to ignore the inference that Perretta's "gash" is the consequence of sexual violence, varying responses to anasyrma illustrate that there may be any number of readings that are not primarily sexual. Contemporaneous sources have seen anasyrma, when performed by women, as a virtuous gesture when used to prevent conflict (Carson, 1994, p. 28). By contrast to naked protest, anasyrma is frequently presented as fundamentally "hilarious" (Caden, 2009, p. 114; see, also, Rosen, 2007, p. 49). Dexter and Mair (2010, p. 37) argue that the power of anasyrma is often its comedy. She identifies many historical examples in which the performer of an anasyrma gesture

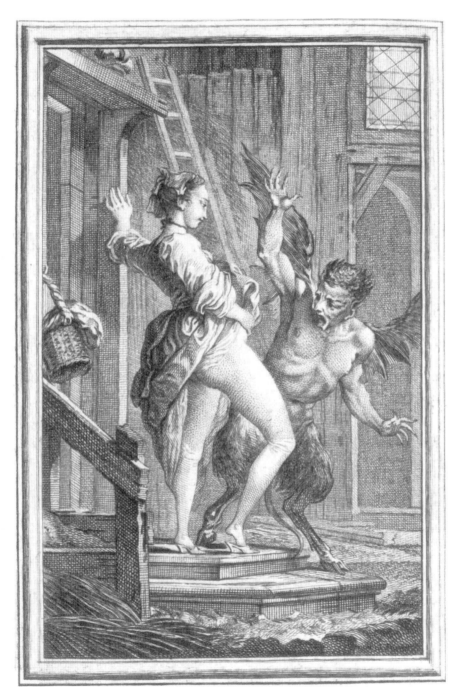

Figure 5.2 Charles-Dominique-Joseph Eisen (1762), illustration for Jean de La Fontaine's "The Devil of Pope-Fig Island," depicting Perretta's skirt-lifting gesture that provides false evidence of her husband's brutality.

achieves her goals by provoking laughter. Anasyrma is also sometimes referred to as the "Baubo gesture," in reference to the *Homoeric Hymn to Demeter* that tells of how Baubo lifts her dress in order to cheer the grieving Demeter with the humorous site of her depilated genitals, which resemble a child's face (Foley, 1994, p. 46). Dexter and Mair suggest that Baubos' tale is founded on earlier Egyptian mythology, in which Hathor, the goddess of love and war, lifts her skirts to provoke laughter from her father, the sun god Ra. These comedic performances separate anasyrma (and arguably other forms of undressing) from naked protest, which rarely, if ever, intends comedic expression.[2]

Dexter and Mair propose that Hathor's anasyrma, while comic, also serves a deeper purpose of providing "knowledge of the possibility of birth and creation" (p. 36). Anasyrma, in Antiquity, was strongly connected to fertility, and operates as evidence of the female's ability to create and regenerate, and this meaning has continued to make it an effective tool in long-term conflict. Legend has it that Caterina Sforza Riario, Countess of Forlì (1463–1509), refused to surrender the stronghold of Rocca di Ravaldino to rebels despite knowing that her children were held hostage and would likely be executed for her continued resistance. She rebuffed the rebels' threats by lifting her skirts to reveal her female body, and crying "I have the mold to make more!" (Alexander, 1974, p. 69). Sforza's flashing of pudenda was proof of the power of her womanhood. It evidenced her ability to create new life, to repopulate her castle and maintain her lineage even after the death of all her existing children.

Anasyrma achieves its goals in part by acting as undeniable proof of the actor's biological sex, and his or her unashamed pride in that sexual identity. Historically, individuals, male and female, have taken it upon themselves to prove or emphasize their sexual identity through this form of undressing. Similar gestures are performed as defensive or aggressive proof of masculinity. Randall Wallace's interpretation of William Wallace's revolt against the English, *Braveheart* (1995), features a war cry punctuated by lifting of kilts at the Battle of Stirling Bridge. Michael D. Sharp (1998, p. 254) reads this retelling of Wallis' story as an expression of "conflict between competing masculinities" of England and Scotland. England, represented by Prince Edward, whose homosexuality is "constructed as a sign of his political ineptitude," faces Scotland, represented by Wallace, whose "heterosexual desire is in many ways the foundation of his patriotism" (pp. 256–257). These two conflicting masculinities are expressed in the body. Prince Edward's homosexuality is so "legible" in his appearance and gestures that Longshanks fears that his presence in battle would undermine the strength of his army. In contrast, the Scots' anasyrma, as evidence of their masculinity, is an "assertion of phallic authority" (p. 258).

Sharp presents the gesture as particularly necessary to combat the perception among the film's audience that the kilt compromises masculinity. The fully clothed body, despite the "valiance and bravery" of its wearer, does not provide sufficient

evidence of Wallace's masculinity. To audiences identified by Sharp (1998, p. 258), the kilt is read as ambiguous in its similarity to a skirt, thus necessitating exposure of the body beneath as proof of its authentic, biological state. Clothing, despite being a primary indicator of gender, conceals those parts that provide unquestionable evidence of an individual's biological sex. Clothing may provide dishonest messages about the wearer's sex, and so the lifting of a skirt may equate to unmasking.

The gesture of skirt lifting is recorded in numerous relics from antiquity, and in particular one variation, the *hermaphrodites anasyromenos*, which are also used to confirm the presence of masculine parts on an otherwise feminine body (Szepessy, 2014, p. 48). In these statues and mosaics, the upper half tends to be clothed, and apparently female. The face is soft, the garments are feminine, and the curves of breasts are visible through delicate cloth. The skirt is typically raised to the waist, revealing male genitals (often erect), so that the clothed half appears female, and the undressed part appears male.

Sequences depicting the unexpected exposure of genitals, as proof of an individual's gender, persist in film. Frances Bonner (1998, as cited in Barcan 2004, p. 98) discusses "exposure shots," in which anatomical exposure offers proof of a cross-dressing character's true gender. Perhaps the most notorious of these is the reveal in Neil Jordan's *The Crying Game* (1992). The film's transsexual character, Dil, is presented as an object of male desire. Throughout the film, the character is constructed as female through her wardrobe and gestures, and the narrative techniques of the film position her as the subject of the male gaze (Jordan, pp. 188–189). It is only when her would-be lover, Fergus, slides off her robe to reveal a penis that he and the audience discover that she is biologically male.

Memorializing the undressed

The fight to maintain control of one's state of dress, or to take control of the body of another, can be a prelude to execution. For innumerable victims, denuding or undressing is the final experience of war, marking the moment at which they lose the last shred of control over their bodies. As World War II unfolded in Europe, prisoners and resisters became gradually aware that their denuding would inevitably precede their deaths, and were motivated to resist denuding to preserve both their dignity and their lives. Records tell of holocaust victims' refusal to undress so that they might retain their dignity until the very moment of death. SS-Oberscharfuhrer Schillinger was killed by a Jewish prisoner after she grabbed his gun while resisting attempts to undress her (Atkins, 2009, p. 70). In other cases, the gesture has failed to save victims but succeeded in preserving their dignity. For one young woman, Liza Perkel, the refusal to undress was the first gesture in her violent resistance against an undignified execution. Although

Perkel did eventually meet her death at the hands of the Gestapo, it was not before she had injured several executioners in her struggle to remain clothed (Gekhman, 2002, p. 34).

When allied troops entered warehouses in Auschwitz in 1945, they encountered immense piles of shoes and clothes that had been discarded after their wearers were forced to undress. At the moment the liberators entered, and confirmed that the camp was a site of tragedy, the pile ceased to be a trash heap and transformed into a vast ready-made memorial. The pile has since been divided and redistributed to several museums including Auschwitz-Birkenau State Museum and the US Holocaust Memorial Museum in Washington, DC.

The significance of undressing in times of conflict—voluntary or involuntary—is evidenced by the use of empty clothes and shoes in the numerous memorials to casualties of war and disaster. Such memorials point directly to the acts of undressing that preceded tragedy. Victims are remembered through the clothes that they left behind, having been separated from them before, or at the moment of death. Personal artifacts left behind by the missing and deceased have become "part of the material culture of war" (Saunders, 2002, p. 178). Clothes and shoes, by virtue of their recent proximity to the missing body, are compatible with "materialist ... modes of mourning" (Doss, 2008, p. 40). Empty clothes can be an invitation "to mourn the loss of the wearers" (Kalpan, 2007, p. 144). Empty shoes in particular, when employed in memorials, reference a long historical association between shoes and the death of the individual who once wore them. As in Christian Boltanski's series of black and white photographs, *The Clothes of Francois C.* (1972), in which empty children's garments are presented in tin frames, clothes without bodies can have what Ernst van Alpen (2001, p. 64) identifies as "the Holocaust-effect." Boltanski's works are described as "portraits"—indexical of a human subject—and the tragedy of the wearer's disappearance is such that one cannot fail to imagine their identity, and their fate.

The piles of clothes and shoes that were left behind at Auschwitz and Dachau give us a sense of the thousands of victims who once owned them. For many of the unfortunate victims of the holocaust, internment at concentration camps commenced with undressing. Inmates were stripped of their clothes before being given identical striped uniforms (Feldman, 2008, p. 121). For those who were destined for the gas chambers, there were designated spaces for the final act of undressing, including a designated "undressing room" in crematorium IV at Auschwitz, where prisoners were led to believe that the purpose of their undressing was to prepare for bathing (Gurtman and Berenbaum, 1994, p. 225). The loss of their clothes marked the final moments of their individual identities, and the first step toward anonymity. This loss of identity, and eventual loss of life, is memorialized in the clothes that remained when the camps were liberated and were later transported to

holocaust museums around the globe. These empty garments speak of the nonexistence of the people who wore them, and in many cases are witnesses to the traumas that they suffered.

Layla Renshaw (2010, p. 47) identifies three categories of victims of tragedy: "the buried body; the missing body; and the disappeared person." The latter of these—the missing body and the disappeared person—necessitate the use of a material substitute. The many large-scale tragedies of the twentieth and twenty-first centuries left innumerable victims missing and deceased. In many cases, bodies are never recovered, forcing mourners to substitute "ritualized objects … as touchstones, material artifacts that can provide some kind of corporeal presence to mediate the absence of a loved one" (Sturken, 2004, pp. 312–313). Surviving artifacts become "linking objects," connecting the bereaved to the absent victim (Sapikowski, 2012, p. 291). As "witnessing objects," these artifacts "function simultaneously as primary evidence and as an incisive signifying device" (Williams, 2007, pp. 31, 29).

Shoes, perhaps more so than other possessions, continue to express their owner's identity even when removed and left behind. Shoes stretch to fit the feet (Mackie, 2008, p. 2), and over time become so "shaped to the individual that they cannot be worn by another" (Nash, 2013, p. 288). Thus, a pair of shoes seems to be a "personal monument," having an inextricable connection with an individual wearer. Holocaust museums in particular display shoes among other primary artifacts as "tangible proof in the face of debate about, and even denial of, what transpired [during the holocaust]" (Williams, 2007, p. 25). Public fascination with the shoes of holocaust victims began, posits Jeffrey Feldmen (2008, pp. 122–123), when a child's shoe was introduced as evidence at the trial of Adolf Eichmann.[3]

Orchestrated violence such as that carried out during the holocaust not only aims to destroy but also to erase all evidence of the destroyed. There was no documentation to list the identities of those buried, for example, in the mass graves of Bergen-Belsen. Of the camp's estimated 80,000 inmates, fewer than half have been named. Commandant Josef Kramer's "last criminal act" was "the vanishment of tens of thousands of names" (Thaler, 2008, p. 200). In the face of such systematic erasure, material evidence is precious. Through conservation of their belongings, memorial museums recover and preserve victims' identities. The preservation of a pair of shoes can save an unnamed victim from anonymity (Williams, 2007, p. 28).

An arrangement of shoes functions in part like a permanent cemetery, "where prolonged spatial and material relations to the deceased are allowed to exist," and in part like mass graves, "where the dead are meant to disappear" (Sørensen, 2010, p. 115). Shoes and other clothing are the only tangible evidence that remains of attempts to erase individuals from history, and the preservation and display of those artifacts has become a means of resisting disappearance. They

attempt to recover the individual identity that was denied the victims at the time of their mass execution, if not by name then at least through a sense of individual presence.

The Auschwitz-Birkenau State Museum divides shoes into two installations: the first is a "mound of decomposing shoes"; the other is a formal presentation of the "best preserved examples" (Henderson, 2013, p. 684). The message expressed by each installation is vastly different. Those that are piled in the mound, as decaying objects of "moldy leather and decomposing rubber," refer directly to the death and suffering of their former owners (Feldman, 2008, p. 122). The pile resembles the situation in which the shoes were found, tossed uncaringly into piles in a vast warehouse. They have begun to lose their shape, distorted under the weight of the pile, as if the former wearers are fading from memory. The arrangement presents itself as an authentic record of how the shoes, and by extension the victims, were so cruelly treated and discarded.

By contrast, in the pairs that are preserved, as in many more recent memorials "death itself is absent" (Doss, 2008, p. 29). References to the circumstances of a death are typically omitted from many recent memorial objects, as well as obituaries and funeral services. Words or objects of memorial instead celebrate the lives of their subjects. Clothing in general provides information about its wearer, and in this respect clothing speaks about peoples' lives, roles and values. Shoes that retain their shape possess a particular ability to refer to "the dead as they were once alive" (Doss, 2008, p. 29), as a record of their presence and the corporeality of their living bodies. In this respect, the shoes that have been specially selected, preserved and displayed on a plinth or in a cabinet express much less somber messages than those that are left to decay in a mound. They are stand-ins for the individual as he or she appears in the survivors' memories, "ratify[ing] what has been rather than what is no longer" (Doss, 2008, p. 29).

The contrasting messages of these differently presented shoes demonstrate the significance of composition in memorial displays. Shoes that are positioned side by side, as they would be when worn on a pair of feet, seem to exhibit more immediacy than pairs that are strewn and piled. To leave shoes side by side is to express the intention of returning to them. At a bedside, by a front door or at the entrance of a temple, shoes are neatly aligned so that when we return to collect them our feet will easily slide into each shoe in turn. Shoes placed side by side therefore convey the impression that their owners are close-by, and ready to return. Their presentation in pairs therefore enhances the sense that lives were taken too soon and without warning.

Gyula Pauer's *Shoes on the Danube* (2005, Figure 5.3) are arranged to express the panic felt by victims when they were forced to remove them (Pauer, as cited in Taylor-Tudzin, 2011, p. 36). Pauer's cast iron shoes, which line the river Danube in Budapest, were installed in memory of the unnamed

MAKE LOVE, NOT WAR

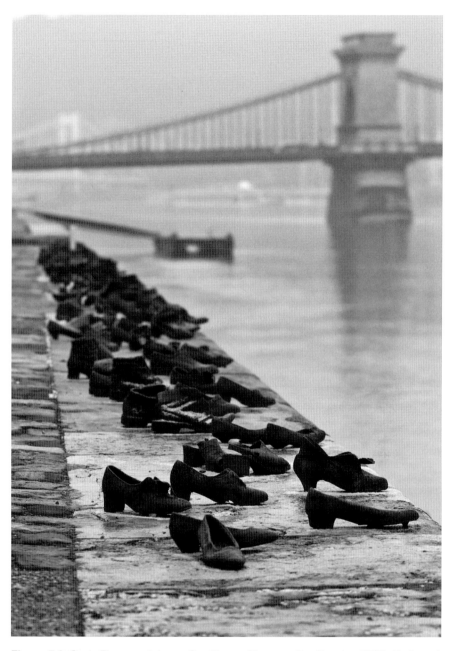

Figure 5.3 Gyula Pauer and Janos Can Togay, *Shoes on the Danube*, 2005, Budapest, cast iron. The chaotic arrangement tells us more about the panic that victims felt when they were commanded to remove their shoes than the execution that followed. Focusing on this act of undressing, the sculpture tells audiences to consider the victims rather than the perpetrators of violence. Photo by Nikodem Nijaki.

civilians who were shot into the river by members of the Arrow Cross party (*Nyilaskeresztes Párt*) in 1945. Pauer secured 1940s costume shoes and cast them in iron, using a process that "disintegrate[s] the original material" so that it is subsumed into the memorial (p. 37). The shoes he selected have "character," with scratches and imperfections that can be read as a record of the actions of their former owners, and so expressions of the qualities of the lives lost (Trezise, 2009, p. 18).

Pauer's sculpture does not directly memorialize the moment that the victims were shot, but rather the act that took place moments before, when they were forced to remove their shoes. It paints a far more vivid picture of the act of undressing than the act of execution that followed. The sixty iron shoes are arranged chaotically, in pairs but not aligned. Some lie on their side, as if kicked off carelessly; others are positioned with one further forward than the other, as if the victim was stumbling toward the river when the shoes were removed, one by one. This arrangement was designed to "reflect a panic situation" (Taylor-Tudzin, 2011, p. 36). The shoes were removed as victims became painfully aware of the "fate that was unraveling before them" (Trezise, 2009, p. 17). Knowing that they may never have the opportunity to put their shoes on again, the victims had no cause to neatly arrange them side by side. Instead of an everyday act of undressing, the removal of the shoes was a hopeless act of abandonment. Bryoni Trezise (2009, p. 18) observes that "the shoes appear to suffer." They are "wilted, dying" objects, reflecting the fear and resignation that colored the moment of their removal. By memorializing the victim's final act rather than the perpetrators' act of execution, Pauer's sculpture tells audiences to focus their attentions on the victims rather than the perpetrators of violence (many of whom were still alive at the time of the creation of the memorial).[4]

Displays at Auschwitz and on the Danube employ location as much as materiality to preserve the memory of past events. "Memory objects" and the "memory landscapes," or "traumascapes," in which they are situated equally contribute to an understanding of the scale and significance of the dramatic events that they commemorate (Saunders, 2002, p. 177; Trezise, 2009, p. 18). The *Shoes on the Danube* stand perilously close to the river's edge, and so their wearers' fate may be apparent even to audiences with no knowledge of the site's history. The proximity of the Auschwitz-Birkenau State Museum to the camp connects the death of the victims to the suffering that preceded it. The embedding of the shoes in this landscape can suggest archeological authenticity. James E. Young (1989, p. 64) writes that "in the case of memorials located at the sites of destruction, where a sense of authentic place tends to invite visitors not only to mistake their actual reality for the death-camps' reality but also to confuse an implicit, monumentalized vision for unmediated history."

Shoe memorials continue to be a reminder of tragedy of past and recent conflicts. The twenty-first century has been characterized by "a preoccupation ... with memorialization" (Sturken, 2004, p. 321), and empty shoes have been employed to commemorate the deaths and disappearance of individuals in tragedies including 9/11, the Iraq War and the invasion of Nanjing. The great losses that communities have suffered in the twenty-first century are often difficult to sufficiently express in words, and the bereaved often find that "traumatic experience is inaccessible to language" (Versluys, 2009, p. 988). As a result, everyday material objects have also been employed in remembrance of victims of smaller scale tragedies, by communities directly affected by loss. Temporary shoe memorials have sprung up in remembrance of victims of traffic accidents on Australian roads, suicides on the Golden Gate Bridge and victims of sexual violence in cities worldwide.

In these many memorials, the size of the memorial space, the distance over which shoes are spread and the extent to which the shoes appear to occupy that space help to convey a sense of the scale of the memorialized event. In 2010, a memorial was installed outside the Nanjing Massacre Memorial Hall, commemorating the lives of the 6,830 Chinese who died as victims of forced labor in Japan in the years following the invasion of Nanjing. The sheer size of the space that is covered by 6,830 cloth shoes arranged in a regular grid at the Nanjing memorial helps to give visitors a sense of the scale of the trauma that took place during and following the Japanese invasion of Jiangsu Province. These shoes are more sparsely spaced than in holocaust memorials, spreading almost to the horizon, and so reinforcing the sense that the deaths were innumerable and inescapable, not confined to a single prison or camp, but spread across the whole of Jiangsu and beyond.

The regular arrangement of the Nanjing memorial acts as a clear and precise visualization of the number of recorded deaths. When the exact death toll is known, pairs of shoes are often presented in an exact 1:1 ratio to the number of victims. Shoe memorials at Golden Gate Bridge (San Francisco), Auditorium Square Park (Ocean Grove, New Jersey) and Martin Place (Sydney) precisely quantify a tragedy. At Golden Gate Bridge in 2012, the Bridge Rail Foundation installed a portable display of 1,558 pairs of shoes, representing the individuals who have committed suicide by jumping from the bridge (Reynolds and Gye, 2012); at Auditorium Square Park, 2,974 pairs of shoes were laid to commemorate the tenth anniversary of 9/11 (Shields, 2011); in 2012 the Australian Road Safety Foundation laid 1,400 pairs of shoes in Martin Place, representing the average number of deaths that occur annually on Australia's roads (Lewins, 2012). Each of these arrangements is laid out neatly, in a grid formation. Jeffrey Feldman (2008, p. 127) argues that it is this arrangement that helps to distinguish these other memorials from those of the holocaust, but it also serves the purpose of making the tragedy more quantifiable to viewers

of the memorial. Spread across large memorial spaces, they convey a sense of the scale of each tragedy with the precision of information graphics. The regularity of their arrangements makes it easy to calculate the precise number of shoes on display, and to read the memorial as a reliable visual representation of statistical data.

Where the Nanjing memorial differs from others is in its use of identical shoes. Every pair of shoes is made from the same black cloth, in identical size and style, revealing nothing about the individual characteristics of the victim that it represents. The victims are reduced to numbers, and their individuality is erased, having the reverse effect of the Holocaust memorials that seek to resurrect missing identities. The Nanjing massacre expresses the "typicality" of shoes, and in so doing "are able to represent a category of experience" that could be shared by many (Williams, 2007, p. 29). It is "the *story* of an object" and the "history to which it is attached," not the indistinctive object itself that is significant (p. 33). The familiarity of shoes provokes viewers to draw parallels with their own experiences and possessions, and makes them able to understand the relationship between the object and the event. These memorials thrive on the metaphor of putting oneself in another's shoes, seemingly enabling "anyone to personally experience the past, no matter how remote or distant" (Doss, 2008, p. 38).

The implicit invitation to imagine oneself in these empty shoes is multiplied at the Nanjing memorial, where shoes are open at the top and arranged as if inviting audiences to step into them. The audience is invited to recall the common act of dressing. The common experience of dressing unites all of us, including victims and survivors, and contemporary audiences who are asked to imagine the experiences of previous generations.

6
ABANDONED CLOTHES: SEPARATING DRESS FROM BODY

Sculptor Jude Tallichet presents a series of cast-off and abandoned clothes, "frozen in the moment a human stepped out of it and dropped it on the floor." Imagining everyday objects without the presence of bodies to fulfill their purpose as wearables, *Dropped Clothes* (2011, Figure 6.1) features a pair of trousers, a dress, a shirt, a bra and a sock, cast in bronze. Tallichet's (2010) interest in clothes stems from the notion that they are "the body's fluid margin." Clothes are an extension of the body, and we are somehow incomplete if we leave them behind. Through the act of undressing, we cast off some vital part of ourselves, as if clothes and body are two parts of a whole, separated.

The separation of body and clothes yields two equally intriguing phenomena: the naked body and the empty garment. Joanne Entwistle (2001, p. 34) tells us that "dress cannot be understood without reference to the body," and this is true even when dress and body are apart. When worn, clothes "cling to the body" and so "the interior is determined by the surface exterior" (Tallichet, 2010). When removed, clothes are remarkable in their formlessness. Where we expect a body there is none, and the body is notable in its absence. Without a body to act or express through its clothed surface, clothes speak on behalf of the absent body.

Tallichet's abandoned clothes take on different significance in different gallery spaces. At the Valentine Gallery in Queens, New York, bronze and fibercol garments trail along a corridor, "like a cinematic tracking shot" of clothes lustfully cast off on the journey toward a sexual encounter (Micchelli, 2014). In *Rowing in Eden*, at the Gund Gallery in Gambier, Ohio, the garments are strewn sparsely across a gallery floor. Just as there are no bodies inside the garments, there is no art on the blank, white walls of the gallery space that holds Tallichet's installation. The space is marked by absence, as if the art that one would expect to see

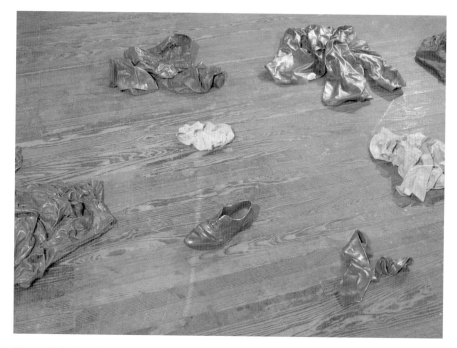

Figure 6.1 Jude Tallichet's installation *Dropped Clothes* (2011) presents garments cast in bronze, recalling the moment after they have fallen to the floor from the wearers' bodies. © Tallichet studio.

adorning the walls, and the bodies that one would expect to see occupying the clothes, have evaporated simultaneously. Their positions suggest that each garment represents an absent visitor, prompting the unnerving sense that any new visitor to the exhibition may meet the same fate as whatever mysterious force caused the disappearance of these wearers' bodies. Aligning her works with postapocalyptic imagery, Tallichet invites audiences to imagine large-scale destruction of the human bodies that have once occupied her garments. These images attempt to suggest the extraction of body from clothes: not, as in other forms of undressing, clothes stripped from people, but people stripped from clothes.

Empty clothes can be considered amid a "growing recognition that objects are … active participants in social practices" (Preucel, 2006, p. 14). Unworn clothes are not unused, rather, their use changes as a consequence of the act of undressing. In Barthes' (1988, p. 182) terms, there is "meaning which overflows the object's use" as clothes. As signifying objects, empty clothes can "dispense knowledge" (Dufrenne, 1973, p. 114), informing observers about the wearer's reasons for undressing, and the absent body's relationship with the surrounding space. Tallichet (2014) writes that "isolated clothes create for us a mystery we must solve." The mystery that must be decoded is how, and with what intention, the clothes were removed from a body. Each of her installations represents the aftermath of an act of undressing, and encoded in the clothes are messages about the missing wearer's motives for disrobing, and events that may have preceded or will follow.

Much has been written about the "language of clothes" (Lurie, 1981). Clothes, and the ways in which they are worn, are understood to constitute a code, expressing meaning about the identity, role and intentions of the wearer (Davis, 1992, pp. 5–9). Those same garments, when removed from the body, may be said to belong to a different code of empty or abandoned clothes, expressing a series of messages that are specific to clothes that do not presently contain a body. The arrangement, location and proximity to other objects of a garment after it has left the body expresses the owner's motivations for disrobing, and his or her intended future interactions with the garment and the space it occupies.

As with clothes on the body, the meaning of an abandoned item of clothing is "unstable" and heavily context-dependent (Davis, 1992, pp. 8–9). Neatly folded garments may indicate the owner's plans to return to the clothes and put them back on; garments strewn on the floor may indicate the intention to launder the clothes before wearing them again. These meanings may be altered if the arrangement is encountered in different locations: on the floor beside a bath, a pile of clothes may express the intention to bathe; discovered beside a much larger body of water, they may indicate loss of life by drowning. Tallichet notes that the apparent significance of abandoned clothing is dependent on

the number of garments. A single abandoned garment, she writes, "could be the flotsam of a messy person, but a roomful implies rapture or disaster." The garments in Tallichet's *Fade to Black (and back)* (2010) are arranged facing one another, as if left by a group of people who were conversing when they suddenly and unexpectedly vanished from their clothes. Such large-scale absence of bodies seems to threaten further, ongoing tragedy.

In public spaces, undressing may be enacted with the intention of deliberately contributing to the space beyond the body in a meaningful way, so that the garments become part of a semiotic landscape (Jaworski and Thurlow, 2010, p. 2). Wearers undress so that their clothes may migrate from one language to another, and to thereby express messages to observers that cannot be expressed while the clothes are being worn. Yet, this language of abandoned garments is not entirely disconnected from the code of worn clothes, as these empty objects are still understood in syntagmatic difference to clothes on a body, and carry some meanings with them after removal. Even in the body's absence, abandoned clothes may be understood as belonging to, and signifying an individual wearer. Removed from the body, clothes may continue to express aspects of the wearer's identity, carrying those meanings beyond the body. As the previous chapter showed, empty clothes can become memorial objects, "mediating, and signifying an absence," and inviting new generations to consider the traumas of the past and the suffering of individual victims (Gibson, 2004, p. 285). Empty clothes can also stand in for the living body in a variety of ways, signifying temporary as well as permanent separation from the wearer's body. On many occasions they articulate the absent wearer's intention to return to an occupied location. We use our clothes to "map out the physical space [we] wish to occupy or reserve in [our] absence" (Shaffer and Sadowski, 1975, p. 408). In this way, empty garments can become territorial markers, suggesting that the wearer maintains rights of occupation even in his or her absence.

Abandoned clothes as territorial markers

"Most generally stated, when someone's in a space, it's theirs, and when they're not, it's up for grabs" (Childress, 2004, p. 201). The space that an individual currently inhabits is not, however, the extent of his or her territory. Individuals find ways of declaring ownership of spaces even when they are absent. Territorial markers extend the presence of an individual beyond his or her body, and thereby temporarily modify the rules of ownership. Individuals and groups can claim a public space solely for their personal use by marking it with objects brought from elsewhere. These territorial markers "reduce the likelihood of an invasion of personal space" by others (Cassidy, 1997, p. 135). Beach towels are left on sunbeds to claim sunbathing spots; books and bags are left on library tables to

mark a study space; coats are draped over the back of chairs in cinemas and bars to reserve a high-value seat.

Territorial markers "forecast both potential and actual behaviour" (Ley and Cybriwsky, 1974, p. 491): they provide information about the owner's intentions and signify a range of possible behaviors to follow. A coat draped on a chair signifies the owner's intention to return and sit down; a pile of clothes left on a washing machine at a launderette signifies the desire to use the machine when it is next available; a towel unfurled on a sun-lounger suggests that its owner will soon by laying semi-clad on top of it. Thus, an abandoned garment can be read as a predictor of its owner's future actions. His or her removal and strategic placement of the garment is carried out with the aim of warning others of future events, and to prevent possible conflict with others' own plans for occupation of the same territory.

Clothes are particularly effective territorial markers because they are so often viewed as an extension of the body. The removal and purposeful placement of a garment extends the body into the surrounding area, thereby establishing new boundaries between self and others beyond the outer layer of worn clothing. Territorial markers are most effective when they are personal (Sommer and Becker, 1969, p. 85). Clothes are among our most personal possessions, appearing to communicate key information about ourselves, including gender, role, age and aspects of personality. Further, an item of clothing tends to be unique in most settings, making it an ideal tool for personalization. When worn, clothes express individuality, and when shed to mark territory they have the same effect of "rendering distinctive" a space beyond the body.

Moreover, clothes are effective as territorial markers because their connection to their owner is perceived as permanent. Peter A. Anderson (2009, p. 808) writes that spatial markers must appear to be valued, "permanent possessions," as they are otherwise assumed to be "trash." A half-consumed picnic lunch or a borrowed library book are less effective at marking territory because its connection to the individual is finite. Individual ownership of such objects is considered to have ended when the user moves away. Clothes, however, are perceived as having an unbreakable connection to the wearer, which remains even after they have been removed from the body.

With personal identity on display in an unguarded garment, observers may make assumptions about the person who intends to return to occupy the marked space. The messages expressed by that garment may work for or against its owner's territorial claim. In the mid-1970s, a study by Shaffer and Sadowski (1975, p. 408) found that male garments are more effective spatial markers than female garments. In the study, researchers left behind a man's jacket and a "woman's jacket trimmed with lace" on chairs in a bar (p. 412), finding that the table marked with a woman's jacket was "invaded more frequently" than that which had been evidently claimed by a man (p. 414). Shaffer and Sadowski

theorize that "potential invaders" are more reluctant to invade the territory of a male occupant who "would likely be perceived as more aggressive than a female occupant, and thus, more likely to respond forcefully to an invasion" (p. 410).

By contrast, in some circumstances the presence of a woman's spatial marker may be read as an invitation for social interaction. Shaffer and Sadowski observe that "a woman's sweater draped over a bar stool may help the stag male customer decide where to position himself in order to increase his chances of interacting with the female" (p. 409). Particularly in places that encourage social interaction, such as bars, the actions of a lone individual who marks his or her territory with a garment may provide others with a cue to move closer rather than further away.

Altman and Chemers (1980, as cited in Cassidy, 1997, pp. 135–136), identify three categories of territory: primary territory, owned by an individual or interdependent group, such as a home; temporarily owned secondary territory, such as a locker; and public territory that is accessible to everyone, such as a beach or park. However, these definitions are fluid, and as Childress (2004, p. 202) observes, some primary, privately owned territory may be perceived as public. Childress observes that an individuals' perceived right to temporarily claim territory is dependent on the "scale and humanity of presumed ownership." Privately owned homes and gardens, or small businesses, are not perceived as available for a temporary claim. "Indicators of ownership and investment" mark such spaces as private, including artifacts that are themselves privately owned by one or few individuals, such as "yard furniture" (p. 201). However, "a corporation or institution holds little experiential claim over places," and these "anonymously owned" properties are treated as public spaces insofar as individuals feel able to take temporary ownership of part of that space.

Temporary territorial markers are only required in certain contexts, as identified by Ralph Taylor (1988, p. 222). These contexts are those in which there is "a nonexistent or low level of acquaintanceship between the individual … and other occupants in the setting." Public or semipublic territory exposes individuals to nonacquaintances, and it is primarily these strangers against whom a territorial marker makes a claim. Many of these locations are what Robert Sommer (1967, p. 654) describes as "sociofugal" spaces, such as libraries, in which "people typically try to avoid one another." In such spaces, verbal communication, particularly between strangers, is discouraged, and so individuals use nonverbal methods of establishing "social distance." Although the setting may itself be designed to encourage isolation, users accept and reinforce their isolation by marking a large territory around their immediate location. This may involve placing coats and scarfs on neighboring chairs, or spreading books across a table.

Even in these contexts, which appear to sanction the use of clothes as territorial markers, the effectiveness of those markers is temporally and spatially limited (Taylor, 1988, p. 222). Clothes are so regularly abandoned that various

businesses have abandoned clothes policies, and so there must be a code identifying those clothes that are trash or lost property, and those that are territorial markers. The time it takes for a garment to cease to be a territorial marker and transform into lost property depends on the location at which it is left. Clothes left at dry cleaners are not assumed to have been abandoned until six months after they were left (Petrarca, 2014), whereas on a park bench that transition from territorial marker to trash may happen overnight. A coat is an effective marker for only so long as the event during which it is laid is over. Territorial claims are not extended by leaving the garment behind. Once the credits have rolled, the teacher dismisses the class, or the wedding reception is over, the coat can no longer function as a territorial marker, and is transformed into waste. When the venue has closed for the night and the crowd has dispersed, the coat is read as a discarded object, and the cleaners or janitors have the right to remove it along with all the other waste that has been left in the environment. Further, its significance is spatially limited in so far as it only marks the intended occupation of a single seat, or a small number of neighboring seats. Should a group of friends wish to carve out territory that incorporates a larger number of seats, several garments are required, spread across a larger area.

Depending on the position of the item of clothing, and its location relative to the owner, its territorial marking function may be different. Becker and Mayo (1971, as cited in Shaffer and Sadowski, 1975, p. 409) observe markers that function to extend, rather than reserve territory. While the owner is present, his or her personal territory may be extended to incorporate a larger area if his or her garments are more voluminous, or if they are removed and placed in the area directly beside the body. This is a relatively common practice on some public transport, where travelers place their personal belongings on the adjacent seat in order to extend their personal space by prohibiting others from sitting next to them.

Hickson and Stacks (1993, p. 73) differentiate between "central markers," which reserve the space to be directly occupied by an individual, and "boundary markers," which divide the territory of one individual from another. If it is spread widely enough, a single garment may be effective as both a central and boundary marker. Sommer (1967, p. 659) observes that "an overlap of several inches … is sufficient to stake out a claim" on a neighboring seat. The markers identified by Becker and Mayo fall into this second category, not marking the owner's own seat, but extending his territory to include surrounding seats. Taylor and Brower (1985, p. 183) identify the value of this adjacent territory, and how its use can impact upon "quality of life." If individuals are able to take temporary ownership of the space that immediately adjoins their "home" territory, they are able to control outside influences that may impact upon the quality of their experience of the immediately occupied space. Control of this secondary space benefits not only the individual who has laid his or her clothes as a marker, but also others

who occupy the surrounding spaces (Taylor and Brower, 1985, p. 189). Marking an empty space, so as to keep it empty, reduces the overall population of an area, thereby ensuring a less crowded atmosphere.

There are circumstances that render a territorial claim void. A claim may be delegitimized if others feel that the claim has been made unfairly, whether as a result of its setting, or because there are overriding circumstances. In order to be claimable, a space must be "replicable" (Taylor, 1988, p. 227). The virtually identical cinema seats, bar stools or patches of grass in a park on which we may spread our coats and jackets are not so unique that the claimant is seen as depriving the community of something of significant value. These are, after all, public, social spaces that democratically offer numerous individuals the same or similar opportunities and experiences. Only a low-value claim is socially acceptable. These low-value claims may also be "contested by others," when there are officially sanctioned prior claims. A numbered cinema ticket, for example, may be presented to nullify the claim made by an individual who has placed his coat on a cinema seat but whose ticket does not reinforce his claim. Such "legitimate counterclaims" have the power to invalidate a garment as a territorial marker.

The office is a peculiar setting in which individuals may occupy a designated space for most of their waking hours, without having any claim of ownership of that space or the objects within it. In the home, "there is no reason for territorial behaviour [as] one has psychological ownership of objects that are not in a social realm" (Brown et al., 2005, p. 579). In contrast, in a place of work employees may occupy an office indefinitely, using the same desk and chair for years, knowing that those objects are the property of an organization.

Brown et al. (2005, p. 577) write that "life in organizations is fundamentally territorial." In a professional environment, the power to claim territory is one means by which an individual can exert identity and status (Ley and Cybriwsky, 1974, p. 441). The need to mark personal space in an organization is driven by the understanding that objects and spaces are allocated to a role rather than to the individual who is employed in that role at any one time. In lieu of legal right of ownership, employees take opportunities to express their indefinite occupation of a working space, asserting attachment when legal ownership is not possible. An office space may be marked with semipermanent expressions of occupation, such as photographs of family on a desk or a name-plaque on the door or with temporary territorial markers such as a coat draped on the back of a chair.

Photographs of Barack Obama in the Whitehouse's Oval Office reveal evidence that the president's personal territory extends beyond the chair on which he sits. A number of images capture Obama at the Resolute Desk, having removed his jacket.[1] In photographs of the early years of his presidency, the jacket is invariably draped not over the president's own chair, but on one of the smaller chairs that are on either side of his desk (see Figure 6.2). As a boundary marker,

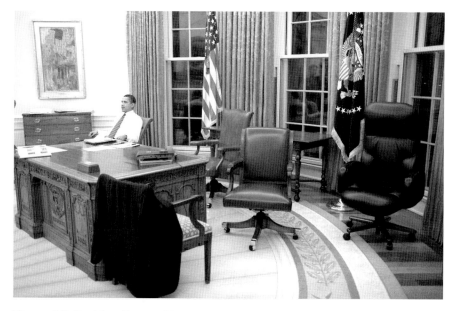

Figure 6.2 President Barack Obama tries out different desk chairs in the Oval Office, 2009. Even before Barack Obama had selected his office chair, he had begun to mark his territory in the Oval Office. Like many office workers, he marks his temporary residence by draping his jacket over the furniture. Official White House photograph by Pete Souza, reused in accordance with the terms of Creative Commons Attribution 3.0 License — http://creativecommons.org/licenses/by/3.0/us/

the jacket serves to prevent others from sitting either side of the desk, asserting his right as its sole user, and prompting colleagues and visitors to keep their distance by standing or sitting elsewhere. Childress' (2004, p. 196) exploration of teenage territory may provide an explanation for the position of Obama's draped jacket. If, as Childress observes, those "prohibited from property ownership" are more inclined to mark their temporary residence, then perhaps Obama too feels inclined to mark his territory as compensation for the impermanence of his role. The Oval Office is not his own, and as a mere custodian of the space he may seek means of asserting his right of occupation.

The characteristics of some work environments reinforce the sense that space does not belong to employees. Open-plan offices, for example, reduce the sense of personal space, and it is in these environments that employees feel the strongest urge to mark their territory (Ley and Cybriwsky, 1974, p. 357). An enforced dress code may provide motivation for workers to use coats, bags or other "identity-oriented marking" to assert individuality where they cannot do so on their own bodies.

When there is a dress code of any kind, such as a uniform or institutional clothing guidelines, an individual is deprived of his or her ability to express identity through clothing. This form of expression is taken for granted in other contexts, in which clothes are one of the primary signifiers of cultural and socioeconomic identity. The inability to express individuality through one's worn clothing forces employees to assert identity through objects placed in their surroundings. The desk and chair become substitute bodies, so that a coat, which must be removed from the wearer's body to adhere to a dress code, functions similarly when draped over a chair as it would if worn.

As a substitute body, the office chair may be clothed according to the same principles as the human body. When the coat and other accessories are removed from the wearer's body, so that he or she may adhere to a dress code, both the clothes and the accompanying signifiers of personal identity are transferred onto the chair. The employee thereby anchors his or her identity to the chair instead of the body.

While individuals find numerous legitimate reasons for using their garments as territorial markers, organizations and institutions have fought back against this practice, which is viewed by some as a health and safety concern or a blight on the landscape.[2] Some organizations have health and safety policies prohibiting the hanging of coast on chairs, fearing that trailing coat tails may be a trip hazard, or that belongings left unattended may pose a security threat (Pouvar, 2006). However, Brown et al. (2005, p. 586) argue that allowing employees to mark their territories with personal belongings reduces conflict in the workplace and increases employees' sense of belonging, thereby reducing staff turnover. The ability to mark and defend a personal space in a shared

office increases the "rootedness and sense of belonging an individual member has with the organization."

Tossed shoes and gang territory

Anyone who glances upward at an urban intersection in the USA and Europe may find territorial markers strung above their heads. Shoe tossing is a phenomenon encountered in many urban environments, in which people tie their shoelaces together and toss the shoes over a power line or branch (see Figure 6.3). The shoes are abandoned out of reach, leaving evidence of the wearer's presence in a shared public space. Todd Sieling (as cited in Bate, 2013, p. 27) describes tossed shoes as "an inversion of the normal order." Ordinary garments are made extraordinary merely by a change in location. Shoes, which are "meant to be on the ground," take on new meaning when they are suspended above our heads.

The motivations for shoe tossing are often unknown, but the most common interpretation is that collections of abandoned shoes on utility lines are territorial markers that "signify the physical boundaries of gang territory" (Smith, 2013). Documentary maker Matthew Bate (2010) invited callers to recount their knowledge and experiences of tossed shoes via an anonymous hotline and recorded the results in his documentary *The Mystery of Flying Kicks*. The common consensus among many of his callers is that shoe tossing is gang-related, as it either marks gang territory or sends other messages related to gang conflicts. One anonymous caller from Spain describes how "the Mafia use sneakers on wires as a signal to the police to stay out of that neighbourhood. It's like a gentleman's agreement between the criminal gangs and the authorities."

One New York caller to Bate's chatline, who identifies himself as "Cheddaboy," describes shoe tossing as "a signature ... like graffiti ... instead of writing graffiti you do it with sneakers. You throw your sneakers on top of a power line to know that you were there." The motivations and settings for graffiti and shoe tossing are indeed very similar. Shoes collect over time, equivalent to the palimpsests of graffiti that develop as numerous graffiti artists layer their work on top of each other over many years. Ed Kholler (founder of shoefiti.com) coined the term "shoefiti" to describe the collections of shoes that he photographed draped over utility lines. He is one of several commentators who have drawn parallels between shoe tossing and graffiti, both in its creators and its urban locations.

Parallels with graffiti reinforce the suggestion that shoe tossing is gang-related. "Street gangs are strongly place specific; in Philadelphia most of them take their

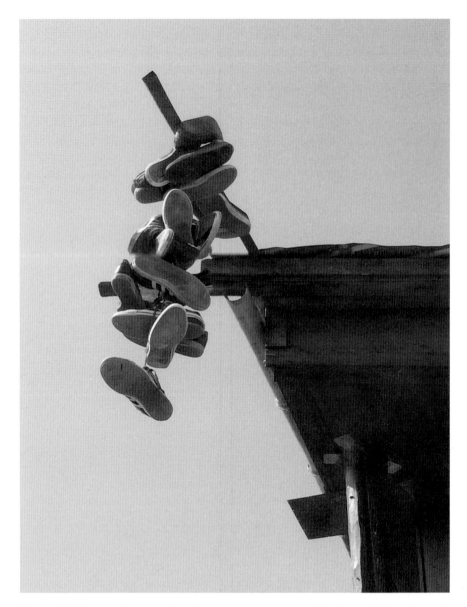

Figure 6.3 Tossed shoes in the Copenhagen commune Christiania, 2014. Photo © Rosy Hill.

names from an intersection near the center of their territory" (Ley and Cybriwsky, 1974, p. 495), and it is at such intersections where utility lines often converge, creating ample opportunity for shoe tossing. Tossed shoes tend to appear on the same "main thoroughfares" in "downtown" locations in which "graffiti written by teenage gangs delineate their turf or area of control" (p. 491).

Ley and Cybriwsky (1974, p. 491) offer hypotheses about graffiti that may explain its evolution into tossed shoes. Graffiti frequently appears in apparently inaccessible spaces is evidence of "spatial conquest." There is a competitive element to tagging that provokes graffiti artists to attempt to outdo "each other in the inaccessibility of locations they invade." To that extent, their activities resemble those of "place hackers"—urban daredevils whose aim is to reach the most inaccessible locations they can find (Poynor, 2013). For any place hacker or graffiti artist, there is no more inaccessible location than one that has no means of direct access; that cannot be touched from the ground beneath or the balconies on either side. There is an element of skill in accessing an apparently inaccessible site, which attracts admiration (or envy) from fellow artists and audiences. Having claimed the walls, balconies and bridges, graffiti artists have looked to utility lines, which are the next inaccessible territory to be conquered.

Former graffiti artist Ad Skewville (as cited in Bate, 2013) progressed to "shoefiti" when he noted that his environment was so saturated with posters, stickers and stencils that there was no space left in which to express himself. He turned to the power lines in this hunt for a "new media space." Skewville feels it is important not to use ready-made sneakers, as appropriated objects would not allow the same opportunities for creative expression that he has found in graffiti. Instead, he produces wooden silhouettes of shoes, each pair hand-painted with a new design and strung together with laces. Skewville reports that onlookers are typically impressed by his antics, and frequently applaud him when he succeeds in the challenge of entangling his shoes in the lines.

Ley and Cybriwsky (1974, p. 494) argue that urban territorial markers are the work of unfulfilled artists whose "access to the mainstream culture" is blocked by circumstance. Despite their lack of access to social mobility and the commercial art world, these individuals "have legitimate artistic ambition." Indeed, it is possible to observe among shoe-tossers many of the practices that are otherwise associated with art. As shoes begin to mount up, the objects on which they hang become saturated. In some cases, many tens or even hundreds of shoes are attached to a single object. These collections cannot just be viewed as the result of a disconnected collection of separate claims to individual territories, but must also be considered as collaborative street art. Individuals toss their shoes knowing that they will be contributing a part to a larger whole, and that their own shoes will be observed in conjunction with, and in relation to, the other shoes that hang alongside it. Ad Skewville's experience of applauding onlookers suggests that shoe tossing is not only meaningful for

what is left behind, but also for the act itself. Indeed, Skewville compares it to performance art. The skill demonstrated in throwing shoes so that they become tangled in the utility line transforms the activity into a performance, or perhaps a spectator sport, worthy of an audience. "The conquest of territory," write Ley and Cybriwsky (1974, p. 494), "is always an act performed for an audience." There is a primary audience who directly view the act of territorial marking, and secondary audience who learn of an individual's presence by observing the marker afterward.

The inaccessibility of sites adorned with shoefiti is also a means of ensuring the longevity of the marker. While street-level graffiti can be easily overpainted, either by street-cleaning crews or by other graffiti artists, graffiti in inaccessible spaces is more difficult to remove. Shoes tossed over utility wires remain there until they are pulled down—a difficult task requiring the use of a cherry picker—and so many remain in their resting place for years or even decades. One subject interviewed in Bate's documentary is shown pointing at a pair of shoes that he recalls having tossed in 1991, and that remain on the same power line at the time of the filming of the documentary in 2009. Bate's interviewee recalls his social and professional situation as it was at the time the shoes were tossed, and contrasts it with the man he has become since, thus reflecting on all that he has achieved in the past eighteen years. The sight of the shoe triggers pride at his many personal and professional accomplishments.

One Australian caller to the "shoefiti hotline" describes other shoes serving the same triggering function in an alleyway in Melbourne. He tells of workers in urban restaurants who remove their shoes at the end of their final day of employment, so that they can toss them over the wires above and leave their mark on the environment. These workers, he tells Bate, "hang their shoes … for just a memory." The hundreds of shoes that now form an irregular canopy above the alley record the presence of several generations of workers, each of whom has left his or her mark. These are not just personal memories, but also an assertion of an individual's presence to others who will follow in their footsteps. They contribute to collective memory about the communities that have inhabited this space. Marcel Danesi (as cited in Bate, 2013) identifies one of the great tragedies of the human condition as our inability to make our mark on the world. Individuals "disappear from communal memory" and it is the knowledge of the insignificance of our lives and actions that drives a desire to "leave our mark." An object that is left behind in an individual's absence asserts territory that an individual may never return to claim. It establishes a "communal long lasting memory, as if we live on" through the material artifact that is left behind. In this way, the tossed shoe becomes a memorial to oneself: a defense against one's own absence.

The same actions and objects are employed in order to memorialize others. One anonymous caller to Bate's hotline describes tossed shoes that once

belonged to gang members who have been shot dead. He describes a local ritual of removing the shoes from a fellow gang member's feet before the police arrive to claim the body. Of the shoes that litter the skies in his local neighborhood, many, he tells us, are visibly stained with blood. These are, like the shoe memorials described in Chapter 5, evidence of the absent owners' existence and of the trauma of their deaths.

Abandoned selves

Unlike other territorial markers, the tossed shoe is never reclaimed. It remains out of reach and serves its purpose as a territorial marked indefinitely, signifying the intention to return but not to retrieve the shoe. When an individual or gang's identity is so clearly marked by an abandoned shoe, there is no need to return to collect the object in order to firmly establish continuing ownership of the space. Despite its permanent separation from the former owner's body, a tossed shoe continues to succeed at territorial marking, outlasting other objects that may have been temporarily left behind for similar purposes. Even after permanent separation, clothes retain a relationship to their former wearer. Any pile of clothes found outside of sanctioned dressing or storage spaces may "immediately raise the question of the … whereabouts of their owners," regardless of how distant that former wearer may be (Alphen, 2001, p. 64).

For some who choose to permanently abandon their clothes, the gesture may be symbolic of leaving themselves, or an aspect of their identity, behind. To cast off one's clothes is to cast off a part of oneself. The loss of a favorite item of clothing can be a personal tragedy, akin to symbolically losing part of oneself.[3] For many, this is a positive process: an act of personal reinvention that begins with the conscious discarding of one's wardrobe. Along with the formation of a false identity, undressing can be a vital step in the substitution of one identity for another: a means of killing off one's former self so that one may become someone else. This is, writes Michael Jay Lewis (2014, p. 346), "a kind of non-corporeal suicide" that destroys "that which has come to represent one's identity." British Labour politician John Stonehouse faked his own death in 1974, leaving a pile of clothes on Miami Beach as false evidence of his drowning. Stonehouse fled to Australia, where he was later tracked down, and was eventually jailed for seven years for fraud (*BBC*, 2005). Investigations revealed that pseudocide was just one of the many acts of deception that Stonehouse had carried out in order to transition from his former life to his new one. Stonehouse had adopted the alternative identity of Joseph Markham "as a psychological safety valve" months before his supposed suicide (*The Telegraph*, 2005). His actions allowed his "ostensible demise while facilitating his ideological liberty" (Lewis, 2014, p. 350): he stripped himself of the wardrobe

of a failure in order that he might "enjoy the feeling of being an honest man" (*The Telegraph*, 2005).

It is not often acknowledged that, when an individual's identity is cast aside by undressing, that identity continues to be expressed in the empty garments that remain. Abandoned clothes endure as evidence of the owner's former identity. Individuals who abandon their identities may have particular reasons for wanting their abandoned clothes to continue to express aspects of identity after being cast off. Indeed, as in territorial marking, the garments may form part of a specific message that the individual hopes to communicate in his or her absence. This is the case in faked suicides, murders or accidents, when an individual undresses with the purpose of leaving false evidence behind, and in particular, evidence that is convincingly linked to his or her identity. In such instances, the act of undressing and abandoning one's clothes is an act of deception, or a subversion of the code to which all abandoned garments belong. John Stonehouse's disappearance coincided with the writing of David Nobbs' tragi-comic novel *The Fall and Rise of Reginald Perrin* (1975). Nobbs' novel and the later BBC television adaptation of the same name (1976–1979) tell the tale of a frustrated salesman who fakes suicide by abandoning his clothes.[4] Perrin's plan, as described in Nobbs' novel (1975, p. 113), originally titled *The Death of Reginald Perrin*, is to "go down to the south coast somewhere, leave his clothes in a neat pile on the beach" and start a new life under an assumed identity. Perrin abandons his garments with the knowledge that those who find them are likely to assume that he has swum out to sea, never to return to shore. This scene of "pseudocide" has been recreated in the real world so many times that it is referred to colloquially as "doing a Reggie Perrin" (*BBC*, 2000).

The opening credits of the BBC television adaptation depict the moment when Perrin removes his clothes. Perrin approaches from the distance, running parallel to the shoreline, clothed in a somber suit. As he runs, he strips one garment at a time, tossing each in the direction of the sea, leaving a trail of clothing behind him. The footage is undercranked, so that the locomotion of Perrin's legs is comically fast, and his undressing appears rushed. He first removes his coat, then his waistcoat, and pulls his suspenders over his shoulders. The task of removing his trousers forces him to stop running. He comes to a standstill, and kicks his off shoes. The shoes fly in different directions, and Perrin appears not to care where they land, having no intention of returning to them. He sheds the remaining clothes in a single pile. When he removes his final two garments—his shirt and underpants—he flings them aggressively, resolutely, determined to separate himself from these garments once and for all, and never to look back. Once naked, Perrin strides into the sea.[5]

Such scenes are authored for "the induction of false belief" (Hancock, 2015, p. 6). As in many fictional "disappearances into the sea," Perrin's actions do not represent death, rather "the sign that [he] will afterward be treated as dead by a

given society" (Lewis, 2014, p. 350). Perrin exercises an opportunity identified by Colin Campbell (2007, p. 159) to treat his clothes as "signs" rather than "things," "actively manipulating them in such a way as to communicate information about [himself] to others." He drops his garments where he knows they will be found, and that when they are discovered will contribute to the belief that he has swum out to sea and drowned. Once abandoned in this way, his garments fulfill Suzanne Briet's (1951) conditions for a "document," being material objects that are "intended to be treated as evidence," having been "made into a document" by the wearer's process of removing and abandoning them in a particular location (Buckland, 1997, p. 806). The document—Perrin's clothes—appears to evidence events that have not really occurred, and their materiality adds weight to the deception.

Abandoned clothes left in carefully selected locations are enough to quite precisely signify tragedy without additional evidence or the false claims of the now-absent deceiver. The audience who discover the clothes, and those with whom they share their discovery, belong to a "clothes-wearing community" who are equipped to read garments, even when empty, as signs of an individual's identity (Davis, 1992, p. 6). Moreover, they are culturally conditioned to read clothes in this setting as evidence of loss. The pervasive image of a pair of empty shoes as a signifier of tragedy permeates all cultural forms. The holocaust memorials described in the previous chapter, and the bloodstained tossed shoes observed on urban power lines, draw on a wider practice of representing the missing, deceased body through garments left behind. Similar imagery appears in art and literature. Heinrich Hoffmann's *Struwwelpeter*, first published in German in 1845, features the cautionary tale of Paulinchen (variously translated as translated as Pauline or Harriet), who is burned alive while playing with matches, and leaves only her "little scarlet shoes" as evidence of her demise. So inextricably linked are clothes with the wearer, and so potent is an empty garment as a signifier of tragedy, that an abandoned garment may seem to indicate tragedy even when none has occurred.

Signifiers of identity are vital to the success or failure of a pseudocide. While pseudocides succeed by reproducing the evidence of genuine tragedies, that evidence must be both similar and different to that discovered at the scenes of previous suicides. The shedding and abandoning of clothes beside a large body of water is a ritual established in genuine suicide attempts, and imitated in pseudocides. However, these pseudocides do not aim to exactly reproduce the evidence of previous drownings, as the pile of clothes left behind cannot be a facsimile of that left by a genuine victim. The abandoned garments must, on each occasion, mark the individual identify of the apparent victim in order to be effective. They must be, in each case, distinct enough to signify the individual identity of the presumed victim. When the clothes fail to sufficiently stand-in for the missing individual, the pseudocide can fail. Thanks to the prominence of

these examples of clothing employed in pseudocide, audiences have not only become familiar with the notion that a pile of clothing signifies drowning, but also equipped with the knowledge that such a scene is easily faked.

Armed with knowledge of these previous pseudocides, audiences have become alert to the suggestion that a pile of clothing may just as likely be evidence of a hoax than of a genuine death. North Carolina resident Robert Lee Battle failed in his attempt to convince the authorities of his suicide because his abandoned clothes revealed more than he had anticipated. Police became suspicious as a result of the objects missing from the pile of clothes that Battle left beside his abandoned truck on a bridge (*Times-News*, 1982, p. 10). The pile did not contain the most valuable parts of Battle's wardrobe, including those items that friends and family said were most precious to him—a voodoo charm and expensive wristwatch. Battle's decision to keep these items prompted a police investigation that later revealed the absence of a suit that Battle had reportedly stored in his tool shed (*The Dispatch*, 1982, p. 22). Battle's act of dressing, when he donned this suit after his pseudocide, undermined the goals of his earlier act of undressing.

CONCLUSION

The kinds of undressing that appear in this book are varied in meaning and mechanics. Neither habitual, domestic undressing nor acts of undressing for public consumption follow the same path: they may be hurried or languid, partial or complete; they may feature different gestures and expressions, or begin and end at different body parts. Nor is it the case that all undressing results in the same conclusion. Undressing does not always operate a transition between dress and nakedness. Of the examples featured in this book, few result in complete nakedness, and several result in a body that is more concealed than it was before the gesture began. Undressing, therefore, can never be spoken about as a single category of action. Rather, efforts must be made to accommodate all of its many styles and characteristics, and to consider each in its own context.

Undressing restructures the relationship between clothes and the body in a variety of ways. The gesture has a specific relationship with the garments that are removed, to the extent that, on some occasions, a particular garment prompts a particular kind of undressing. The choreography of undressing is sometimes restricted or enabled by the features of a garment, as when its fastenings terminate at a particular site on the body. Ultimately, all clothes must be designed not only to be worn, but also to enable dressing and undressing, and so undressing is a concern for all costume and fashion designers alike, not only those who directly engage with acts of undressing such as those described in this book.

The book has predominantly engaged with acts of undressing, distinguished from habitual motions of disrobing largely by its conscious choreography. It is, however, important not to imply that domestic or habitual undressing is an intuitive or instinctive activity. Like many other domestic activities, it is learned, and often more complex than we may assume.

Taras and Matese (1990, p. 293) observe the difficulties faced when teaching methods of undressing to persons with profound learning difficulties, and note that, to avoid confusion, it is essential to distinguish between dressing and undressing. In an intensive program developed by Nathan Azrin et al. (1976, p. 30), "the easier skill of undressing" is taught before dressing, as the removal of garments is considered simpler than the donning and arrangement of those same garments. Underpinning this method is the observation that there is a correct way to dress, and that undressing can be a more free-formed process.

When undressing, there is no requirement that the garments end up in a particular place or in a particular arrangement.

Learning how to undress oneself every day is not adequate preparation for a performed act of undressing. The gestures involved in acts of undressing are often so different from those of everyday undressing that they require special preparation and consideration. Performance of undressing often requires the performer to relearn familiar gestures. Burlesque dancers, for example, retrain their bodies to perform the removal of garments with artificially exaggerated femininity (Ferreday, 2008, p. 50, see Chapter 2). This training reminds performers that although their performance takes inspiration from an everyday event, it cannot be performed as it is in the privacy of one's own home. Rather, it must be deconstructed and redesigned.

Performances often seem to complicate undressing, seeking to make the otherwise everyday gesture into a more complex event for both audience and actor. Trisha Brown (2014, p. 124), dancer and choreographer of *Floor of the Forest* (1969), describes in her work "horizontal dressing and undressing," "reshaped by the vertical pull of gravity." The piece is performed within a grid of ropes, suspended inside a square frame. Garments have been threaded into the ropes, forming a series of obstacles through which two dancers must climb. Moving across the grid, the dancers post their bodies through the suspended garments, transferring themselves from one garment to the next (see Figure C.1). Their bodies are supported almost entirely by the clothes, so that they must be securely contained within a new garment before removing themselves from the one that they leave behind. Brown describes "great strain and effort to support the body while negotiating buttons and zippers" as the dancers fight against their own weight to slide in and out of the clothes. In these actions, undressing is defamiliarized for the audience and for the dancers, who must relearn the act of undressing under these new conditions.

Despite the vast differences between different acts of undressing, the investigation represented in this book has revealed several key features shared by public performance of undressing in all its forms. One thing that unites all acts of undressing is that, as uncommon spectacle, they demand to be observed. Perhaps it is so difficult to tear our eyes away from an act of undressing because it is a fleeting and unpredictable exchange, during which no two gestures are the same. To turn away would be to risk experiencing tmesis. As an action rather than a static state, undressing constantly progresses toward a point of resolution, and we are driven by a desire to know what form that resolution may take. Alan Langdale (2002, p. 20) considers an incomplete sequence of "a girl undressing," imagined by film theorist Hugo Münsterberg (1916, p. 121), "where the shot ends before the final garment is discarded." Langdale posits that "the viewer is obliged to imagine the completion of the action and picture her nakedness mentally." It seems that observers seek the satisfaction of witnessing the end of

CONCLUSION

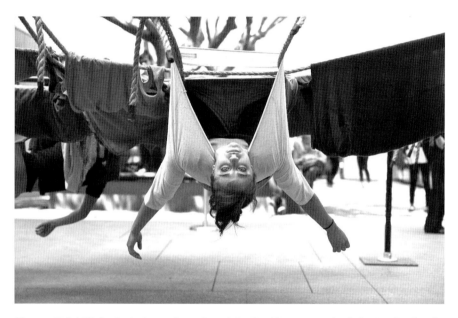

Figure C.1 UCLA students perform Forest to the Floor as part of Center for the Art of Performance at UCLA's Trisha Brown Dance Company Retrospective at the Hammer Museum, Los Angeles, 2013. As part of the performance, dancers thread themselves through a series of garments, suspended from ropes. Photo © Phinn Sriployrung.

an action or gesture, and are so driven by that desire that if they do not directly witness a resolution they must imagine one for themselves.

Also common to all examples in this book is the importance of temporality. Burlesque dancers are differentiated from strippers because of their performance of delay (see Chapter 2); streakers rely on suddenness for impact and their undressing is a race against time (see Chapter 4); abandoned clothes act as territorial markers only during the opening hours of a venue and only for a relatively brief period (see Chapter 6). Whether undressing is erotic or comedic is often a question of timing. In Gerald Thomas' *Carry On Camping* (1969), the bikini top worn by Barbara Windsor is flung off as during vigorous exercise, landing in Kenneth William's face. The malfunction was staged with the help of a fishing line, hooked to the top and jerked away as Windsor flung her arms backward (Windsor, 2012). The camera reveals Windsor's breast for a split second, before cutting to another angle. The gesture is both comedic and erotic, owing to its unexpected timing, Windsor's apparent innocence and the short length of the exposure. Such fleeting glimpses of bare skin have the potential to be far more enticing when kept coyly brief. Comically timed exposures such as this are a staple of slapstick comedy, including staged wardrobe malfunctions. Charlie Chaplin's first performance of a malfunctioning trouser button was reportedly an accident, which he later incorporated into his show by selecting trousers with intentionally baggy waistbands, rigged to fail at a carefully timed moment (Merton, 2009, p. 23).

All of the examples in this book have shown that the meaning of undressing is dependent on the actor's intention and the audience's perception. As an expressive gesture, undressing is performed in order to communicate particular messages to observers, and to provoke particular response. It may arouse or antagonize. It may deprive the subject or the observer of dignity, but in doing so may serve as a powerfully radical gesture. Both transmission and reception contribute to the meaning of any act of undressing. However, neither the actor's intention nor the audience's perception is an independently reliable indicator of how an identical gesture may be perceived in alternative contexts. The actor's intention and the audience's perception do not always align. There is room for aberrant decoding, and for actors of undressing to exploit that misinterpretation to transform their undressing into an act of deception. Like any other message, undressing can mislead (see Chapter 6). Equally, it can reveal the truth, uncovering bodies that have been deceptively concealed by clothing. Clothing artificially constructs identities that can be stripped away through an act of undressing.

Though this book has focused specifically on undressing, it has also introduced connections between dressing and undressing, sometimes revealing that a single gesture can involve both simultaneously, and that gestures of undressing can be used to cover rather than expose (see, for example, Masako Matsushita's

CONCLUSION 117

UN/DRESS, in Chapter 1). Dressing and undressing are two sides of the same coin, often containing similar gestures in reverse. Both place the actor in a state of transition, and both are required when exchanging one ensemble for another. Still photographs of dressing and undressing may be indistinguishable; a fact exploited by photographer Flora Borsi in her *Lookbook* series (2013). The series depicts a white vest, suspended from a hanger and draped over a female model's head and shoulders in various poses. In one shot, the model's arms hang limply out of the armholes; in others, her head appears tangled in the fabric. In all of the shots, it is not clear whether the model is on her way to donning or removing the vest. She is swathed as if stuck half way between dress and undress, and unsure whether to retract herself from the garment or to push further into it. Frozen in these images, the actions of dressing and undressing become static states, an effect that highlights the importance of temporality in defining dressing or undressing, and in differentiating them from the states of dress or nakedness.

The commonalities that unite undressing and dressing should make many texts that discuss dressing equally useful in understanding undressing. When we seek to understand undressing, we may also learn about dressing, and vice versa. However, when existing literature explores dressing and undressing they treat these two activities as markedly different. This is likely a consequence of researchers' and commentators' inclination to prioritize the destination over the journey. Texts that explore dressing tend to present it as a means of constructing a public identity, focusing in particular on the choice of clothes and the meaning that will be expressed through those garments when worn. Texts that address undressing tend instead to focus on the outcome (usually nudity). When we set aside these destinations and focus on the gestures themselves, dressing and undressing are not so dissimilar. Both are sequences of interactions between body and garments that place the actor in a state of transition, and in both there is power in the uncertainty of the outcome. A body that is passively clothed or naked must be distinguished from one that is actively dressing or undressing.

There is territory that I have not covered in this book but that readers may wish to explore with some additional reading: Lisa M. Dresner's "Love's Labour's Lost?" (2010) considers how inexperienced lovers negotiate undressing together, as part of a wider discussion about sexual inexperience as depicted in films of the 1980s. Though her text merely scratches the surface of this potentially rich area of study, she reveals that there is scope to further explore mutual undressing. Tatia Pilieva's *Undress Me* (2014), a short film made in collaboration with television production company Showtime, is just one example of how practitioners have explored subversions of mutual undressing. In this film, Pilieva presents footage of strangers awkwardly undressing each other on the occasion of their first meeting. Pilieva's subjects are participants and observers at the

same time, and introducing social dimensions to the act of undressing that is not normally present when a single actor undresses his or her own body.

Readers may also want to consider in greater detail acts of denuding. Although a few acts of denuding have been addressed in this book, most notably Yoko Ono's *Cut Piece* (see Chapter 1), there is scope to devote an investigation to the various forms of denuding that have occurred throughout human history, particularly with the aim of dehumanizing the subject. Recent debate focuses on the dehumanizing power of the strip searches carried out in prisons and juvenile detention centers, and the identities of those who are denuded in these institutions, including ethnic minorities (Newburn et al., 2004), migrants (Bhatia, 2015) and children (Willow, 2015). Discussions about the dehumanizing power of strip searches has extended to include airport settings as a result of the recent introduction of "whole body imaging technologies," which operate virtual strip searches as travelers pass through security. This new technology is frequently discussed within the context of "ever-expanding surveillance practices of the state" (Magnet and Rodgers, 2012).

There are numerous biblical acts of undressing that could be the subject of further research, including the disrobement of Christ at the tenth station of the cross, and numerous examples in which disrobing signifies devotion to a higher power or spiritual cause, through the discarding of worldly goods. Philip Carr-Gomm (2010, p. 78) provides the example of St Francis of Assisi, who "tore off his clothing in a dispute with his father," declaring that his only true father was his Christian God. Unmasking and unveiling has been explored in anthropological research, and there is scope to address contemporary acts of undressing in these terms. When the French government recently banned the use of Islamic headscarves in public schools, the subsequent unveiling became a metaphor for liberation and progress (Masquelier, 2005, p. 4). I also believe that there are opportunities to explore undressing spaces, including dressing rooms and wardrobes, perhaps with particular focus on how these spaces are typically segregated, perhaps building upon the research of Donn Short (2007) and Marianne Clark (2011). I invite other scholars to engage with these gestures with the aim of expanding this hitherto underexplored field of research.

NOTES

Chapter 1

1. It is important to note that dressing arrangements would differ according to class, before, during and after the Victorian era.
2. Jeremy Bertham's Panopticon, a circular prison designed so that inmates would never know if they were being watched from a central guard tower, prompted them to behave as if under constant surveillance. The use of the term "panoptic" here is intended to prompt consideration of the fine line between observation and supervision, or voyeurism and surveillance.
3. It is worth noting that later performers have tended to wear cheap and disposable garments for their interpretations of *Cut Piece*. John Hendricks, for example, wore a suit purchased for the occasion from a thrift store.
4. The potential for voyeurism is why, argues Shawver (1996, p. 226), spaces for undressing are typically segregated. Widespread acknowledgment that this gaze may be homosexual undermines the principles behind segregation.
5. This shift can be located alongside what Wendy Shalit (1999, p. 15) describes as "the war on embarrassment." She observes a "return to modesty" that has governed the character of some bodily display in recent decades. Shalit's observations relate to a relatively small community, for whom modesty is a rebellious defense against self-consciousness, it has subsequently been associated with a wider conservatism of Bush-era USA. Shalit stresses that this modesty is not synonymous with prudery. She locates modesty in the flexible middle ground between two unerotic extremes of promiscuity and prudery (p. 182).

 This book does not directly explore the "cultural battle [against 'raunch culture'] being fought by the Christian right in America" as this potentially contentious topic has been addressed elsewhere (Cameron, 2013, p. 149). Susan O. Michelman (2003, p. 76), for example, discusses norms and parameters of modesty within "American religious discourse with fashion."
6. Although they have similar names and similarly combine dressing and undressing, the Undress system is not to be confused with UN/DRESS, Masako Matsushita's performance piece.
7. In other, longer performances, UN/DRESS includes the process of gathering the bras from the floor, where they are neatly laid in a row, and strapping each on in turn around her waist, before proceeding to the more frequently performed act that is described in this text. See, for example, the video of her rehearsal at Teatro Moriconi at http://vimeo.com/108175982

Chapter 2

1. Undressing is not a remarkable act. It is so familiar to all of us that particular efforts must be made to transform it into spectacle. Context is the primary characteristic that differentiates mundane undressing from a performance. Within the context of a burlesque stage, where striptease is commonplace, innovation (in the form of a gimmick) is required to make each act of undressing seem original and worthwhile.
2. In popular depictions of striptease, stripping is often justified in the context of a larger narrative that exists beyond the act itself. Philip Carr-Gomm (2010, p. 225) observes that the male stripteases performed in the British comedy film *The Full Monty* (Peter Cattaneo, 1997) may have in other circumstances been viewed as exhibitionistic, but instead the film's narrative leads to a perception of the act as "heroic and socially responsible."
3. Neo-burlesque presents critical reflections on other aspects of the feminine ideal too, including motherhood. Here also, the performances can contrast the ideal with a grotesque vision of the reality. The *Desperate Housewives* performance by Sherril Dodds' (2013, p. 75), in her burlesque identity, Scarlett Korova, depicts mothers who are disgusted by the sight of their dirty babies. Beside signs that read "hazardous waste," they dangle baby dolls by their ankles and "ditch them" on a "poor male spectator."

Chapter 3

1. It is interesting to note the origins of the slash in garment design. The "puff and slash" method was historically employed to allow a sleeve to be expanded, as in the paned sleeves of the Renaissance. These sleeves were typically slashed at intervals, creating a puff that allowed free movement of the elbows or shoulders. Thus, even at this time the slash was associated with the movement of the body in a garment.
2. Reports that the sound of Velcro coming unstuck was giving away the position of army personnel led to the US Army replacing it with buttons, which can be unfastened in silence (Barnett, 2010, p. 3).

Chapter 4

1. I argue that Forsyth's comparison to nudism is flawed. Streaking occurs in part because of the naked body's value as spectacle, and this effect would be eliminated if nakedness were to become routine. Nudity is powerful precisely because it is unusual in a public setting, and to normalize, and thereby neutralize nudity (as in nudism) would be to destroy its power as a tool for protest or exhibitionism.
2. FEMEN write their messages of protest directly onto their torsos. The position of these messages invites the viewer to look directly at the breasts. Exposed breasts make gender, and difference, visible. By highlighting gender difference, these

NOTES

feminist protests are not cries for equality, rather for acknowledgment of the value of women, equivalent to—but different from—men.

3 Much could be written about the relationship between disrobement and written texts. Protest gestures cannot be said to be entirely independent of written texts, since even if there is no placard or other written slogan present at the protest, there are often manifestos that inform or explain the event. In the case of the Syracuse University disrobement, there are several texts that provide meaning for the gesture. The various regulations and statements of values published by the university offer a written record of the values that are embodied in the robe, and are written evidence of the values that are opposed in the robe's removal. The meaning of the gesture is also clarified in the students' spoken manifestos, interviews with newspapers and the call for action that was posted on Facebook.

4 When sports express unconventional values, clothing practices other than undressing have the same effect of expressing opposition to the values of the game. In Dunedin's annual nude rugby game (New Zealand), "reverse streaking" occurs, in which clothes spectators run onto the pitch in defiance of the games' rules on total nudity (Carr-Gomm, 2010, p. 15).

5 The removal of trousers usually necessitates a pause in the sprinter's dash, as (s)he must pull the trousers over his or her feet. Trousers have been the downfall of numerous streakers, who can be observed on YouTube videos tripping over as their jeans become tangled around their ankles. See, for example: "Football Streaker Fail," https://www.youtube.com/watch?v=p44WCzNt0Yw (accessed April 17, 2015).

6 There were fears that Symonds may be charged for his aggressive defense of the pitch, since the International Cricket Council player's code of conduct forbids "physical assault of a rival player, an official or a spectator" (*The Telegraph*, 2008).

7 The video, uploaded to YouTube, records one friend advising the streaker to "run right in front of them," and another advises that timing is essential to the success of his dash, saying "if you wait until the end of the quarter it'll be chaos. You can't do that. They're gonna [sic] be on lock-down at the end of the quarter." Shortly before he leaps out of his seat, another friend advises him that he should "rip your [sic] boxers off as you run." Together, these friends take the role of coach, advising on tactics and providing motivation. https://www.youtube.com/watch?v=f4eTR3uPGDY (accessed February 27, 2015).

8 It is also only within this context that the plastic beads hold their special value (Shrum and Kilburn, 1996, p. 429).

9 Roberts does not have to factor the value of lost clothes into his calculations because the police typically retrieve and return his clothes immediately. He tells *The Guardian*, "the first thing the police or security do is grab my clothes, give them to me and tell me to put them back on" (Graham, 2015).

Chapter 5

1 Ruth Barcan (2002, p. 4) recognizes a fine art tradition for a single exposed breast (as opposed to a complete pair) to express "exalted or sacred overtones." Hollander (1988, p. 187) observes that a single breast is maternal.

2 Though texts do acknowledge the potential for humorous presentation of the naked body, there is a tendency to present only the male body in this way (see, for example, boylesque, Chapter 2, or slapstick comedy, see Conclusion), and not in the context of protest. Barcan (2002, p. 6) explores the many meanings of naked female protest, and lists those that are "shocking (but natural); aggressive (but innocent); criminal (but free); anti-social (but true)," but does not suggest that naked protest can be comedic. Likewise, other texts do not suggest that female naked protest can be comedic (see, for example, Comm-Garr, 2010).

3 For a transcript of this part of the trial, see Session 26 of the Trial of Adolf Eichmann at "The Nizkor Project," http://www.nizkor.org/hweb/people/e/eichmann-adolf/transcripts/Sessions/Session-026-01.html (accessed April 27, 2015).

4 Jessica Taylor-Tudzin (2011, pp. 38–40) describes a political atmosphere in present-day Hungary in which "people would like to forget" the crimes of the Arrow Cross party, and argues that this is manifested in the Ministry of Culture's failure to make the monument more accessible.

Chapter 6

1 Official Whitehouse photographer Pete Souza has captured Obama's jacket draped on one of the chairs either side of his desk on a number of occasions, including many within his first 100 days in office, and continuing into his second term, including an infamous image of Obama leaning back in his chair, with his feet on the desk, on February 25, 2013.

2 Baraban and Duricher's (2010, p. 94) guide to Successful Restaurant Design warns of the aesthetic impact of coats left on chairs, and encourages restaurateurs to take their customers' coats on entry, or to provide alternative storage options, so that the coats will not "destroy the look" that a designer has thoughtfully developed for the interior. It is perhaps ironic that these businesses, whose spaces are designed primarily for the use of customers, object to signs of the presence of those customers.

3 In North Carolina, "a juvenile court judge can confiscate a favourite item of clothing," on the understanding that this will be a significant loss, and therefore adequate punishment, for some offences (Bowman and Kearney, 2010, p. 464).

4 *The Fall and Rise of Reginald Perrin* was adapted again by the BBC in 2009, with the abbreviated title of Reggie Perrin. As in Nobbs' novel and the 1976 series, this series follows Perrin as he travels to Brighton and removes his clothes on the beach (series 1, episode 6). However, in this adaptation Perrin decides against pseudocide having experienced a vision of his own funeral that reminds him of the fondness he feels for his wife (series 2, episode 1).

5 This credit sequence appears from the very first episode, thereby presenting Perrin's undressing and his subsequent march toward the sea as the defining acts of the series. However, Perrin does not enact his pseudocide until episode five of the first season. When it finally plays out, Perrin's pseudocide differs markedly from the scene presented in the credit sequence. The credit sequence depicts a daylight scene of gleeful undressing, in which Perrin's act is a celebration of his

new freedom. In contrast, episode 5 depicts Perrin's pseudocide as a clandestine affair, carried out in the darkness, in which his feelings of doubt take precedence over his act of undressing. Perrin arrives at the beach in the dead of night, in a commandeered delivery truck. His walk along the pebble beach is languid and thoughtful. He carries a suitcase containing his disguise, on which he perches for a moment. As he stares out to sea, Perrin experiences a moment of doubt. He ponders a genuine suicide attempt. His internal monologue considers his shame at being labeled a fraud, and how much more effective a statement his suicide would make if it were genuine. He raises his arms in the air, and takes a few steps into the ocean, fully clothed. He stops suddenly when he feels the cold water lap at his ankles, and his doubts are suddenly erased. He dashes back onto the beach and all suggestions of genuine suicide are quickly forgotten.

 This episode does not show Perrin undressing. The scene cuts to a shot of him donning the disguise that has been unpacked from his suitcase, including a false beard and overcoat. He bids goodbye to his former identity in the third person via his discarded clothes, saying, "Goodbye Reggie's clothes. Goodbye Reggie." His words reveal that the act of undressing has had personal significance for Perrin. As he sheds his clothes, he frees himself piece-by-piece from the tedium and frustrations of his former life. The suit has been a symbol of oppression throughout the series so far, and his former life is distinguished from the numerous identities that he adopts later through the means of a variety of alternative costumes. Shedding his suit, Perrin liberates himself from the restraints imposed by a single, fixed identity.

BIBLIOGRAPHY

Adams, C. J. (2011), "After MacKinnon: Sexual Inequality in the Animal Movement," in J. Sanbonmatsu (ed.), *Critical Theory and Animal Liberation*, Plymouth: Roman & Littlefield, pp. 257–276.
Aggrawal, A. (2009), *Forensic and Medico-legal Aspects of Sexual Crimes and Unusual Sexual Practices*, New York: CRC Press.
Aguirre, B. E., E. L. Quarantelli and J. L. Mendoza (1988), "The Collective Behavior of Fads: The Characteristics, Effects, and Career of Streaking," *American Sociological Review*, vol. 53, no. 4, pp. 569–584.
Alexander, S. (1974), *Lions and Foxes: Men and Ideas of the Italian Renaissance*, New York: MacMillan.
Allison, E. (2013), "43,000 Strip-Searches Carried Out on Children as Young as 12," *The Guardian* [online], 3 May, http://www.theguardian.com/society/2013/mar/03/43000-strip-searches-children (accessed November 16, 2015).
Alphen, E. (2001), "Deadly Historians: Boltanski's Intervention in Holocaust Historiography," in B. Zelizer (ed.), *Visual Culture and the Holocaust*, London: The Athlone Press, pp. 45–73.
Altman, I. and M. Chemers (1980), *Culture and Environment*, Monterey, CA: Brooks/Cole.
Anderson, P. A. (2009), "Proxemics," in S. W. Littlejohn (ed.), *Encyclopedia of Communication Theory*, London: Sage, pp. 807–808.
Ardener, S. (1974), "A Note on 'Mooning' and 'Streaking', as Forms of Non-violent Protest," *Journal of the Anthropological Society of Oxford*, vol. 5, no. 1, pp. 54–57.
Art Gallery of NSW (2006), "Doris Salcedo," *Art Gallery of New South Wales Contemporary Collection Handbook* [online]. http://www.artgallery.nsw.gov.au/collection/works/372.1997.a-o/ (accessed September 26, 2014).
Atkins, S. E. (2009), *Holocaust Denial as an International Movement*, Westport, CT: Praeger Publishers.
Ayres, I. (2013), "Scissors to Widow's Weeds: Yoko Ono's Cut Piece 2003," *The Original Van Gogh's Ear Anthology* [blog], 30 January. http://theoriginalvangoghsearanthology.com/2013/01/30/scissors-to-widows-weeds-yoko-onos-cut-piece-2003-by-ian-ayres/ (accessed October 5, 2014).
Azrin, N. H., P. M. Shaeffer and M. D. Wesolowski (1976), "A Rapid Method of Teaching Profoundly Retarded Persons to Dress by a Reinforcement-Guidance Method," *Mental Retardation*, vol. 14, no. 6, pp. 29–33.
Bader, S. M., K. A. Schoeneman-Morris, M. J. Scalora and T. K. Casady (2008), "Exhibitionism: Findings from a Midwestern Police Contact Sample," *International Journal of Offender Therapy and Comparative Criminology*, vol. 52, no. 3, pp. 270–279.

BIBLIOGRAPHY

Badiou, A. (2005), *Handbook of Inaesthetics*, A. Toscano (trans.), Stanford, CA: Stanford University Press.

Bar, N. (2014), "Nipplegate by Numbers," *ESPN* [online], 28 January. http://espn.go.com/espn/feature/story/_/id/10333439/wardrobe-malfunction-beginning-there-was-nipple (accessed November 10, 2014).

Baraban, R. S. and J. F. Duricher (2010), *Successful Restaurant Design*, 3rd edition, Hoboken, NJ: John Wiley & Sons.

Barcan, R. (2001), "The Moral Bath of Bodily Unconsciousness: Female Nudism, Bodily Exposure and the Gaze," *Continuum: Journal of Media and Cultural Studies*, vol. 15, no. 3, pp. 305–319.

Barcan, R. (2002), "Female Exposure and the Protesting Woman," *Cultural Studies Review*, vol. 8, no. 2, pp. 62–82. Reproduced at https://www.academia.edu/425279/Female_Exposure_and_the_Protesting_ Woman (accessed January 7, 2015).

Barcan, R. (2004), *Nudity: A Cultural Icon*, Oxford: Berg.

Barnard, M. (ed.) (2007), *Fashion Theory: A Reader*, London: Routledge.

Barnet, L. (2010), "Haberdashery: Velcro Comes Unstuck with the US Army," *The Guardian*, 17 June, p. 3.

Barthes, R. (1975), "Where the Garment Gapes," in M. Barnard (ed.), (2007) *Fashion Theory: A Reader*, New York: Routledge, p. 601.

Barthes, R. (1976a), *The Pleasure of the Text*, R. Miller (trans.), London: Jonathan Cape.

Barthes, R. (1976b), *Sade/Fourier/Loyla*, R. Miller (trans.), New York: Hill and Wang.

Barthes, R. (1988), *The Semiotic Challenge*, New York: Hill and Wang.

Barthes, R. (1991 [1972]), *Mythologies*, Trans. Annette Lavers, New York: Noonday Press.

Bastian, M. L. (2005), "The Naked and the Nude," in A. Masquelier (ed.), *Dirt, Undress, and Difference: Critical Perspectives on the Body's Surface*, Bloomington: Indiana University Press, pp. 34–60.

Bate, M. (2013), "Shoes on a Line," *Scars Magazine*, Fall 2013, pp. 55–58. https://issuu.com/ivanloughlen/docs/scars_magazine_reader_spreads (accessed March 13, 2016).

Bate, M. (dir.) and V. Papadopoulos (prod.) (2010), *The Mystery of Flying Kicks*, Australia: Plexus Films.

Baumeister, R. F. (1991), *Escaping the Self: Alcoholism, Spirituality, Masochism, and Other Flights from the Burden of Selfhood*, New York: Basic Books.

BBC (1999), "'Reggie Perrin' Father Escapes Punishment," *BBC News* [online], 8 June. http://news.bbc.co.uk/1/hi/uk/364379.stm (accessed December 26, 2014).

BBC (2000), "Pseudocide: Doing a Reggie Perrin," *BBC News* [online], 14 February. http://news.bbc.co.uk/1/hi/uk/639098.stm (accessed October 15, 2014).

BBC (2005), "MP Planned Death for Months," *BBC News* [online], 29 December. http://news.bbc.co.uk/1/hi/uk_politics/4564226.stm (accessed January 29, 2015).

Beanland, C. (2008), "The Cheekiest Streakers Ever," *The Sun* [online], 30 July. http://www.thesun.co.uk/sol/homepage/features/1485627/The-cheekiest-streakers-throughout-recent-history.html (accessed December 27, 2014).

Becker, F. D. and C. Mayo (1971), "Delineating Personal Distance and Territory," *Environment and Behaviour*, vol. 3, pp. 375–382.

Belton, J. (1996), "The Production Code," in J. Belton (ed.), *Movies and Mass Culture*, London: Althone Press, pp. 135–152.

Berger, J. (1972), *Ways of Seeing*, London: Penguin.

Bhatia, M. (2015), "Turning Asylum Seekers into 'Dangerous Criminals': Experiences of the Criminal Justice System of Those Seeking Sanctuary," *International Journal for Crime, Justice & Social Democracy*, vol. 4, no. 3, pp. 97–111.

Bille, M., F. Hastrup and T. F. Sorensen (2010), "An Anthropology of Absence," in M. Bille, F. Hastrup, and T. F. Sorensen (eds), *An Anthropology of Absence*, London: Springer, pp. 3–22.

Birringer, J. and M. Danjoux (2006), "The Emergent Dress: Transformation and Intimacy in Streaming Media and Fashion Performance," *Performance Research*, vol. 11, no. 4, pp. 41–52.

Blaize, I. (2010), *Burlesque Undressed* [DVD].

Blanchette, A. (2013), "Revisiting the 'Passée': History Rewriting in the Neo-burlesque Community," *Consumption Markets & Culture*, vol. 17, no. 2, pp. 158–184.

Bonner, F. (1998), "Forgetting Linda: Women Cross-dressing in Recent Cinema," *Continuum: Journal of Media and Cultural Studies*, vol. 12, no. 3, pp. 267–277.

Boorstin, D. J. (1992), *The Image: A Guide to Pseudo-events in America*, first Vintage Books edition, New York: Vintage.

Bowman, A. and R. Kearney (2010), *State and Local Government*, 8th edition, Boston, MA: Wadsworth.

Braun, S. (2008), "Audio Description Research: State of the Art and Beyond," *Translation Studies in the New Millennium*, vol. 6, pp. 14–30.

Breivik, G. (2007), "Can Base Jumping Be Morally Defended?" in M. McNamee (ed.), *Philosophy, Risk and Adventure Sports*, Oxon: Routledge, pp. 168–185.

Breward, C. (2003), *Fashion*, Oxford: Oxford University Press.

Briet, S. (1951), *Qu'est-ce que la documentation?* Paris: Édit.

Brown, G., T. B. Lawrence and S. L. Robinson (2005), "Territoriality in Organizations," *Academy of Management Review*, vol. 30, no. 3, pp. 577–594.

Brown, T. (2014), "Trisha Brown: An interview," in T. Bradshaw and N. Witts (eds), *The Twentieth Century Performance Reader*, 3rd edition, London: Routledge, pp. 119–127.

Brown Crawford, A. E. (2002), *Hope in the Holler: A Womanist Theology*, Louisville, KY: Westminster John Knox Press.

Brownie, B. and D. Graydon (2015), *Superhero Costumes: Identity and Disguise in Fact and Fiction*, London: Bloomsbury.

Bryant, C. D. (1982), *Sexual Deviancy and Social Proscription: The Social Context of Carnal Behaviour*, New York: Human Sciences Press.

Bryant, C. D. and C. J. Forsyth (2005), "'Carpe Diem (or the Hour or Minute) and Wretched Excess': Some Conceptual Notes on Temporal Opportunity Structure, Deviance Compression, and Bingeing Behaviour," *Free Inquiry in Creative Sociology*, vol. 33, no. 1, pp. 21–33.

Buckland, M. (1997), "What Is a Document?" *Journal of American Society for Information Science*, vol. 48, no. 9, pp. 804–809.

Burton, T. I. (2014), "Wing Bowl: Chicken Eating with a Difference," *BBC News* [online], 16 March. http://www.bbc.co.uk/news/magazine-26576277 (accessed September 5, 2014).

Bye, E. and E. McKinney (2007), "Sizing up the Wardrobe—Why We Keep Clothes That Do Not Fit," *Fashion Theory*, vol. 11, no. 4, pp. 483–498.

Cabrera, A. (2010), *101 Things I Learned in Fashion School*, New York: Hachette.

Caden, F. (2009), "Politics and Sexuality in Pasolini's *Petrolio*," in S. Fortuna and M. Gragnolati (eds), *The Power of Disturbance: Elsa Morante's Aracoeli*, Leeds: Legenda, pp. 107–117.

Camerani, M. (2009), "Joyce and Early Cinema: Peeping Bloom through the Keyhole," in F. Ruggieri, J. McCourt, and E. Terrinoni (eds), *Joyce in Progress: Proceedings*

BIBLIOGRAPHY

of the 2008 James Joyce Graduate Conference, Newcastle: Cambridge Scholars Publishing, pp. 114–128.

Cameron, H. (2002), "Memento Mori: Mourning, Monuments and Memory," *Prefiz Photo*, no. 5, pp. 48–57.

Cameron, J. (2013), "Modest Motivations: Religious and Secular Contestation in the Fashion Field," in R. Lewis (ed.), *Modest Fashion: Styling Bodies, Mediating Faith*, New York: I.B. Tauris, pp. 137–157.

Campbell, C. (2007), "When the Meaning Is Not a Message: A Critique on the Consumption as Communication Thesis," in M. Barnard (ed.), *Fashion Theory: A Reader*, London: Routledge, pp. 159–169.

Capps, K. (2014), "Perspectives: Chiharu Shiota at the Arthur M. Sackler Gallery to June 7, 2015," *Washington City Paper* [online], 12 September. http://www.washingtoncitypaper.com/articles/46253/perspectives-chiharu-shiota-at-the-sackler-gallery-reviewed-unremarkable-shoes/ (accessed September 24, 2014).

Carr, L. (2007), "You Can Keep Your Hat On," *Ouch!*, BBC, 23 July. http://www.bbc.co.uk/ouch/features/you_can_keep_your_hat_on.shtml (accessed January 31, 2016).

Carr-Gomm, P. (2010), *A Brief History of Nakedness*, London: Reaktion.

Carson, A. (1994), "The Gender of Sound," *Thamyris*, vol. 1, no. 1, pp. 10–32.

Cassidy, T. (1997), *Environmental Psychology: Behaviour and Experience in Context*, New York: Psychology Press.

Cavallaro, D. (2001), *Critical and Cultural Theory*, London: Athlone Press.

Cazares, D. (2007), "Hooded Changing Garment," US Patent 20070061940 A1.

Chandler, D. (2007), *Semiotics: The Basics*, 2nd edition, Oxon: Routledge.

Chalayan, H. (2015), Q&A with Hussein Chalayan, Alastair Spalding and Damien Jalet, Saddler's Wells, London, 29 October.

Childress, H. (2004), "Teenagers, Territory and the Appropriation of Space," *Childhood*, vol. 11, no. 2, pp. 195–205.

Choe, J. (2007), "Hussein Chalayan's Transforming Mechanical Dresses," *Core77* [online], 20 September. http://www.core77.com/blog/object_culture/hussein_chalayans_transforming_mechanical_dresses_7516.asp (accessed July 11, 2010).

Clark, M. (2011), "Whose Eyes? Women's Experience of Changing in a Public Change Room," *Phenomenology & Practice*, vol. 5, no. 2, pp. 57–69.

Cochrane, L. (2014), "Milan Fashion Week: Versace Tones Down for Autumn/Winter," *The Guardian* [online], 21 February. http://www.theguardian.com/fashion/2014/feb/21/milan-fashion-week-versace-tones-down-autumn-winter (accessed January 26, 2015).

Cogan, M. (2014), "In the Beginning, There Was a Nipple," *ESPN* [online], 28 January. http://espn.go.com/espn/feature/story/_/id/10333439/wardrobe-malfunction-beginning-there-was-nipple (accessed November 10, 2014).

Concannon, K. (2008), "Yoko Ono's 'Cut Piece': From Text to Performance and Back Again," *The Journal of Performance Art*, vol. 30, no. 3, pp. 81–93.

Cooper, E. (1990), *Fully Exposed: The Male Nude in Photography*, Oxon: Routledge.

Cumming, L. (2013), "Art under Attack: Histories of British Iconoclasm—Review," *The Observer* [online], 6 October. http://www.theguardian.com/artanddesign/2013/oct/06/art-under-attack-tate-review (accessed October 5, 2014).

Cwerner, S. B. (2001), "Clothes at Rest: Elements for a Sociology of the Wardrobe," *Fashion Theory*, vol. 5, no. 1, pp. 79–92.

Davis, F. (1992), *Clothes, Identity and Culture*, London: University of Chicago Press.

Davis, L. J. (1995), *Enforcing Normalcy: Disability, Deafness and the Body*, London: Verso.
Davis, A. (2011), *Baggy Pants Comedy: Burlesque and the Oral Tradition*, New York: Palgrave Macmillan.
Delite, E. (2013), "Burlesque Acts," ElizaDelite.com. http://eliza-delite.wix.com/burlesque#!acts/vstc4=article-2 (accessed August 25, 2013).
Dexter, M. R. and V. H. Mair (2010), *Sacred Display*, Amherst, NY: Cambria Press.
Disman, A. (2014), "The Politics of Burlesque: A Dialogue Among Dancers," *Canadian Theatre Review*, vol. 158, pp. s1–s16.
The Dispatch (1982), "Suicide Hoax Didn't Work," *The Dispatch*, Lexington, NC, 30 June, p. 22. http://news.google.com/newspapers?nid=1734&dat=19820630&id=wuYbAAAAIBAJ&sjid=IIIEAAAAIBAJ&pg=4610,9453646 (accessed December 20, 2014).
DiVirgilio, L. (2010), "New Protest Tactic: SU Students to Disrobe during Commencement Speech," *Syracuse.com* [online], 14 May. http://www.syracuse.com/have-you-heard/index.ssf/2010/05/new_protest_tactic_su_students.html (accessed November 13, 2014).
Dixon, N. (2001), "The Ethics of Supporting Sports Teams," *Journal of Applied Philosophy*, vol. 18, no. 2, pp. 149–158.
Dodds, S. (2013), "Embodied Transformations in Neo-burlesque Striptease," *Dance Research Journal*, vol. 45, no. 3, pp. 75–90.
Dodds, S. (2014), "The Choreographic Interface: Dancing Facial Expression in Hip-Hop and Neo-burlesque Striptease," *Dance Research Journal*, vol. 46, no. 2, pp. 38–56.
Doss, E. (2008), *The Emotional Life of Contemporary Public Memorials: Towards a Theory of Temporary Memorials*, Amsterdam: Amsterdam University Press.
Dougherty, L. (2009), "Fraudulent Undressings: Bawdy Politics in Burlesque Performance," *St. John's University Humanities Review*, vol. 8, no. 1, pp. 27–36.
Dresner, L. M. (2010), "Love's Labour's Lost? Early 1980s Representations of Girls' Sexual Decision Making in *Fast Times and Ridgemont High* and *Little Darlings*," in T. J. McDonald (ed.), *Virgin Territory: Representing Sexual Inexperience in Film*, Detroit: Wayne State University Press, pp. 174–200.
Dublon, A. (2010), "Sound, Violence, Photography: Ono, Ortega, Owens," *University of Toronto Art Journal*, vol. 3, pp. 12–26.
Dufrenne, M. (1973), *The Phenomenology of Aesthetic Experience*, Evanston, IL: Northwestern University Press.
Dunsone, J. (2014), "Stuck to the Pole: Raven Virginia and the Redefinition of Burlesque in Calgary," *Canadian Theatre Review*, vol. 158, pp. 22–26.
Eco, U. (1990), *The Limits of Interpretation*, Bloomington: Indiana University Press.
Edkins, R. (2006), Interviewed in R. Ross, "Transforming Clothes," *Technology Review* [online], 7 October. http://www.technologyreview.com/news/406705/transforming-clothes/ (accessed July 11, 2010).
Edwards, N. (2012), *On the Button: The Significance of an Ordinary Item*, London: I.B. Tauris.
Eisenman Architects (1998), "Realis Erungsentwurf: Engeres Auswahl verfahren zum Denkmal für die ermordeten Juden Europas" pamphlet from Deutsches Historisches Museum, Berlin, as cited in Cameron (2002).
Entwistle, J. and E. B. Wilson (2001), *Body Dressing*, London: Bloomsbury.
Estrada, A. (2014), "The Undress," http://www.theundress.com (accessed September 2, 2015).
Extant (2012), "Background," *Sheer* [online]. http://sheer.org.uk/background/ (accessed November 24, 2014).

BIBLIOGRAPHY

Extant (2014), "Why Are We Doing It?" *Extant* [online]. http://www.thequestion.org.uk/why/ (accessed November 24, 2014).

Feldman, J. (2008), "Untying Memory: Shoes as Holocaust Memorial Experience," in E. Nahshon (ed.), *Jews and Shoes*, Oxford: Berg, pp. 119–130.

Ferreday, D. (2008), "Showing the Girl: The New Burlesque," *Feminist Theory*, vol. 9, no. 1, pp. 47–65.

Fields, J. (2007), *An Intimate Affair: Women, Lingerie and Sexuality*, London: University of California Press.

Foley, H. P. (1994), "Commentary on the Homeric Hymn to Demeter," in H. P. Foley (ed.), *The Homeric Hymn to Demeter: Translation, Commentary and Interpretive Essays*, Princeton, NJ: Princeton University Press, pp. 28–64.

Forsyth, C. J. (1995), "Parade Strippers: A Note on Being Naked in Public," in N. J. Herman (ed.), *Deviance: A Symbolic Interactionist Approach*, Oxford: General Hall, pp. 384–392.

Foucault, M. (1977), *Discipline and Punish: The Birth of the Prison*, A. Sheridan (trans.), New York: Vintage.

Fowles, S. (2010), "People without Things," in M. Bille, F. Hastrup, and T. F. Sorensen (eds), *An Anthropology of Absence*, London: Springer, pp. 23–44.

Frank, K. (2005), "Body Talk: Revelations of Self and Body in Contemporary Strip Clubs," in A. Masquelier (ed.), *Dirt, Undress, and Difference: Critical Perspectives on the Body's Surface*, Bloomington: Indiana University Press, pp. 96–120.

Fraser, M. (2013), Interviewed in *Exposed: Beyond Burlesque*, [DVD] B. B., Matchbox films: USA.

Friedel, R. (1994), *Zipper: An Exploration of Novelty*, New York: Norton.

Gekhman, E. (2002), "In My Hometown (Brailov)," in I. Ehrenburg, V. Grossman (eds), and D. Patterson (ed. and trans.), *The Complete Black Book of Russian Jewry*, New Bruswick, NJ: Transaction Publishers, pp. 29–37.

Gersak, J. (2014), "Wearing Comfort Using Body Motion Analysis" in D. Gupta and N. Zakaria (eds), *Anthropometry, Apparel Sizing and Design*, Cambridge: Woodhead Publishing, pp. 320–333.

Gibson, M. (2004), "Melancholy Objects," *Mortality*, vol. 9, no. 4, pp. 285–299.

Girard, Q. (2012), "Bare Breasts, High Heels," P. Brett (trans.), *Vox Europ*, 20 September. http://www.presseurop.eu/en/content/article/2729841-bare-breasts-heads-high (accessed November 14, 2014).

Giulianotti, R. (2002), "Supporters, Followers, Fans and Flaneaurs: A Taxonomy of Spectator Identities in Football," *Journal of Sport and Social Issues*, vol. 26, no. 1, pp. 25–46.

Goffman, E. (1959), *The Presentation of Self in Everyday Life*, New York: Anchor Books.

Goma-i-Freixanet, M. (2004), "Sensation Seeking and Participation in Physical Risk Sports," in R. M. Stelmack (ed.), *On the Psychobiology of Personality*, London: Elsevier, pp. 185–201.

Goodrich, T. (2012), "Yoko Ono Tribute Art Will Be Presented by Baylor University Art and Theatre Students," *Baylor: Media Communications*, 5 October. http://www.baylor.edu/mediacommunications/news.php?action=story&story=123680 (accessed October 5, 2014).

Gorilla Tango Theatre (2014), "Don't Blink: A Doctor Who Burlesque," *Show Details*. https://www.gorillatango.com/cgi-bin/public/gttv2.cgi?location_number=2&show_id=989 (accessed October 29, 2014).

Goulding, C. (2002), "An Exploratory Study of Age Related Vicarious Nostalgia and Aesthetic Consumption," *Advances in Consumer Research*, vol. 29, pp. 542–546.

Graafland, A. (2003), *Versailles and the Mechanics of Power: The Subjugation of Circe*, Rotterdam: 010 Publishers.

Graham, B. A. (2015), "'I'd been paid $1m': How to streak at the Super Bowl," *The Guardian* [online], 30 January. http://www.theguardian.com/sport/2015/jan/30/id-been-paid-1m-how-to-streak-at-the-super-bowl (accessed December 6, 2015).

Guins, R. (2009), *Edited Clean Version: Technology and the Culture of Control*, Minneapolis: University of Minnesota Press.

Gurtman, Y. and M. Berenbaum (1994), *Anatomy of the Jewish Death Camp*, Bloomington: Indiana University Press.

Guttmann, A. (1996), *The Erotic in Sports*, New York: Columbia University Press.

Hancock, P. (2015), *Hoax Springs Eternal: The Psychology of Cognitive Deception*, New York: Cambridge University Press.

Hangarfest (2014), "UN:DRESS by Masako Matsushita," *Vimeo*. http://vimeo.com/87879648 (accessed February 23, 2015).

Hanna, J. L. (1988), *Dance, Sex, and Gender: Signs of Identity, Dominance, Defiance, and Desire*, London: University of Chicago Press.

Hanna, J. L. (2012), *Naked Truth: Strip Clubs, Democracy, and a Christian Right*, Austin: University of Texas Press.

Harper, P. B. (1994), *Framing the Margins: The Social Logic of Postmodern Culture*, New York: Oxford University Press.

Harvey, J. (2008), *Clothes*, Stocksfield: Acumen.

Haskell, B. and J. Hanhardt (1991), *Yoko Ono: Arias and Objects*, Layton, UT: Gibbs Smith.

Hastings, M. (1987), *The Korean War*, New York: Simon and Shuster.

Hatty, S. E. and J. Hatty (1999), *The Disordered Body: Epidemic Disease and Cultural Transformation*, Albany: State University of New York.

Helvey, R. L. (2004), *On Strategic Nonviolent Conflict: Thinking about the Fundamentals*, Boston, MA: The Albert Einstein Institute.

Henderson, S. (2013), "'Clogs, Boots and Shoes Built to the Sky': Initial Findings from a Sociomaterial Analysis of Education at Auschwitz-Birkenau State Museum," in P. Cunningham (ed.), *Identities and Citizenship Education: Controversy, Crisis and Challenges. Selected Papers from the Fifteenth Conference of the Children's Identity and Citizenship in Europe Academic Network*, London: CiCe, pp. 678–689.

Herman, N. J. (1995), "Introduction: What Is Deviant Behaviour?" in N. J. Herman (ed.), *Deviance: A Symbolic Interactionist Approach*, New York: General Hall, pp. 1–6.

Herring, E. (2008), "We're Going Streaking: The Theory of Sanctioned Deviance at Hamilton College," *Insights*, vol. 2, no. 1, pp. 3–16.

Hertz, C. (2011), "Costuming Potential: Accommodating Unworn Clothes," *Museum Anthropology Review*, vol. 5, no. 1–2, pp. 14–38.

Hess, T. B. (1972), "Pinup and Icon," in T. B. Hess and L. Nochlin (eds), *Woman as Sex Object: Studies in Erotic Art 1730–1970*, New York: Newsweek, pp. 223–237.

Hickson, M. L. and D. W. Stacks (1993), *Nonverbal Communication: Studies and Applications*, Reading, PS: William C. Brown.

Hill, E. (2013), "Catharsis and Purification in Neo-burlesque Striptease," *CUJAH* 9. http://cujah.org/past-volumes/volume-ix/essay-5-volume-9/ (accessed October 18, 2014).

Hoffmann, F. W. and W. G. Bailey (1991), *Sports and Recreation Fads*, New York: Haworth Press.

BIBLIOGRAPHY

Holland, S. L. (2009), "The 'Offending' Breast of Janet Jackson: Public Discourse Surrounding the Jackson/Timberlake Performance at Super Bowl XXXVIII," *Women's Studies in Communication*, vol. 32, no. 2, pp. 129–150.

Hollander, A. (1988), *Seeing through Clothes*, Berkley, LA: University of California Press.

Howe, E. (1851), "Improvement in Fastenings for Garments," US Patent no. 8540 A. http://www.google.com/patents/US8540 (accessed November 9, 2014).

Huehls, M. (2008), "Foer, Spiegelman, and 9/11's Timely Traumas," in A. Keniston and J. Follansbee Quinn (eds), *Literature after 9/11*, New York: Routledge, pp. 60–81.

Hutcheon, L. (2000), *A Theory of Parody: The Teachings of Twentieth–Century Art Forms*, New York: Methuen.

Huxley, A. (1932), *Brave New World*, New York: Bantam Books.

Iarocci, L. (2009), "Dressing Rooms: Women, Fashion and the Department Store," in J. Potvin (ed.), *The Places and Spaces of Fashion, 1800–2007*, New York: Routledge, pp. 169–185.

Iltanen-Tähkävuori, S., M. Wikber and P. Topo (2012), "Design and Dementia: A Case of Garments Designed to Prevent Undressing," *Dementia: The International Journal of Social Research and Practice*, vol. 11, no. 1, pp. 49–59.

ITC (2000), "ITC Guidance on Standards for Audio Description," *Ofcom* [online]. http://www.ofcom.org.uk/static/archive/itc/uploads/ITC_Guidance_On_Standards_for_Audio_Description.doc (accessed November 24, 2014).

Jaworski, A. and C. Thurlow (2010), "Introducing Semiotic Landscapes," in A. Jaworski and C. Thurlow (eds), *Semiotic Landscapes: Language, Image, Space*, London: Continuum.

Jeffreys, D. S. (2009), *Spirituality and the Ethics of Torture*, New York: Palgrave McMillan.

Jeon, E. (2009), "Object Playing with Movement: A Source of Comfort and Enjoyment," paper presented at *International Association of Societies of Design Research 2009*, 18 October, Seoul, Korea. https://crash.curtin.edu.au/research/groups/body/EJ_Jeon_IASDR09.2009.pdf (accessed November 9, 2014).

Johnson, C. (2014), "Performance Photographs and the (Un)clothed Body: Yoko Ono's Cut Piece," *Clothing Cultures*, vol. 1, no. 2, pp. 143–154.

Jones, M. T. (2009), "Mediated Exhibitionism: The Naked Body in Theory, Performance, and Virtual Space," paper presented at *Joint Conference of the National Popular Culture and American Culture Associations*, 8–11 April, New Orleans, Louisiana. http://www.mattsmediaresearch.com/MediatedExhibitionism.html (accessed May 16, 2014).

Jones, M. T. (2010), "Mediated Exhibitionism: The Naked Body in Theory, Performance, and Virtual Space," *Sexuality and Culture*, vol. 14, no. 4, pp. 253–269.

Jones, J. (2013), "Art under Attack: The Exhibition That Risks Desecrating Itself," *The Guardian* [online], 30 September. http://www.theguardian.com/artanddesign/2013/sep/30/art-under-attack-tate-britain-review (accessed October 5, 2014).

Joseph, L. (2012), "Blurring the Gender Line: When the Frock Just Won't Fit," *The Independent* [online], 17 February. http://blogs.independent.co.uk/2012/02/20/blurring-the-gender-line-when-the-frock-just-won't-fit/ (accessed October 29, 2014).

Kalina, D. (2002), "Body Covering Garment for Use during Clothes Changing," US Patent 20020170104 A1.

Kane, B. (2011), "Acousmatic Fabrications: Les Paul and the 'Les Paulverizer'," *Journal of Visual Culture*, vol. 10, no. 2, pp. 212–231.

Kaplan, B. A. (2007), *Unwanted Beauty: Aesthetic Pleasure in Holocaust Representation*, Champaign: University of Illinois Press.

Kaplan, I. (2013), "Purim's Other Woman: Vashti, the Queen Who Kept Her Clothes On," *Jewish Journal* [online], 20 February. http://www.jewishjournal.com/purim/article/purims_other_woman_vashti_the_queen_who_kept_her_clothes_on (accessed December 19, 2014).

Kaufman, C. (2009), "PETA's State of the Union Address," *Audrey Monroe* [blog], 25 October. https://audreymonroe.wordpress.com/2009/10/25/petas-state-of-the-union-undress/ (accessed November 12, 2014).

Kaysen, R. (2005), "The Naked Truth about the Power of Protest Today," *The Villager* [online], vol. 75, no. 12. http://thevillager.com/villager_119/talkingpoint.html (accessed March 1, 2015).

Keaton, S. A. and C. C. Gearhart (2013), "Identity Formation, Strength of Identification, and Self-categorization as Predictors of Behavioral and Psychological Outcomes: A Model of Sport Fandom," paper presented at the *International Association for Communication and Sport*, Austin, Texas, 22–24 February.

Kendon, A. (2004), *Gesture: Visible Action as Utterance*, Cambridge: Cambridge University Press.

Khan, N. (2000), "Catwalk Politics," in S. Bruzzi and P. C. Gibson (eds), *Fashion Cultures. Theories, Explorations and Analysis*, New York: Routledge, pp. 114–127.

Kiremidjian, G. D. (1969), "The Aesthetics of Parody," *The Journal of Aesthetics and Art Criticism*, vol. 28, no. 2, pp. 231–242.

Kirkpatrick, B. (2008), "'It Beats Rocks and Tear Gas': Streaking and Cultural Politics in the Post-Vietnam Era," *Journal of Popular Culture*, vol. 43, no. 5, pp. 1023–1047. Reproduced at http://www.billkirkpatrick.net/streaking1.html (accessed January 1, 2015).

Koda, H. (2003), *Goddess: The Classical Mode*, New York: The Metropolitan Museum of Art.

Kohe, G. Z. (2012), "Decorative Dashes: Disrobing the Practice of Streaking," *Costume*, vol. 46, no. 2, pp. 197–211.

Krammer, A. (2008), *Prisoners of War: A Reference Handbook*, London: Praeger Security International.

Kuppers, P. (2003), *Disability and Contemporary Performance: Bodies on Edge*, Oxon: Routledge.

Kutner, M. (2014), "What's in a Shoe? Japanese Artist Chiharu Shiota Investigates," *Smithsonian.com* [online], 28 August. http://www.smithsonianmag.com/smithsonian-institution/whats-shoe-japanese-artist-chiharu-shiota-investigates-180952458/ (accessed September 24, 2014).

La Fontaine, J. (1896), "The Devil of Pop Fig Island," in *Tales and Novels in Verse*, vol. 2, London: The Society of English Bibliophilists, pp. 131–137. Reproduced at *Project Gutenberg*, http://www.gutenberg.org/files/5300/5300-h/5300-h.htm (accessed December 11, 2014).

Langdale, A. (2002), "S(t)imulation of Mind: The Film Theory of Hugo *Munsterberg*," in A. Langdale (ed.), *Hugo Münsterberg on Film: The Photoplay: A Psychological Study and Other Writings*, London: Routledge, pp. 1–43.

Lehman, P. (1993), *Running Scared: Masculinity and the Representation of the Male Body*, Detroit: Wayne State University Press.

Leonard, D. J. and C. R. Lugo-Lugo (2005), "Women, Sexuality and the Black Breast: Seeming Acts of Transgression in Popular Culture and the Consequences (the case of the 2003 VMA and the 2004 Super Bowl Half-Time Show)," in V. P. Messier and

N. Batra (eds), *Transgression and Taboo: Critical Essays*, Mayaguez: Caribbean Chapter Publications, pp. 95–114.

Levine, P. (2008), "States of Undress: Nakedness and the Colonial Imagination," *Victorian Studies*, vol. 50, no. 2, pp. 189–219.

Lewins, D. (2012), "Empty Shoes a Stark Reminder of National Road Toll," *ABC News* [online], 25 May. http://www.abc.net.au/news/2012-05-25/shoes-fill-martin-place-in-road-safety-campaign/4033986 (accessed September 17, 2014).

Lewis, V. D. (2007), "Sizing and Clothing Aesthetics," in S. Ashdown (ed.), *Sizing in Clothing*, Cambridge: Woodhead, pp. 309–327.

Lewis, M. J. (2014), "'Am I Not Really Dead?' Pseudocide, Individuation, and the Fictional Awakening," *Literary Imagination*, vol. 16, no. 3, pp. 344–365.

Ley, D. and Cybriwsky, R. (1974), "Urban Graffiti as Territorial Markers," *Annals of the Association of American Geographers*, vol. 64, no. 4, pp. 491–505.

Liepe-Levinson, K. (1998), "Striptease: Desire, Mimetic Jeopardy, and Performing Spectators," *TDR*, vol. 42, no. 2, pp. 9–37.

Lo, D. (2013), "Here's a 1930s Burlesque Stars' Guide to How a 'Wife' Should Undress," *Glamour* [online], 18 July. http://www.glamour.com/fashion/blogs/dressed/2013/07/heres-a-1930s-burlesque-stars (accessed December 4, 2014).

Lowndes, S. (2008), "Report: Back to You: Contemporary Performative Practice," *Map Magazine* [online], 1 October. http://mapmagazine.co.uk/8930/report-back-to-you-contempor/ (accessed October 5, 2014).

Lumley, R. (2014), "The Body in and of the Image in the Films of Yervant Gianikian and Angela Ricci Lucchi," in S. P. Hill and G. Minghelli (eds), *Stillness in Motion: Italy, Photography, and the Meanings of Modernity*, Toronto: University of Toronto Press.

Lunceford, B. (2012), *Naked Politics: Nudity, Political Action, and the Rhetoric of the Body*, Plymouth: Lexington.

Lurie, A. (1981), *The Language of Clothes*, New York: Random House.

Lyczba, F. (2013), "The Living Realities of Romance": Playing with the Illusion of Reality in 1920s Film Reception Paratexts," paper presented at *Media Mutations 5*, 21–22 May, Universita di Bologna.

Maas, D. (2001), "Convertible Costume Construction," US Patent 6308334 B1. http://www.google.co.uk/patents/US6308334 (accessed January 1, 2015).

Mackie, V. (2008), "Doris Salcedo's Melancholy Objects," *Portal: Journal of Interdisciplinary International Studies*, vol. 5, no. 1, http://epress.lib.uts.edu.au/journals/index.php/portal/article/view/373/535 (accessed September 26, 2014).

Magnet, S. and T. Rogers (2012), "Stripping for the State: Whole Body Imaging Technologies and the Surveillance of Othered Bodies," *Feminist Media Studies*, vol. 12, no. 1, pp. 101–118.

Mälzer-Semlinger, N. (2012), "Narration or Description: What Should Audio Description Look Like?" in E. Perego, *Emerging Topics in Translation: Audio Description*, Trieste: EUT Edizioni Università di Trieste, pp. 29–36.

Markham, M. (2010), "Jamie Dimon Stirs Outcry from College Students," *ABC News* [online], 16 April. http://abcnews.go.com/WN/syracuse-university-students-protest-jpmorgan-chase-ceo-jamie/story?id=10365948&singlePage=true (accessed March 1, 2015).

Martin, R. H. (1997), *Gianni Versace*, New York: Metropolitan Museum of Art.

Martin, R. (1998), "A Note: Gianni Versace's Anti-bourgeois Little Black Dress," *Fashion Theory*, vol. 2, no. 1, pp. 95–100.

Mason, W. E. (1919), "Conscientious Objectors: Remarks of Hon. William E. Mason of Illinois in the House of Representatives," Washington: Government Printing Office. Reproduced in Moore, H. W. (1993), *Plowing My Own Furrow*, Syracuse, NY: Syracuse University Press, pp. 199–214.

Masquelier, A. (2005), "Dirt, Undress, and Difference: An introduction," in A. Masquelier (ed.), *Dirt, Undress, and Difference: Critical Perspectives on the Body's Surface*, Bloomington: Indiana University Press, pp. 1–33.

Mauss, M. (2005 [1936]), "Techniques of the Body," in M. Fraser and M. Greco (eds), *The Body: A Reader*, Abingdon, Routledge, pp. 73–77. Originally published in Economy and Society, no. 2, pp. 70–88.

Maycroft, N. (2009), "Not Moving Things Along: Hoarding Clutter and Other Ambiguous Matter," *Journal of Consumer Behaviour*, vol. 8, no. 6, pp. 345–364.

McCusker, G. (2005), *Public Relations Disasters: Talespin–Inside Stories and Lessons Learnt*, London: Kogan Page.

Media Access Australia (2014), "Audio Description Guidelines," *Media Access Australia* [online]. http://www.mediaaccess.org.au/practical-web-accessibility/media/audio-description-guidelines (accessed November 20, 2014).

Meir, R. A. (2009), "Tribalism, Team Brand Loyalty, Team Brand Value and Personal/Group Identity in Professional Rugby Football," PhD thesis, Southern Cross University, Lismore, NSW.

Merton, P. (2009), *Silent Comedy*, London: Random House.

Meyer, M. (1991), "I Dream of Jeannie: Transsexual Striptease as Scientific Display," *TDR (1988-)*, vol. 35, no. 1, pp. 25–42.

Meyer, M. (2012), "Placing and Tracing Absence: A Material Culture of the Immaterial," *Journal of Material Culture*, vol. 17, no. 1, pp. 103–110.

Micchelli, T. (2014), "Impossible Beauty, Erotic and Sublime," *Hyperallergic*, 1 March. http://hyperallergic.com/111685/impossible-beauty-erotic-and-sublime/ (accessed January 29, 2015).

Michelman, S. O. (2003), "Reveal or Conceal? American Religious Discourse with Fashion," *Etnofoor*, vol. 16, no. 2, pp. 76–87.

Miller, D. (2010), *Stuff*, Cambridge: Polity Press.

Misri, D. (2011), "'Are You a Man?': Performing Naked Protest in India," *Signs*, vol. 36, no. 3, pp. 603–625.

MMA (2008), "Unzipped," *Blog.Mode: Addressing Fashion*, Metropolitan Museum of Art, http://blog.metmuseum.org/blogmode/2008/01/24/unzipped / (accessed October 2, 2015).

MMA (2014), *Charles James: Beyond Fashion*, Exhibition Catalogue, 8 May–10 August, Metropolitan Museum of Art, New York.

Monahan, M. (2015), "Gravity Fatigue, Hussein Chalayan, Sadler's Wells, review: 'clothes with a life of their own'," *The Telegraph* [online], 29 October. http://www.telegraph.co.uk/dance/what-to-see/gravity-fatigue-hussein-chalayan-sadlers-wells-review/ (accessed October 31, 2015).

Monks, A. (2010), *The Actor in Costume*, New York: Palgrave Macmillan.

Moran, L. J. (2001), "The Gaze of Law: Technologies, Bodies, Representations," in J. Hassard and R. Hollida, (eds), *Contested Bodies*, London: Routledge, pp. 107–117.

Moran, L. J. and D. McGhee (2000), "Perverting London: The Cartographic Practices of Law," in D. Herman and C. Stychin (eds), *Sexuality in the Legal Arena*, London: Althone Press, pp. 100–110.

BIBLIOGRAPHY

Motion Picture News (1922), "Blind Bargain Victim Brings Space in Newspapers," *Motion Picture News*, 23 December.

Mounsef, D. (2008), "The Seen, the Scene and the Obscene: Commodity Fetishism and Corporeal Ghosting," *Women & Performance: A Journal of Feminist Theory*, vol. 15, no. 2, pp. 243–261.

Moye, D. (2012), "Masked Streaker at Florida High Scholl Football Game Gets Away," *Huffington Post* [online], 11 November. http://www.huffingtonpost.com/2012/09/11/masked-streaker-florida-high-school-video_n_1874987.html (accessed December 28, 2014).

Muehlemann, N. (2013), "Criptease at Southbank Centre's WOW Festival," *Disability Arts Online*, 15 March. http://www.disabilityartsonline.org.uk/southbank-centre-criptease (accessed November 24, 2014).

Münsterberg, H. (1916), *The Photoplay*, New York: D. Appelton and Co. Reproduced at Project Gutenberg, http://www.gutenberg.org/ebooks/15383 (accessed November 16, 2015).

Nally, C. (2009), "Grrrly Hurly-Burly: Neo-burlesque and the Performance of Gender," *Textual Practice*, vol. 23, no. 4, pp. 621–643.

Napier, A. D. (1986), *Masks, Transformation, and Paradox*, Berkley: University of California Press.

Nash, John (2013), "Exhibiting the Example: Virginia Woolf's Shoes," *Twentieth-Century Literature: A Scholarly and Critical Journal*, vol. 59, no. 2, pp. 283–308.

Nasrin, M. (2007), "Erotic Actions vs. Sexual Happenings," paper presented at *The Erotic: 3rd Global Conference*, Salzburg, Austria, 16–18 November.

National Conference of State Legislatures (2006), "Moon on in Maryland," *The Free Library*. http://www.thefreelibrary.com/Moon+on+in+Maryland.-a0142923264 (accessed September 10, 2015).

Nelson, K. (2002), "The Erotic Gaze and Sports: An Ethnographic Consideration," *Journal of Sport History*, vol. 29, no. 3, pp. 407–412.

Newburn, T., M. Shiner and S. Hayman (2004), "Race, Crime and Injustice?: Strip Search and the Treatment of Suspects in Custody," *British Journal of Criminology*, vol. 44, no. 5, pp. 677–694.

Newman, B. (2004), *Subjects on Display: Psychoanalysis, Social Expectation and Victorian Femininity*, Athens, OH: Ohio University Press.

Nobbs, D. (1975), *The Death of Reginald Perrin: A Novel* [later reissued as *The Fall and Rise of Reginald Perrin*], London: Gollanz.

Norner, N. (2013), "Abandoned Clothes Spark Search," *The Parksville Qualicum Beach News* [online], 14 March. http://www.pqbnews.com/news/198046721.html (accessed October 15, 2014).

Ono, Y. (1974), "If I Don't Give Birth Now, I Will Never Be Able To," *Bungei Shunju*. Reproduced in Suzuki, A. (trans.) (1986) *Just Me! The Very First Autobiographical Essay by the World's Most Famous Japanese Woman*, Tokyo: Kodansha International, pp. 34–36.

Ono, Y. (2009), "Yoko Ono: The Stanford Lecture," lecture presented at Stanford University, 14 January 2009. Reproduced on *Imagine Peace*, 11 March. http://imaginepeace.com/archives/5576 (accessed October 5, 2014).

Owen, D. (2014), "Neo-burlesque and the Resurgence of Roller Derby: Empowerment, Play, and Community," *Canadian Theatre Review*, vol. 158, pp. 33–38.

Pandaram, J. and P. Bibby (2008), "Symonds Hits a Streaker for Six," *The Sydney Morning Herald* [online], 5 March. http://www.smh.com.au/news/cricket/symonds

-hits-a-streaker-for-six/2008/03/04/1204402461316.html (accessed December 28, 2014).

Pantouvaki, S. (2014), "Narratives of Clothing: Concentration Camp Dress as a Companion to Survival," *International Journal of Fashion Studies*, vol. 1, no. 1, pp. 19–37.

Patterson, E. (2008), *On Brokeback Mountain: Mediations about Masculinity, Fear, and Love in the Story and the Film*, Plymouth: Lexington.

Patton, P. (1998), "Foucault's Subject of Power," in J. Moss (ed.), *The Later Foucault. Politics and Philosophy*, London: Sage, pp. 64–77.

Pauletto, S. (2014), "Film and Theatre-based Approaches for Sonic Interaction Design," *Digital Creativity*, vol. 25, no. 1, pp. 15–26.

Perniola, M. (1989), "Between Clothing and Nudity," in M. Feher (ed.), *Fragments of the Human Body: Part two*, Cambridge, MA: MIT Press, pp. 237–265.

Petrarca, E. (2014), "What Actually Happens to Clothes Left at the Dry Cleaner?" *The Cut* [online], 30 January. http://nymag.com/thecut/2014/01/what-happens-to-clothes-left-at-the-dry-cleaner.html (accessed October 14, 2014).

Petrides, M. (2006), "Chadors and Graffiti, EU Flags and Iconic Bodies: Four Contemporary Visual Artists," *Opticon1826*, vol. 1, http://dx.doi.org/10.5334/opt.010611 (accessed January 19, 2015).

Pickert, K. (2014), "Tank Man at 25: Behind the Iconic Tiananmen Square Photo," *Time* [online], 4 June. http://lightbox.time.com/2014/06/04/tank-man-iconic-tiananmen-photo/ (accessed October 12, 2014).

Piety, P. J. (2004), "The Language System of Audio Description: An Investigation as a Discursive Process," *Journal of Visual Impairment and Blindness*, vol. 98, no. 8, pp. 453–469. Reproduced at http://files.eric.ed.gov/fulltext/EJ683817.pdf (accessed January 30, 2015).

Pouvar, A. (2006), "Coats on Office Chair Backs: Health and Safety Concern?" *Visor Down* [forum post], 20 June. http://www.visordown.com/forum/general/coats-on-office-chair-backs---health-and-safety/233895.html (accessed October 31, 2014).

Poynor, R. (2003), *No More Rules: Graphic Design and Postmodernism*, London: Laurence King Publishing.

Poynor, R. (2013), "Occupation Hazardous," *Eye Magazine* [online], 13 November. http://www.eyemagazine.com/opinion/article/occupation-hazardous (accessed October 13, 2015).

Prager, J. (2014), "Colorado Students Strip Naked in Protest of 'Censorship' of AP History Classes," *Americans Against The Tea Party*, 26 September. http://aattp.org/colorado-students-strip-naked-in-protest-of-censorship-of-ap-history-classes-imagesvideo/ (accessed March 1, 2015).

Preucel, R. W. (2006), *Archeological Semiotics*, Oxford: Blackwell.

Puri, T. (2013), "Fabricating Intimacy: Reading the Dressing Room in Victorian Literature," *Victorian Literature and Culture*, vol. 41, no. 3, pp. 503–525.

Quick, H. (2009), "From Fashion and Back: Hussein Chalayan's Latest Exhibition," *The Telegraph* [online], 20 January. http://www.telegraph.co.uk/fashion/4299978/From-Fashion-And-Back-Hussein-Chalayans-latest-exhibition.html (accessed July 7, 2010).

Quinn, B. (2002a), *Techno Fashion*, Oxford: Berg.

Quinn, B. (2002b), "A Note: Hussein Chalayan, Fashion and Technology," *Fashion Theory*, vol. 6, no. 4, pp. 359–368.

Ranshaw, L. (2010), "Missing Bodies Near-at-Hand: The Dissonant Memory and Dormant Graves of the Spanish Civil War," in M. Bille et al. (eds), *An Anthropology of Absence: Materializations of Transcendence and Loss*, London: Springer, pp. 45–61.

Ravel, J. S. (2007), "The Coachman's Bare Rump: An Eighteenth-Century French Cover-up," *Eighteenth-Century Studies*, vol. 40, no. 2, pp. 279–308.

Reichert, T. (2003), *The Erotic History of Advertising*, New York: Prometheus.

Reus, T. G. and T. Gifford (2013), "Introduction," in T. G. Reus and T. Gifford (eds), *Women in Transit through Literary Liminal Spaces*, New York: Palgrave Macmillan, pp. 1–16.

Reynolds, R. and H. Gye (2012), "Thousands of Empty Shoes Commemorate Grim Side of Golden Gate Bridge as Notorious Suicide Spot Celebrates Its 75th Anniversary," *Daily Mail* [online], 28 May. http://www.dailymail.co.uk/news/article-2151059/Golden-Gate-Bridge-marks-75th-birthday-day-long-celebration-magnificent-fireworks-display.html (accessed September 27, 2014).

Rhee, J. (2005), "Performing the Other: Yoko Ono's *Cut Piece*," *Art History*, vol. 28, no. 1, pp. 96–118.

Rhodes, Z. and A. Knight (1984), *The Art of Zandra Rhodes*, London: Michael O'Mara Books.

Ribeiro, A. (1986), *Dress and Morality*, London: Batsford.

Richardson, B. (2006), "Support Your Local Team: Resistance, Subculture, and the Desire for Distinction," *Advances in Consumer Research*, vol. 33, pp. 175–180.

Rock, I. (1975), *An Introduction to Perception*, New York: Macmillan.

Ronayne, K. (2010), "Commencement 2010: Student Protestors Plan to Take Off Graduation Robes during Dimon's Address," *The Daily Orange* [online], 10 May. http://www.dailyorange.com/2010/05/commencement-2010-student-protestors-plan-to-take-off-graduation-robes-during-dimon-s-address/ (accessed March 1, 2015).

Rosen, R. M. (2007), *Making Mockery: The Poetics of Ancient Satire*, New York: Oxford University Press.

Rosenau, M. (2005), "Identity in the Lining: Hussein Chalayan's Clothes Tell Stories and Reveal Dreams of Flying," *Sign and Sight* [online], 26 April. http://www.signandsight.com/features/124.html (accessed November 8, 2014).

Rossiter, L. (2004), "Real Reginald Perrin Incidents," *Reggie Online: The Official Reginald Perrin Website*, http://www.leonardrossiter.com/reginaldperrin/Real.html (accessed December 26, 2014).

Rothstein, N., M. Ginsburg, A. Hart, V. D. Mendez and P. Barnard (1984), *Four Hundred Years of Fashion*, London: V&A Publications.

Rowley, A. A. (2002), *U.S. Prisoners of War in the Korean War: Their Treatment and Handling by the North Korean Army and the Chinese Communist Forces*, Paducah, KY: Turner.

Sampaoi, D. M. (2013), "The Image of Revolution," paper presented at TVAD seminar, 20 November, University of Hertfordshire, Hatfield.

Sandoval, C. (2000), *Methodology of the Oppressed*, Minneapolis: University of Minnesota Press.

Sapikowski, L. (2012), "Mourning in Absent Memorials," *International Journal of Humanities and Social Sciences*, vol. 2, no. 13, pp. 288–295.

Saunders, N. J. (2002), "Memory and Conflict," in V. Buchli (ed.), *The Material Culture Reader*, Oxford: Berg, pp. 175–180.

Scheub, H. (1977), "Body and Image in Oral Narrative Performance," *New Literary History*, vol. 8, pp. 345–367.

Schwichtenberg, C. (1981), "Erotica: The Semey Side of Semiotics," *SubStance*, vol. 10, no. 3, pp. 26–38.

Scott, S. and R. Gilbert (2014), "Teasing, Transgressing, Defining—Broadening the Spectrum of Sexy," *Canadian Theatre Review*, vol. 158, pp. 5–6.

Seely, S. D. (2013), "How Do You Dress a Body without Organs?: Affective Fashion and Nonhuman Becoming," *Women's Quarterly Studies*, vol. 41, no. 1–2, pp. 247–265.

Segal, D. (2007), "Cover Garment for Changing Clothing," US Patent 20070017000 A1.

Selwyn-Holmes, A. (2009), "The Twickenham Streaker," *Iconic Photos* [blog], 30 July. http://iconicphotos.wordpress.com/tag/michael-obrien/ (accessed December 27, 2014).

Sera, K. (2013), "Kay Sera Spoke Word Burlesque," http://m.bhojpurinama.com/trendsplay/B5hha4C0H9c/Kay-Sera-Spoken-Word-Burlesque-Strictly-Germ-Proof (accessed October 29, 2014).

Shaffer, D. R. and C. Sadowski (1975), "This Table Is Mine: Respect for Marked Barroom Tables as a Function of Gender of Spatial Marker and Desirability of Locale," *Sociometry*, vol. 38, no. 3, pp. 408–419.

Shalit, W. (1999), *A Return to Modesty: Discovering the Lost Virtue*, New York: Touchstone.

Sharp, M. D. (1998), "Remaking Medieval Heroism: Nationalism and Sexuality in *Braveheart*," *Florilgium*, vol. 15, pp. 251–266.

Shawver, L. (1996), "Sexual Modesty, the Etiquette of Disregard and the Question of Gays and Lesbians in the Military," in G. Herek, J. Jobe, and R. Carney (eds), *Out in Force: Sexual Orientation and the Military*, Chicago: University of Chicago Press, pp. 226–244.

Shields, N. (2011), "Empty Shoes Fill with Memories at 9/11 Memorial," *Asbury Park Press* [online]. http://www.app.com/article/20110909/NJNEWS/309090048/Empty-shoes-fill-memories-Ocean-Grove-9-11-memorial (accessed September 27, 2014).

Short, D. (2007), "The Informal Regulation of Gender: Fear and Loathing in the Locker Room," *Journal of Gender Studies*, vol. 16, no. 2, pp. 183–186.

Shrum, W. and J. Kilburn (1996), "Ritual Disrobement at Mardi Gras: Ceremonial Exchange and Moral Order," *Social Forces*, vol. 75, no. 2, pp. 423–458.

Smith, G. (2004), "The Subway Gate Scene in *The Seven Year Itch*: 'The Staging of an Appearance as Disappearance'," *Cinémas: Journal of Film Studies*, vol. 14, no. 2–3, pp. 213–244.

Smith, B. (2010), "Streaker Faces Fine and May Cop Cup Ban," *Taranaki Daily News* [online], 16 October. http://www.stuff.co.nz/taranaki-daily-news/news/4240105/Streaker-faces-fine-and-may-cop-Cup-ban (accessed December 29, 2014).

Smith, M. R. (2013), "The Mysterious Phenomenon of Shoe Tossing and Shoe Posting," *The Silo* [online], 2 April. http://www.thesilo.ca/the-mysterious-phenomenon-of-shoe-tossing-and-shoe-posting/ (accessed October 10, 2014).

Smith, M. (2014), "Tank Man: What Happened to the Man Who Stood in Front of Tanks in Tiananmen Square?" *The Mirror* [online], 4 June http://www.mirror.co.uk/news/world-news/tank-man-what-happened-man-3644636 (accessed October 12, 2014).

Solomon, M. (2000), "Twenty-Five Heads under One Hat: Quick Change in the 1890s," in V. Sobchack (ed.), *Meta-Morphing: Visual Culture and the Culture of Quick Change*, Minneapolis: University of Minnesota Press, pp. 3–20.

Sommer, R. (1967), "Sociofugal Space," *American Journal of Sociology*, vol. 72, no. 6, pp. 654–660.

Sommer, R. and F. D. Becker (1969), "Territorial Defense and the Good Neighbor," *Journal of Personality and Social Psychology*, vol. 11, no. 2, pp. 85–92.

Sørensen, T. F. (2010), "A Saturated Void: Anticipating and Preparing Presence in Contemporary Danish Cemetery Culture," in M. Bille et al. (eds), *An Anthropology of Absence: Materializations of Transcendence and Loss*, London: Springer, pp. 115–130.

Sowers, A. (2014), "Tit for Tat: Burlesque and Pop Culture," paper presented at *35th Annual Southwest Popular/American Culture Association Conference*, 19 February. https://www.academia.edu/6204856/Tit_for_Tat_Burlesque_and_Pop_Culture_An_Exploration_of_the_Potential_Benefits_and_Drawbacks_to_the_Mutual_Appropriation_Between_Mainstream_Media_and_Neo-Burlesque (accessed September 1, 2014).

Spiegelman, A. (2004), *In the Shadow of No Towers*, New York: Viking.

Steele, V. (1998), "A Museum of Fashion Is More Than a Clothes-Bag," *Fashion Theory*, vol. 2, no. 4, pp. 317–335.

Steele, V. (2001), *The Corset: A Cultural History*, London: Yale University Press.

Steele, V. (2014), "A Hole in the Sole: The Sinful Symbology and Shadowy History of the Fishnet," *CR Fashion Book*, issue 5, 28 October. http://www.crfashionbook.com/text/a-hole-in-the-sole/ (accessed November 10, 2014).

Stevens, J. (2011), "Streaker Posing as a Referee Sends Football Game into Chaos as Confused Players Start Brawl," *The Daily Mail* [online], 21 October. http://www.dailymail.co.uk/news/article-2051977/Streaker-posing-referee-sends-Arizona-football-game-chaos-confused-players-start-brawl.html#ixzz3N9MiNRSo (accessed December 28, 2014).

Stone, J. (1988), "Velcro: The Final Frontier," *Discover*, vol. 9, no. 5, pp. 82–84.

Sturken, M. (2004), "The Aesthetics of Absence: Rebuilding Ground Zero," *American Ethnologist*, vol. 31, no. 3, pp. 311–325.

Sutton, B. (2007), "Naked Protest: Memories of Bodies and Resistance at the World Social Forum," *Journal of International Women's Studies*, vol. 8, no. 3, pp. 139–148.

Szepessy, V. L. (2014), "The Marriage Maker: The Pergamon Hermaphrodite as the God Hermaphroditos, Divine Ideal and the Erotic Object," MA Thesis, University of Oslo.

Tallichet, J. (2010), "Press Release: Abandoned Clothes," *Jude Tallichet Studio* [online]. http://judetallichetstudio.com/index.php?/press-release/abandoned-clothes-2010/ (accessed October 15, 2014).

Tallichet, J. (2012), "Rowing in Eden," *Jude Tallichet Studio* [online]. http://judetallichetstudio.com/index.php?/press-release/rowing-in-eden-2012/ (accessed March 26, 2015).

Tallichet, J. (2014), "Six Features," *Jude Tallichet Studio* [online]. http://judetallichetstudio.com/index.php?/press-release/six-features/ (accessed April 17, 2015).

Taras, M. E. and M. Matese (1990), "Independent Dressing," in J. L. Matson (ed.), *Handbook of Behaviour Modification with the Mentally Retarded*, New York: Plenum Press, pp. 288–293.

Tate (2013), "Art under Attack: Histories of British Iconoclasm," Press release, 28 May. http://www.tate.org.uk/about/press-office/press-releases/art-under-attack-histories-british-iconoclasm (accessed October 5, 2014).

Taylor, R. B. (1988), *Human Territorial Functioning: An Empirical, Evolutionary Perspective on Individual and Small Group Territorial Cognitions, Behaviours, and Consequences*, Cambridge: Cambridge University Press.

Taylor, R. B. and S. Brower (1985), "Home and Near-Home Territories," in I. Altman and C. Werner (eds), *Human Behaviour and Environment: Advances in Theory and Research*, New York: Plenum, pp. 183–212.

Taylor-Tudzin, J. (2011), "Holocaust Memorials in Budapest, Hungary, 1987–2010: Through the Words of the Memorial Artists," MA thesis, Central European University.

Tejirian, E. (2000), *Male to Male: Sexual Feeling across the Boundaries of Identity*, New York: Routledge.

The Telegraph (2005), "John Stonehouse 'shed his guilt by adopting new identity'," *The Telegraph* [online], 29 December. http://www.telegraph.co.uk/news/uknews/1506526/John-Stonehouse-shed-his-guilt-by-adopting-new-identity.html (accessed January 29, 2015).

The Telegraph (2008), "Andrew Symonds Knocks Streaker for Six," *The Telegraph* (online), 5 March. http://www.telegraph.co.uk/sport/cricket/2293513/Andrew-Symonds-knocks-streaker-for-six.html (accessed December 28, 2014).

Thaler, H. L. (2008) "Holocaust Lists and the Memorial Museum," *Museum and Society*, vol. 6, no. 3, pp. 169–215.

Thomas, E. (2013), "Mexican Congressman Strips Down to His Underwear to Protest Energy Bill," *Huffington Post*, 13 December. http://www.huffingtonpost.com/2013/12/13/mexican-congressman-strips-in-protest_n_4440466.html (accessed December 12, 2014).

Times-News (1982), "Elaborate Suicide Hoax Foiled by Bondsman," *Times-News*, Hendersonville, NC, 29 June, p. 10. http://news.google.com/newspapers?nid=1665&dat=19820629&id=O2AaAAAAIBAJ&sjid=zSQEAAAAIBAJ&pg=6455,8097717 (accessed December 20, 2014).

Tischauser, L. V. (2012), *Jim Crow Laws*, Santa Barbara, CA: ABC-Clio.

Toolan, J. M., M. Elkins and P. D'Encarnacao (1974), "The Significance of Streaking," *Medical Aspects of Human Sexuality*, vol. 8, pp. 152–165.

Tores, B. (2007), *Making a Killing: The Political Economy of Animal Rights*, Edinburgh: AK Press.

Trezise, B. (2009), "Ambivalent Bereavements: Embodying Loss in the Twenty-First Century," *Performance Paradigm*, vol. 5, no. 2.

Turner, T. S. (2012), "The Social Skin," *HAU: Journal of Ethnographic Theory*, vol. 2, no. 2, pp. 486–504.

Udo, J. P. and D. I. Fels (2010), "Re-fashioning Fashion: An Exploratory Study of a Live Audio-Described Fashion Show," *Universal Access in the Information Society*, vol. 9, no. 1, pp. 63–75.

Urish, B. (2004), "Narrative Striptease in the Nightclub Era," *The Journal of American Culture*, vol. 27, no.1, pp. 157–165.

Versluys, K. (2009), "Art Spiegelman's *In the Shadow of No Towers*: 9/11 and the Representation of Trauma," *Modern Fiction Studies*, vol. 5, no. 4, pp. 980–1003.

Verstraete, P. (2013), "The Standing Man Effect," *IPC-Mercator Policy Brief*. http://ipc.sabanciuniv.edu/en/wp-content/uploads/2013/07/IPC_standingman_SON.pdf (accessed November 16, 2014).

Von Teese, D. (2006), *Burlesque and the Art of the Tease*, New York: Harper Collins.

Wark, J. (2006), *Radical Gestures: Feminism and Performance Art in North America*, Quebec: McGill-Queen's University Press.

Waterford, V. (1994), *Prisoners of the Japanese in World War 2: Statistical History, Personal Narratives, and Memorials Concerning POWs in Camps and on Hellships,*

Civilian Internees, Asian Slave Laborers, and Others Captured in the Pacific Theater, Jefferson: McFarland.

Weiss, S. R. (2012), "Ellen DeGeneres' Sofia Vergara Costume Will Rescue Halloween," *VH1+ Celebrity*, 31 October. http://www.vh1.com/celebrity/2012-10-31/ellen-degeneres-sofia-vergara-costume-will-rescue-halloween/ (accessed January 1, 2015).

Whitehead, J. (2014), "Are You Staring at the Size of My Gimmick? Applying Burlesque to a Different Anatomy," *Canadian Theatre Review*, vol. 158, pp. 27–32.

Widener, J. (2014), Interviewed in "Behind the Picture," *Time* [online], 4 June. http://ti.me/1krBlv8 (accessed October 12, 2014).

Williams, P. (2007), *Memorial Museums: The Global Rush to Commemorate Atrocities*, London: Bloomsbury.

Willow, C. (2015), *Children behind Bars*, Bristol: Polity Press.

Windsor, B. (2012), Interviewed by Neil Young at *Bradford International Film Festival, National Media Museum blog* [online]. http://blog.nationalmediamuseum.org.uk/2012/04/27/video-barbara-windsor-eastenders-carry-on-camping-biff-2012/ (accessed April 11, 2015).

Wolff, J. (2008), "Foreword," in T. G. Reus and A. Usandizaga (eds), *Inside Out: Women Negotiating, Subverting, Appropriating Public and Private Space*, Amsterdam: Rodopi, pp. 15–18.

Woodall, W. (2011), *Audio Production and Post Production*, Sudbury, MA: Jones & Bartlett Learning.

World Famous Bob (2012), "Welcome to the Wonderful World of the World Famous *Bob*." http://theworldfamousbob.com/ (accessed October 29, 2014).

Worsley, H. (2011), *100 Ideas That Changed Fashion*, London: Laurence King.

Wynkfield, R. (1587), "The Execution of Mary Queen of Scots," reproduced with modernized spelling at *Tudor History* [online]. http://tudorhistory.org/primary/exmary.html (accessed November 2, 2014).

Young, J. E. (1989), "The Texture of Memory: Holocaust Memorials and Meaning," *Holocaust and Genocide Studies*, vol. 4, no. 1, pp. 63–76.

Young, J. E. (1993), *The Texture of Memory: Holocaust Memorials and Meaning*, London: Yale University Press.

INDEX

absence 8, 88–94, 95–8, 108, 110–12
anasyrma 83–7
asymmetry 43
athleticism 67, 68, 69. *See also* sports
audiences 1, 4, 6, 10, 14, 16–19, 29, 31, 33, 37, 38, 39–41, 45, 53, 61–2, 64, 66, 74, 75, 86–7, 92, 94, 108, 111–12
 participation 11, 16–20, 31, 40, 66
audio description 38–41
Auschwitz 88, 90, 92
autobiography 35–7, 37–8

Bambi the Mermaid 30
Barcan, Ruth 1, 2, 3, 36, 59, 60, 64, 75, 77, 80, 87, 121, 122
Barthes, Roland 7, 25, 33, 43–7, 52, 97
body language 57
boylesque 33, 35
Boylesque TO 33
Braveheart 86
Brave New World 54
breakaway clothing 62–3, 70
breasts 32, 33, 36, 46, 61–3, 72, 74, 75, 80, 82, 87, 116, 120, 121
Brown, Trisha 114
Bunny Love 32
burlesque 7, 14, 24, 25–41, 45, 54, 114
buttocks 60, 61, 72

Can Cam 74
Carr, Liz 37–8
Carry On Camping 116
catwalk shows 44–5, 48, 55
Cavallo, Amelia 39–41
ceremonies 11, 65–6, 73
chairs 8, 15, 99, 100, 101, 102–4, 122
Chalayan, Hussein 7, 49–53

Chaplin, Charlie 116
choreography 4, 6, 9–10, 14, 15, 20, 22, 27, 29, 44, 51, 52, 113, 114
comedy. *See* humor
commodification 66, 72–6
conflict 8, 77–94, 99, 104, 105, 107
corsets 11, 12, 27, 28, 31–2, 36, 61
costumes 1, 2, 7, 25, 27, 29, 30, 31, 32, 33, 38, 68, 70, 73
court rulings 61, 62, 63–4, 122
covering up 20–4
Criptease 37–9
cross-dressing 32. *See also* boylesque; transsexuality
Crying Game, The 87
cultural capital 19, 72–3
Curtis, Jamie Lee 9–10

dance 21–3, 52–3, 61, 114
data visualization 93–4
dehumanization 118, 77–8
dementia 21
denuding 16–20, 77–8, 82–3, 88
deviance 14, 59–62, 67, 69, 72–4
Devil of Pope Fig Island, The 83–4
disability 37–41
 learning difficulties 113
domestic space 10, 11–15
Draupadi 82–3
dressing 1, 9, 10, 21, 94, 112, 113, 114, 116–17
 rooms 10, 11–12, 20, 118

empowerment 32, 35–6, 37–8, 41, 80, 82, 83
eroticism 6, 7, 9–10, 12, 25, 28, 29, 31, 33, 35, 37–8, 39, 41, 43–4, 45–7, 55, 60, 67

INDEX

Errazuriz, Sebastian 55–7
ethnicity 17, 60–1, 62, 78, 118
exhibitionism 1, 64, 66, 67, 68, 72–3

Fall and Rise of Reginald Perrin, The 110–11, 122–3
fashion 6, 7, 19, 44–52, 53, 68, 79, 113
FEMEN 64–5, 75, 76, 82, 83
feminine ideal 7, 31–2, 41, 46
femininity 31–2, 33, 114
feminism 16, 19, 28–9, 64, 82–3
flashing 7–8, 44, 59–60, 72–6
Flora Gattina 33
Fraser, Mat 37–8

gangs 105–9
gaze 10, 11, 12, 14, 20, 33, 38, 47, 53, 55, 57, 67, 75, 87
gender 27, 31–5, 36, 60, 87, 99–100. *See also* feminism; masculinity; transsexuality
 construction 32, 33, 64
gendered garments 31–2, 99–100
genitals 32, 33, 35, 59, 72, 83–7
gestures 1–6, 38, 43, 53, 57, 114–17
 Baubo gesture 86 (*see also* anasyrma)
 concealing gestures 22
 defiant gestures 61, 66, 78, 79–82
 erotic gestures 10, 14–15, 29–31, 37, 41, 46
 gendered gestures 33
 hostile gestures 17, 59
 interpretation of gestures 61, 63–4, 116
 reciprocal gestures 4, 72–3
 symbolic gestures 77, 79, 109
 unresolved gestures 22, 53, 114–16
gloves 27, 30, 38
graffiti 105, 107–8
gratification 25, 45–6

habitual undressing 4, 6, 15, 113
holocaust 87–93
How to Undress in Front of Your Husband 12–15, 24
humor 28, 35, 60, 84–6, 110, 116, 122

identity 1, 8, 9–10, 17, 27, 28, 36–7, 59, 65, 66, 68, 77, 79, 86, 88–90, 97, 98, 104, 109–11
imperfection 31–2, 37

indecent exposure 7, 59, 60–4
instability 3, 43, 51, 55, 58, 82
intermittence 43–4, 46–7, 55

Jackson, Janet 61–3
James, Charles 53–4
Jeannie 36–7
Jolie, Angelina 48

Leyla Liquorice 28, 33
lingerie 27, 61, 63

Mardi Gras 72–4, 76
masculinity 20, 32, 33, 51, 86–7
Matsushita, Masako 21–2, 116
Mayer, Morris. *See* Jeannie
McQueen, Alexander 43
memorials 8, 87–109, 111
Mimi Amore 29
mirrors 9–10, 15, 41
modesty 20–1, 33, 57, 119
Monroe, Marilyn 44
mooning 7–8, 59, 61, 66, 76, 78
motion. *See* movement
movement 4, 43–9, 51–2, 55, 58, 67. *See also* gestures; choreography
museum exhibits 88–90, 92

nakedness 1–3, 17, 36, 37–8, 60, 64–6, 67–71, 75, 77, 78, 79–82, 113, 117. *See also* denuding; nudity
Nanjing 93–4
narration 15, 39–41
neo-burlesque 27–41
nipples 33, 37, 62
nudity 1, 2, 4, 7, 25, 27, 29–30, 31, 35, 41, 43, 52, 59–65, 68, 75, 77, 79, 80, 82, 83, 117. *See also* denuding; nakedness

Obama, Barack 102–4
observation 9–15, 20–1
Ono, Yoko 15, 16–20
oppression 8, 64, 75, 78, 80, 82

Pauer, Gyula 90–2
penis 32, 33, 35, 86–7
performance art 16–20, 21–3, 39–41, 108, 114

Perniola, Mario 45, 77
PETA 75
photographs 4, 12–14, 44, 45, 48, 69, 80, 88, 102, 117
　as static images 47, 80, 117
postmodernism 28–9
prevention (of undressing) 21, 70–2
privacy 11–12, 20–1, 37–8
private spaces 100. *See also* domestic space
props 28, 30, 37
prostheses 32, 35, 37, 75
protest 8, 60, 61, 64–6, 75–6, 78, 79–83, 86
pseudocide 8, 109–12

quick-change 1, 2, 70

rape. *See* sexual assault
reinvention 36, 109–10
religion 1–2, 16, 64, 118
Rhodes, Zandra 47, 49
risk 68–9, 75
ritual 11, 72–3, 89, 109, 111
Ruthe Ordare 35

safety pin 47, 49
Schiaparelli, Elsa 53
sculpture 90–2, 95–8
seams 53, 54
semiotics 1, 65, 68, 77, 79, 80, 89, 97, 98–104, 105, 110–12
sexual assault 17, 82–3
Sforza Riario, Caterina 86
shirt-rending 80
shoes 15, 37, 88–94, 105–9, 110, 111
skirt-lifting. *See* anasyrma
slavery 77, 78
slogans 64, 82, 120
social contract 79
social media 65, 70–1, 76, 121
sound 38–9, 54–5
speed (of undressing) 27, 29–30, 54, 69–70, 116
sports 21, 24, 66–72
　cricket 70

football (American) 69–70
football (soccer) 66, 72
Stonehouse, John 109–10
streaking 7–8, 59–60, 66–72, 75, 76, 78, 116
strip searches 118
striptease 7, 9–10, 16, 25–41, 46, 59, 75
students 60, 64, 65–6, 68, 72
suicide 93, 111. *See also* pseudocide
Super Bowl 8, 61–3
Superman 1, 38
surveillance 14–15, 118

Tallichet, Jude 95–8
tear-away. *See* breakaway clothing
tease 9, 25–41, 44–5, 54, 75
technology 49–52, 53, 54, 118
territorial markers 98–108
Timberlake, Justin 61–3
tmesis 43, 114
transsexuality 32, 36–7, 87. *See also* boylesque
True Lies 9–10

unfastening 11, 38, 53–8
uniform 65, 70, 78, 80, 88, 104
unzipping. *See* zipper

vaudeville 28, 30
Velcro 54–5, 120
Versace 7, 44–9, 55
visual impairment 38–41
Vivid Angel, The 35
Von Teese, Dita 27, 28

War. *See* conflict
wardrobe malfunction 47, 52, 61, 62, 116
Westwood, Vivienne 45
Windsor, Barbara 116
Wing Bowl 73
workplaces 102–5
World Famous *Bob* 32

zipper 11, 21, 38, 52–7, 114